Reluctant**Partners**

Art and Religion in Dialogue

edited by Ena Giurescu Heller

The Gallery at the American Bible Society
1865 Broadway (at 61st Street)
New York, New York, 10023
212.408.1500 phone
212.408.1456 fax

This publication is the outcome of the symposia series
New Directions in the Study of Art and Religion. This
three-year project was organized by The Gallery at the
American Bible Society and sponsored by The Henry
Luce Foundation, Inc.

Editor: Ena Giurescu Heller
Contributing Editor: Ute Schmid
Catalog Design: Vincent Lisi and Grace Suhr
of Two Dogs Design
Printing: Frantz Lithographic Services, Inc., Bensalem, PA
Typeset in FF Scala Sans and Filosofia

ITEM NUMBER 113018
ISBN 158516772-X

113602

APPENDICES

For nearly 200 years, the American Bible Society has steadfastly pursued its mission, "to make the Bible available to every person in a language and format each can understand and afford." This venerable organization creatively extended its reach with the opening of The Gallery at the American Bible Society in 1998 on Columbus Circle, providing an exhibition space dedicated to Judeo-Christian art and the inspiration it has found in the Bible. Imaginatively directed from the outset by Ena Heller, the Gallery has quickly achieved an excellent reputation for the quality of its exhibitions, publications and educational programs, bringing the Bible to new audiences as artists and scholars have done for centuries.

In the same decade that The Gallery at the American Bible Society opened, controversies about the relationship between religion and the arts repeatedly unfolded here in New York and around the nation. The media followed stories of sacrilege and censorship, portraying religious and artistic communities as necessary adversaries. With long-standing commitments in theology, American art, and humanistic scholarship, the Henry Luce Foundation provided support for a variety of projects and educational programs, hoping to find ways that the best expressions of the human spirit could be partners, rather than tearing at an already frayed social fabric. Among the most promising of those ventures was a series of symposia, *New Directions in the Study of Art and Religion,* which The Gallery at the American Bible Society undertook with our support, offering opportunities for cross-disciplinary exchange and fostering fresh notions in what was becoming a cultural minefield.

This volume presents some of the best fruits of those symposia. Through engaging presentations and lively discussions, a widely diverse group of participants has not only developed important understandings but also forged a community of inquiry, represented in the essays that follow. On behalf of the Luce Foundation, I commend the work of Ena Heller, her associate Patricia Pongracz, and all their colleagues at the American Bible Society for this bold and immensely helpful undertaking. Through their efforts, we see anew the mysteries of at the heart of the Scriptures, speaking to us still and inviting our imaginative, faithful response.

MICHAEL GILLIGAN
President
The Henry Luce Foundation, Inc.
New York, December 2003

This book is the result of the three-year research project *New Directions in the Study of Art and Religion,* organized by The Gallery at the American Bible Society and sponsored by the Henry Luce Foundation. On behalf of all of us involved in this book, and more generally all professionals involved in the field of art and religion, I would like to thank the Henry Luce Foundation for their constant and generous support of individuals, institutions and projects seeking to forge new roads in our understanding of art, religion, and their interconnection in our society. Michael Gilligan, President of the Luce Foundation, who at the time of our grant proposal was Project Director for Theology, believed in our project from the beginning and helped mould our initial inquiries into a coherent plan. Without his trust and belief in the value of this project, and his patient guidance during the various stages of research and development, this publication would not have been possible.

This volume has been shaped by the knowledge, expertise and support of many talented people. First and foremost, my deepest gratitude goes to the contributors to this book: Doug Adams; Marcus B. Burke; Vivian B. Mann; David Morgan; Robert L. Nelson; and S. Brent Plate. Their scholarship, dedication to the many facets of history, and passion for the visual educated and inspired me, as I am sure it will all readers of this book. Together, their essays illustrate the best in today's writing on the dialogue between art and religion.

The members of the Advisory Committee for *New Directions in the Study of Art and Religion* had a major impact in the final formulation of the project and its various events. Their expertise in the various fields that comprise the discourse on art and religion helped me focus and highlight particular issues that needed addressing. They are: Doug Adams (Graduate Theological Union); Diane Apostolos-Cappadona (Georgetown University); Susan Boynton (Columbia University); Marcus B. Burke (The Hispanic Society of America); Margot Fassler (Institute of Sacred Music, Yale University); Ronne Hartfield (Center for the Study of World Religions, Harvard University); Rabbi Shirley Idelson (Hebrew Union College); David Morgan (Valparaiso University); Robert Bruce Mullin (General Theological Seminary). To every one of them, my special thanks. I would also like to acknowledge the speakers who shared their expertise and insights during our symposia: Doug Adams (GTU); Hondi Duncan Brasco (Center for Spiritual Growth, Christ Church, Bronxville); Susan N. Braunstein (The Jewish Museum); Marcus B. Burke (The Hispanic Society of America); James Clifton (Sarah Campbell Blaffer Foundation); Terrrence E. Dempsey, S.J. (MoCRA); Margot Fassler (Institute of Sacred Music, Yale University); Alessandro Garcia-Rivera (Jesuit School of Theology, GTU Berkeley); Georgette Gouveia (The Journal News); Ronne Hartfield (Center for the Study of World Religions, Harvard University); Rabbi Shirley Idelson (Hebrew Union College); Robin M. Jensen (Andover-Newton

Theological Seminary); Charles Little (The Metropolitan Museum of Art); Charles Long (emeritus, University of California); Vivian B. Mann (The Jewish Museum and Jewish Theological Seminary); Ellen Miret (artist); Robert L. Nelson (University of Chicago), Gustav Niebuhr (Center for the Study of Religion, Princeton University); Patricia C. Pongracz (The Gallery at the American Bible Society); Jean Bloch Rosensaft (Hebrew Union College – Jewish Institute of Religion Museum); Geri Thomas (Thomas & Associates, Inc.); Wilson Yates (United Theological Seminary of the Twin Cities).

Special thanks go to Doug Adams, whose encouragement and relentless enthusiasm for, as well as knowledge of the field of art and religion, guided me through the whole process; and to David Morgan, who from my early days at The Gallery at the American Bible Society has been a constant inspiration, an undisputed mentor and an ever helpful resource. David's recent forays into creating a new type of dialogue between art and religion have informed our own efforts here; his expertise helped make our focus clearer, and this volume, better.

My staff at The Gallery at the American Bible Society has, as always, contributed to this project in essential ways. My research assistant, Lindsay M. Koval, was my right hand throughout the project, ever helpful whether it was finding obscure bibliographic references, compiling a comprehensive bibliography or requesting feedback from participants in our sessions and the community at large. Most importantly, Lindsay's fresh perspective on this field helped me think through many an issue, and forced me constantly to ask the question: will this book be useful to scholars in the early stages of their career? Patricia Pongracz helped me (re) evaluate every stage of this project; I have learned to rely on and benefit from her astute analytical and synthetic skills, as well as her unrelenting perfectionism. Ute Schmid patiently and skillfully managed the process of turning pages of manuscript into a beautiful book, insuring that we deliver on time and at budget. Kim Aycox assisted in all administrative and legal matters; Peter Feuerherd took on the task of copy-editing with his usual efficiency. Vincent Lisi and Grace Suhr of Two Dogs Design proved that reference books could be aesthetically attractive.

During the three years of the project *New Directions in the Study of Art and Religion*, a community of sorts was formed. Speakers to our symposia, members of the panel discussions, attendees, colleagues who responded to our frequent queries, feedback questionnaires, and informal focus groups—every one of the members of this community had a role in shaping, re-shaping, and improving our efforts. To all of them—and to all scholars who seek to better our understanding of the religious in art, and of the artistic in religion, my heartfelt thanks.

ENA GIURESCU HELLER
New York, December 2003

Interpreting the Partnership
of Art and Religion

Ena Giurescu Heller

Several years ago, as the newly appointed director of The Gallery at the American Bible Society, I pondered the task of organizing exhibitions of religious art, and finding the right balance between studying the art and interpreting its religious significance and symbolism for a general public. I felt confident I could handle the art historical analysis: it was, after all, what I had trained for in graduate school. On the other hand, attempting to convey, with some accuracy, the original religious context of these objects, and the significance they held for their beholders, seemed somewhat daunting. How does one talk about religious ritual and faith in a way that educates the general public yet does not offend the practicing faithful? My own background revealed little in the way of the systematic study of religious history or theology. During graduate school at New York University's Institute of Fine Arts, and especially as I researched and wrote my dissertation dedicated to family chapels in fourteenth-century Florence, I certainly gained many insights into the religious functions, patronage and messages of art and architecture. Notions of religion were integral to the study of medieval art—and yet there were no mandatory courses in religious history or theology.

Are religion and art two worlds that have a hard time meeting in our society? Recent studies reveal that, in spite of a perceived need for more dialogue between people involved in the arts and those involved in religion, an obvious gap between the two groups continues to exist. And although arts and religious leaders alike expressed the need for, as well as their personal interest in, more cooperation and dialogue, still only relatively little interaction between the two worlds exists.[1]

This may be about to change. Significant efforts have been made in recent years to create a dialogue between art and religious institutions, and between the two fields of inquiry.[2] Exhibitions featuring religious art have multiplied, and a number of museums dedicated to exploring various religious traditions have opened in the last decade. A number of public forums, research projects, and publications have explored the relationship between art and religion in our society.[3] The project which led to the publication of this book finds its place among these.

The three-year project *New Directions in the Study of Art and Religion*, organized by The Gallery at the American Bible Society and sponsored by the Henry Luce Foundation, included research, discussion sessions and a series of two-day symposia.[4] Our goal was an assessment of current practices and methodologies for the display of and discourse on Judeo-Christian religious art in our society.[5] The initial research revealed that my graduate school experience was rather typical within the framework

of academic curricula and the history of teaching and writing about religious art in our country.[6] The discourse of art history on religious art has been historically secularized.[7] That legacy, still visible in the way we present religious art today, continues to be one of the shortcomings of our current approach to the field. While we diligently unpack the formal, stylistic and symbolic components of a work of art, and situate it in its socio-cultural and historical context, we often fail to explore the religious significance that the object would have had for its original beholders. We focus on producers and the object itself at the expense of its audience and ritual usage. This approach is partly a result of academic structure and method, which is characterized by compartmentalization. Sally Promey has aptly noted the "...historical absence of interdisciplinary collaboration between those invested in the academic study of art and religion— and especially the disinclination of art historians to come to scholarly terms with religion."[8] Intellectual historians, in turn, are often reluctant to use art as a document of its time.[9] In a time of ever-greater specialization, when each discipline lacks the tools and methods of others, and no one scholar can master all fields of knowledge, it is imperative that we facilitate the dialogue between specialties.

The project *New Directions in the Study of Art and Religion* set out precisely to facilitate such collaborations. It was devised to expand upon the dialogue initiated by exhibitions at The Gallery at the American Bible Society by exploring the intersection of art and religion in different academic settings and public venues. A second but no less important objective was to initiate a network of scholars interested in the connection between art, religion, and culture. Since art often contributes to bringing traditions together and breaking down patterns of division, we started from the premise that the study of art in the context of religion, and of religion through the arts, may create a greater sense of community and integration. Our symposia brought together historians of art, culture and religion and proposed a forum for enhanced dialogue. We hoped to lay the foundations for a more integrated culture, where scholars working in distinct yet related fields would be able to better exchange viewpoints, methods and resources, as well as reference tools.

The symposia focused on the principal arenas in which the dialogue between art and religion takes place in our society: the academy (secular colleges and universities as well as theological seminaries), museums and galleries, and the press. The first two sessions were conceived from the point of view of the art world, through the eyes of academics, museum professionals, and the press. They posed the question of how the study of art history may benefit from an understanding of theology and

religious history, and how the two may be combined in presenting religious art to a general public. The third session turned the tables and asked how an understanding of aesthetic (and a knowledge of art and its history) can allow students in theological seminaries to have a better historical consciousness and a better sense of religious dimension.

The lectures, panel presentations and ensuing discussion groups revealed the need for a written assessment of the state of the field and the current methodologies employed by scholars, museum professionals and educators working in different disciplines. Has our discourse about religion, and in particular religious art, changed in recent years (or even historically)? How do we conduct this discourse in classrooms and museums today? What are the limitations of the current approaches? Finally, how do we see the future? How would we like, in an ideal world, to see the relationship between art and religion being explored, exhibited, and taught? What changes in research and teaching, what new partnerships and collaborations, what new tools would be necessary or useful?

This volume was devised to answer some of these questions. It both captures ideas put forth in our symposia of the last two years and proposes new ones. All the essays included in the section *Art and Religion: Facets of Dialogue* are derived from presentations given in our sessions. Each of them illustrates a different method of connecting art and religion. Together, they show that the tone of the discourse and the specific research methods employed vary according to a number of factors. Primary among them is the intended audience. An art history lecture given at a secular university likely takes a different approach than one intended for students at a theological seminary. Presenting sacred art to a museum audience has quite a different emphasis than discussing it with a religious congregation. Yet either approach can, and should, learn from the other. The disciplines of theology, art history and museology put their distinctive stamps on these studies; read together, they illustrate the variety of possible roads to take when investigating the religion in art, or the artistic components of religion.

The two essays in the section *Art and Religion: The State of the Field* were commissioned specifically for this volume. They responded to the need, expressed by many of the participants in our project, for a systematic historiography, and a vision for the future of the field. They act as bookends to the other essays, creating the larger context for art and religion as a field of study at this particular moment in time.

This volume was conceived primarily as a tool to be used in the classroom. We hope that it will provide a useful framework for students and scholars exploring the interconnection of art and religion and the many voices of their dialogue(s). Most importantly, we hope that it will act as a springboard for further research. By sketching the historiography and the current landscape of our discourse on art and religion, it may provide a starting point for a more engaged dialogue between scholars of different disciplines and representing different types of institutions. Ultimately, it may contribute to the coalescing of an integrated community of scholars, practitioners, students, and an interested general public—a community of which we had a glimpse during the symposia organized by The Gallery at the American Bible Society.

At the end of one of the symposia, a member of the audience asked the presenters how they would change their papers as a result of the two days of discussion by this particular group of attendees. The question was an acknowledgement of the fact that the event had brought a listening community together, a community that allowed people to share facets of their work which they do not always talk about, or address "delicate" issues with a greater freedom than at other scholarly or public forums. One of the graduate students attending our May 2002 session summed up a feeling also noted by many other participants, stating:

> Most of us present there felt that the creation of such a group or community, made of people engaged in the study of art and religion, and coming to the table from multiple perspectives, is important as it secures a special climate which allows, but does not force, religious aspects of art to be drawn out which might otherwise be suppressed.[10]

By bringing together the descriptive approach of historians and the prescriptive method of theologians, we laid the foundations for creative, constructive dialogue in the future. That was, in my opinion, the single most important achievement of the project titled *New Directions in the Study of Art and Religion*. And I hope that this volume documents and expands that dialogue, while making it available to a wider audience.

[1] Robert Wuthnow, "Arts Leaders and Religious Leaders: Mutual Perceptions," in Alberta Arthurs and Glenn Wallach, eds., *Crossroads. Art and Religion in American Life* (New York: The New Press, 2001), cap. 39f.

[2] Witness a number of newly endowed chairs in "art and religion" at theological seminaries, which indicate a shift of emphasis toward the visual and its relationship to religious thought. In a study of theological seminaries in this country conducted in the 1960s, only six institutions expressed interest in programs dedicated to the study of art and religion; a similar study conducted in the 1980s revealed a much different landscape, with only six seminaries which were *not* interested. I thank Doug Adams of Graduate Theological Union for bringing these studies to my attention. Prof. Adams, who is one of the pioneers of the field, is so encouraged by recent developments as to suggest that the partnership of the art and religion has advanced from a "reluctant" to an "expectant" stage.

[3] To cite a few among such recent efforts, the Henry Luce Foundation sponsored a research project on Americans' experiences with the arts and religion, and the perceived relationships and conflicts between them; see Arthurs and Wallach *Crossroads*. The Center for the Study of World Religions at Harvard University developed a number of research initiatives involving religion, the arts, and museums, leading to the design of a conceptual Museum of World Religions. For a detailed description of this ongoing *Religion and the Arts Initiative*, see their website at http://www.hds. harvard.edu/cswr/research/. The *Five Faiths* project spearheaded by the Auckland Art Museum, at the University of North Carolina at Chapel Hill brought together museum professionals, religious leaders, scholars and journalists to analyze a series of questions about museum education in the context of religious art displays. Their forthcoming publication of workbooks for museum professionals around issues of display and interpretation of religious

objects, and teaching about the world's religions through encounter with sacred art objects, will complement this publication. *Arts and Religion in the Twin Cities*, sponsored by the Henry Luce and Rockefeller Foundations, consisted of a series of dialogues aimed at examining "the intersection of art and religion…at the grass-roots." Bringing together local organizations involved in the exploration of arts and religion, professionals from religious and cultural groups, and the community at large, the project sought to answer the question: "…are art and religion as deeply in contention as they have been depicted?" For a description of the project see Shirley Idelson, "The Project: Arts and Religion in the Twin Cities," *Arts. The Arts in Religious and Theological Studies*, 14/1 (2002): 4–8. The University of Northern Iowa sponsored a series of events in the spring of 2001, which explored the role religion plays in American individual, cultural and community life and was centered around the exhibition *Picturing Faith: Religious America in Government Photography, 1935–43* at the UNI Museum. I would like to thank David Morgan for bringing this last project to my attention and Martha J. Reineke of UNI for making the information available to me.

[4] This project benefited from the expertise of a committed Advisory Committee, under whose guidance it was refined to better serve the field and its constituents. I would like to acknowledge the members of the Committee, to whom I am deeply grateful: Doug Adams (Graduate Theological Union, Berkeley); Diane Apostolos-Cappadona (Georgetown University), Susan Boynton (Columbia University); Marcus B. Burke (The Hispanic Society of America); Margot Fassler (Institute of Sacred Music, Yale University); Ronne Hartfield (Harvard Center for World Religions); Rabbi Shirley Idelson (Hebrew Union College); Lindsay M. Koval (Columbia University); David Morgan (Valparaiso University); Robert Bruce Mullin (General Theological Seminary); Patricia C. Pongracz (The Gallery at the American Bible Society).

[5] See *Appendix A* for a description of the project.

[6] The situation is different in theological seminaries; as mentioned above, many such institutions offer today advanced degrees in "art and religion" or "theology and the arts." Among them, Graduate Theological Union at Berkeley remains unique by offering a Ph.D. degree in this specialty.

[7] See also the essays by David Morgan and Robert Nelson in this volume.

[8] See Sally M. Promey, "The Visual Culture of American Religions: An Historiographical Essay," in *Exhibiting the Visual Culture of American Religions*, David Morgan and Sally M. Promey, eds., Brauer Museum of Art, Valparaiso University (Valparaiso, IN: 2000), 5. See also Promey's recent article "The Return of Religion in the Scholarship of American Art," *The Art Bulletin* LXXXV/3 (September 2003): 581–603.

[9] See Robin Margaret Jensen, *Understanding Early Christian Art* (London: Routledge, 2000), 2.

[10] I would like to thank Stephanie Wilken for her thorough analysis of one of our sessions, from which this paragraph is excerpted. Ms. Wilken received an MFA with a concentration in printmaking from the University of Minnesota.

art and religion: the state of the field

toward
a modern
historiography
of art and
religion

David Morgan

W hat is the history of writing about art and religion? The question begs another: is there, in fact, a history of art and religion *as a field of study*? History writing comes in the shape of specializations—nineteenth-century New England women devotional writers or Baroque chapels in Southern Europe or Protestant theology in West Africa. In cases such as these, scholars have scrutinized people, things, or ideas as the focus of self-conscious study. They have read one another's work, subjected the work to critical, historiographical reflection, trained their students in a genealogy of thought, and collectively advanced the conversation or discourse in their published works. Is there anything like this in the study of art and religion? Has "art and religion" been a discrete and circumspect topic of inquiry?

Certainly there has long been an abundance of art historians who study religious art, theologians who explore the implications of art and aesthetics for theology, philosophers who consider the relationship between aesthetics and belief, scholars and historians of religion who investigate aesthetics, architecture, myth, and ritual, and anthropologists who examine the relationship between myth, ritual, folklore, kinship, and art. All of these scholars can adduce a large body of scholarly literature on which they rely for the training of students as well as for critical reflection and the assessment of new work. Yet it seems presumptuous to say that there is a distinct field of study called "art and religion," which is the purview of an identifiable group and tradition of scholars. In my experience, few scholars are conversant in the literatures of more than two of the discourses named.

The Question of a Field

Art and religion" is certainly a "field" if by that one means no more than to signal the general concentration of one's study, in a manner comparable to "art and psychology" or "art and sociology" or "art and gender." Designations like these indicate a broad intersection *where* one studies, but they say little or nothing about *how* one studies the subject or *what* intellectual formation may be requisite for such study. Compare them, for instance, with rubrics like "Marxist art history" or "psychoanalytic analysis of art," both of which imply the sort of questions scholars will bring to the examination of works of art as well as the kinds of literature in which they will be conversant. The study of art and religion is so broad, so differentiated by language, geography, religion, and national history, that no single scholar operates

with a normative sense of a unified, singular field of inquiry. In other words, there is no primary or universal discourse called "art and religion." Art historians who focus on art and religion typically observe an allegiance to art history as a discipline far more than to any nexus called "art and religion." In the discipline I know best, art history, which has likely produced more studies of religious art over the last 150 years than any other single field or discipline, there is no sub-specialty known as "art and religion." There are simply art historians who study the art of one religious tradition or another in a particular historical period. There are, of course, many well-known and influential scholars who are recognized for their work on religious art. But if an organized, self-critical discourse is the principal measure of a field of inquiry, one cannot say that art and religion is such a field.

But it could become one, and perhaps is in the process of doing so. Why it should happen and whether the formation of such a discourse is worth encouraging are questions worthy of careful consideration. If critical reflection on the study of art and religion will advance and deepen the study of religious art, then it is well worth pursuing. The formation of a discourse on art and religion is valuable not in order to form new academic organizations, departments, jobs, or tenure lines. The value of an organized discourse is the critical scrutiny and insight that it fosters and depends upon. The task of this essay, therefore, is to sketch out the historiographical foundations for thinking about the relation of art and religion. The point is not to delineate the boundaries of a new discipline, but to heighten critical awareness of the themes, questions, and history of thought (vast as it is) about art and religion. Rather than lumping a host of different kinds of scholars into a new amalgam, this will succeed if it can make even a small contribution toward helping art historians, anthropologists, theologians, and philosophers do their disciplinary work better and toward conducting their interdisciplinary conversations with one another with greater understanding. If "art and religion" should become a recognized field of study in the strong sense of an organized, reflexive discourse, it will do so as an interdisciplinary crossroads. Describing that intersection's intellectual history is the goal of this essay.

PART I.
DEFINING THE FIELD: SEVERAL STRATEGIES

There are perhaps several ways at our disposal for determining what the scholarly association of art and religion means. One might consult library and archive classification systems in order to learn which rubrics have been used to organize books and records and what the contents of these forms of classification have been. Important institutions such as the New York Public Library, the Library of Congress, the British Museum, Marburg or Heidelberg University Library, or La Bibliothèque Nationale, to name only a few, house within their cataloguing and organization fascinating histories of the structure of knowledge, whose subtle influence on research should not be underestimated. But since tools and collections derive from scholarly publications and the holdings of each in major libraries, we can pass to the books themselves. Certainly the archaeology of knowledge embedded in classification

systems will offer up important insights into the cognitive mapping of the subject of art and religion, but I leave that to specialists equipped for the task, since any substantive research in this domain would require careful historical tracing of the rubrics, institutional analysis of particular libraries, and consideration of national variation.[1]

A number of indices and lexicons provide further information about the organization of religious art as a subject of study.[2] Each of these provides an indispensable tool for identifying iconography, distinguishing subject matter, and following the development of motifs over time. But such indices and lexicons should not be taxed to offer a representative guide to the understanding of art and religion since they are limited in scope. Of greater promise may be a longitudinal study of textbooks and comprehensive histories of Christian art (or Jewish, Hindu, Muslim, or Buddhist). There is an abundance of such books going back in the case of Christian art to the mid-nineteenth century. A systematic examination of their methods and themes, the conceptualization of their purpose and audience, the resources they employ, and their organizing ideas or rationale might illuminate current thought and practice.[3]

A third approach is to review significant works by scholars who have made the effort to reflect on the study of art and religion in some programmatic manner. Taken together, these reflections form a history of thought about art and religion.[4] As ways of thinking, they are distinguished from one another by the problems their practitioners wish to solve. By sifting through scores of studies, I have distilled five approaches, which may be illustrated by the work of influential scholars over the last several generations in order to construe the dominant avenues scholars have taken toward the study of art and religion.

Construing the Field

1. The evolutionary approach. Some scholars wish to know how religious art partici-pates in and reflects the evolution of culture or mind. This "evolutionary" approach regards art and religion as fundamental aspects of the development of human consciousness as it is encountered in the history of culture. In this model, art is almost always subordinated to religion, as a means to an end. The British poet, critic, and author Herbert Read even claimed that the evolution of religion from ritual and belief to rationalization implied "if not an increasing distance between art and religion, at least an increasing critical attitude on the part of religion towards art." He followed contemporary anthropologists such as Lucien Lévy-Bruhl on this, but was deeply indebted to Hegel, who proposed perhaps the most sweeping and influential account of religion and art within the historical evolution of mind.[5] Still, the approach sees works of art as traces of historical development, as direct evidence of the movement and unfolding of human consciousness.

2. The cognitive approach. Another approach, one that is not in some key respects unrelated to the evolutionary model (indeed, Herbert Read united the two in his work), posits that art and religion are both forms of perception. The principal question

determining research is "how does religious art participate in the constructive perception, understanding, and experience of the world and the sacred?" Margaret Miles has nicely summarized this approach:

> The function of art is to identify and articulate a range of subjective patterns of feeling and to give objective form to feeling…Religion needs to orient individuals and communities, not only conceptually but also affectively, to the reality that creates and nourishes, in solitude and in community, human life. Religion…is a complex of concepts about the self, the world, and God; it is also an altered perception of the meaning and value of the sensible world…Both are cognitive functions; both involve an organization of experience, but they are different in content and they train different capacities in human beings.[6]

Miles therefore focuses on the capacity of images to interpret, and religious images to function as means of world interpretation. The hermeneutics of visual images she practices is aimed at illuminating the study of religious worlds, communities, the history of the church, women's experience, and what she calls "the life of the body."

3. The visual (and material) culture approach. The operative question in the study of religious visual practice is: "how do imagery or objects or spaces contribute to the construction of life-worlds among believers?" Rather than singularly focusing on objects, scholars engaged in the study of visual or material culture will stress the reception and use of these objects in religious practices. Methods of study that attend to material culture seek additional forms of evidence, the testimony of the material substrate of which the work of art consists—not only the intentional features of its making such as style, but the traces of its use, its circulation, the sedimentation over time, its erasures, melding, and renovations, and the afterlives of the object in which it is both forgotten and then remembered.[7] Where material culture attempts to measure use not necessarily intended by maker or patron, we become mindful of the importance of studying the reception of religious artifacts. Meaning is not limited to encoded content, but is also constructed by those who make the image or space their own, endowing it with significance by virtue of social function, ritual, local narrative, or personal use. For instance, discerning the "life of the body" that Miles sets out as an aim of her work is not simply a matter of the "correct" reading of iconography and style, but a careful examination of the response to images, their use in ritual, and their physical location, display, and manipulation.[8]

The emphasis placed on reception, visual practice, and function in the "visual culture" approach to religious images runs the risk of marginalizing the image or object unless it strives for integrating production with reception. Scholars pursuing this approach rely on ethnographic method, when possible, and, when it is not, train their attention on posing socially-minded questions of the uses of images and the practices that put them to use.[9] The advantages of the approach are that it avoids taste-distinctions such as "high" and "low;" it attends to the cognitive frameworks that shape perception and the experience of images and help determine meaning;

and it aims finally at understanding the world-building activity of imagery and visual practice, thereby holding much in common with the cognitive approach discussed above.

4. The traditional art historical approach. Consisting essentially of the study of style and iconography, this approach asks "why does religious art look the way it does and what does it mean?" In an autobiographical reflection on her work as a teacher in Christian seminaries, art historian Jane Dillenberger outlined a method of study that derived from the standard art historical approach of iconography, as developed most succinctly by Erwin Panofsky, and from another major strand of art historical study, stylistic analysis. Dillenberger articulated the study of Christian art in three steps: identifying subject matter, stylistic description of the work of art, and exploration of its content or meaning.[10] The study of subject, style, and content are the indispensable contribution of art historical investigation to the study of religious images and their consideration belongs to the intellectual preparation of every art historian. And rightly so, since the manner of visual communication the method is designed to interpret is a common aspect of religious imagery.

 A more sophisticated program was outlined in a short essay in 1992 by John Dixon, a scholar who combined the study of religion and art history in his appointment at the University of North Carolina.[11] Like Dillenberger, Dixon identified subject matter, style, and form as the matrix of the study of religious art. More critically minded, however, he urged those interested in forming a "field" of art and religion to attend to fundamental questions about the relationship between material and method and between the historian's own preparation and purpose and the choice of material he or she analyzes. Dixon encouraged his contemporaries to move toward identifying "the theoretical issues involved in the study [of art and religion] and thus build up a common body of definitions" and a critical bibliography in order to work toward "a common direction that can subsume individual commitments. In short, it might provide a curriculum for study and teaching."[12]

 Dixon's work is an intellectually substantive contribution to this end. Yet iconography, style, and form are by no means all that images are about and any approach that privileges them falters when it reaches Dillenberger's third stage, where the limits of meaning are hardly contained by the coordinates of subject matter and style. Iconographic, stylistic, and formalist analysis will predict with limited accuracy what happens in front of an image. Several studies over the last twenty years or so have scrutinized the visual exchange between image and devotee.[13]

5. The phenomenological approach. A final approach to be outlined here, the phenomenological method employed most famously by Gerardus van der Leeuw, seeks to define the experience of holiness in art, asking "how do the arts register the holy?" Van der Leeuw's method is to identify the distinctive features of each of the arts and thereby to delineate the medium and operation peculiar to each as a consciousness or realization of the holy. Sound, movement, space, time, image and word each constitute the formal media of the arts. Van der Leeuw proceeds in each

case by articulating a number of definitions within the domain of an art form (in the case of images: image, ornament, likeness). These he calls the "paths and boundaries" of each medium. Taken together, they comprise a system or theory of the art form, which he then explicates as a typology in terms of primary historical examples such as the Iconoclastic controversy in the case of images. Van der Leeuw continues with consideration of the "influences" of each medium as an instance of the holy in art, by which he means the effect or experience of the formal elements of a medium. He ends each discussion of an art form with a formulation of the theological aesthetic of the medium, once again selecting major examples from the art form's history in order to make his point.[14]

This approach, which seeks to mount a systematic explanation of the arts, and is traceable to Hegel (and ultimately to Aristotle), relies on observation and analysis of actual works, but begins by presuming the relative autonomy of each medium. It is inclined to take the material features of the medium seriously (though van der Leeuw can be inconsistent here). It is a method that suits monotheism (most of his examples are Western and Christian), since it is premised on Rudolf Otto's definition of the holy as the "wholly other," that is, the transcendent deity or ground that is manifested principally in the human feeling of radical dependence on it (deriving, as Otto did, his conception from Schleiermacher's romantic theology).[15] The arts evoke the numinous effect of the holy without actually revealing its essence, which must remain shrouded in utter mystery. Thus, van der Leeuw describes the consciousness of the holy in the arts in such terms as "ghostly," "awe-inspiring," "sublime," and so forth.

Although his study made a singular contribution to the investigation of art and religion by foregrounding the idea that the holy was not merely illustrated by the arts, but could be studied as manifest in them, van der Leeuw's approach is unsatisfactory for several reasons. It prefers the systematic arrangement of the arts over attention to the particularities that engage the historian and ethnographer. And it regards media as static and governed by intrinsic, formal structures. As a result, it tends to use history as content for its typologically-driven search for the taxonomic rules delineating artistic media—delineations which historical and ethnographic analysis show are rarely operative in practice.

Sorting Out Disciplinary Dispositions

It is helpful to distinguish between programmatic essays on the issue of studying art and religion and philosophical or theoretical approaches to art and religion as human activities. The latter were in vogue in the mid-twentieth century when overarching generalizations about human nature and its creative activities in art, mythology, and ritual occupied many scholars in the history of religion, anthropology, and philosophical theology.[16] Still another group of studies argues for an overarching spiritual, mystical, theosophical, hermetic, or occult definition of art that often posits a sweeping capacity to interpret art the world over.[17]

In many of the studies, art serves as a means for understanding religion and culture, although art may be intricately bound up in it. Scholars of religion wish to understand religion better by studying religious art or aesthetics as a vital aspect

of religious life.[18] But there are also scholars of religion whose work has focused on the religious dimensions of art in such a way that it is difficult to classify their work as religious studies or art criticism.[19] Some historians find religious images an important datum or form of evidence in the study of history.[20]

Art historians, by contrast, are principally concerned with explaining artifacts, and consider religion an integral part of their explanation in the case of sacred art.[21] Although some art historians betray a deeper interest in art and use religion as the means of explaining it, in much of the most impressive work this subordination of one or the other does not occur.[22] Indeed, it can be quite inappropriate since many forms of visual piety do not make the academic distinction between "art" and "religion." Some of the best art historical inquiry of religious objects situates the work fully in the historical, social, and ritual context of its production and use.[23] This contextualist approach is able to balance art and religion rather than instrumentalizing one to explain the other. It is not by chance that most of the titles of these studies carry the telling conjunction "and" in them, signaling the connection of two domains, or at least two rubrics on the academic map of cultural interpretation. Not only does constructive scholarship seek to avoid marginalizing one or the other, it resists merging them into a single phenomenon such as an "aesthetic faculty" or "aesthetic emotion" as Formalist accounts are inclined to do.[24]

Theologians want to enrich theological discourse by examining art or aesthetics.[25] Liturgists and seminary professors have studied the role of the visual arts in shaping Christian worship.[26] These and other religious teachers and scholars (a few art historians among them) with faith commitments which they wish to apply to their work pursue an interest in art in order to enliven or deepen the understanding and practice of religious faith.[27]

Other scholarship focuses neither on works of religious art nor on religious belief per se, but on the history of ideas that engage the two domains of cultural activity. These scholars may scrutinize the philosophy of art, the history of aesthetics, the theology of beauty or culture, liturgics, theories of religious ritual, or concepts of sacred space.[28]

All such studies tend to fall into one of three categories, including the five approaches described above.[29] Judging from their published works, scholars who devote a study to some aspect of art and religion have in mind to accomplish one of three things. Their investigations are either object-centered or practice-centered in approach, or they are concerned with the intellectual history of theology and aesthetics. Each turns on the preponderance of its analysis, which is generally reflective of the scholar's disciplinary orientation.

1. **Object-centered studies.** There are several divisions within this, the largest category, that break down according to the nature of the religion under question. Within this group, the most common approach is studies that focus on sacred objects or spaces, considering religion as the ritualistic, institutional, or intellectual setting in which the object appears, and is therefore regarded as a set of ideas or a disposition encoded in the iconography, style, patronage, location, or function of the object.

Scholarship in this category is concerned centrally with the analysis of sacred art and architecture—the imagery, built-environment, and material culture of organized, institutional religion. A second area of focus is studies of the imagery and material culture of civil religion, that is, the religion of the nation or state or clan—not the religion of gods, but ritual and practice and public theology whose transcendent referent is the civic order that binds members of a society into a sacred identity. A third group of studies is largely modern in focus, but includes studies of ancient philosophy and thought: the imagery and material culture of spirituality, hermeticism, mysticism, the occult or personal belief. A final category consists of studies no less modern—art as a spiritual epiphany. Art as itself a process of contemplation, meditation, introspection, and revelation.

2. Practice-centered studies. The second general group, which consists of the visual and material culture approach, concentrates on the cognitive and behavioral frameworks in which religious or spiritual images and spaces are experienced. This approach seeks to scrutinize visual practices—what people do with images and spaces—and ways of seeing, that is, the cognitive as well as perceptual schemes, assumptions, and habits or conventions that condition what and how people see in a given time and place. "Visual culture" is used here to designate this approach and to distinguish it from traditional art historical practice. Visual culturalists are by no means uninterested in images, but study them by integrating them into the frameworks that viewers presume when seeing images. This approach has stressed the importance of studying the response to images, particularly in the domain of popular reception.[30]

3. Religious Aesthetics. The final group of studies dedicated to art and religion is those investigations that consider the theological implications of art or the aesthetic significance of religion. We may call this rubric "religious aesthetics" as a general term designating both emphases. This approach is philosophical or theological in content, and often spends little or no time analyzing actual works of art. The point is not to add to the knowledge of concrete images or spaces, or to the visual practices of a particular faith or belief, but to the theological understanding of art, or to provide an understanding of the aesthetic significance of religious experience or teachings. This is one of the oldest bodies of literature in the field of art and religion, having served as the focus of a great deal of philosophical work in the nineteenth and early twentieth centuries, much of it influenced by Hegel and Romantic thought.[31]

PART II.
THE MODERN SETTING OF "ART AND RELIGION"
Any history of the study of art and religion must acknowledge the deeply modern and Western character of the subject. Failing to do so will lead inevitably to historical and cultural misrepresentation. Although all cultures have fashioned artifacts for use in ritualistic practice, it is presumptuous to call the artifacts "art" and the rituals "religion." What do art and religion have to do with one another? Put in this manner,

the subject is a deceptively modern one: "art and religion" were not a topic of reflection before the eighteenth century, and for good reason: "art" per se only began to emerge as a rubric in the modern sense during the sixteenth and seventeenth centuries and "religion" consisted of a single vast distinction—ours, the true one, and all others, the collectively false. But a host of social, cultural, political, and international processes inaugurated in the course of the eighteenth and nineteenth centuries led to the emergence of art and the recognition of religious plurality within the new democratic state. But I am already ahead of myself. In order to show the significance of what I have just claimed it will be necessary to focus greater attention on the intellectual and cultural conditions in which "art" and "religion" came to be associated with one another. Art and religion have been very much on the minds of cultural critics, writers, moralists, theologians, and philosophers since the eighteenth century. This is not to deny that the religious significance of visual artifacts and buildings occupied philosophers or theologians long before modernity. The use of monuments and city planning to shape civil religion is as old as ancient Egypt, Mesopotamia, or China.

There are perhaps two major reasons that "art and religion" has emerged as a subject of special interest among modern scholars: modern cultural history bears two trends that might be said to dispose many to scrutinize art for its religious and spiritual significance. One is the tendency in the nation-state to look to art for a powerful moral effect on the public and citizenry; the other is the tendency since the eighteenth century to spiritualize art and its experience. Understanding this cultural history is crucial for situating the rubric of "art and religion" within its proper historical context. Failing to do so leads inevitably to misrepresenting the connection by reifying or universalizing it. Moreover, these two modern impulses are often diametrically opposed to one another: spiritualizing art was something considered inaccessible or elevated above the modern masses. The spiritual in art could even be a countervailing force in modern democracies, where taste was low and art that tried to elevate it was often derided as merely didactic and anything but avant-garde. Art-for-art's-sake, after all, developed as an aesthetic ideal in France in reaction to the control of the state and church over artistic production.[32] The ideal helped shape both the Romantic notion of the artist as individual agent and the sacrosanct nature of art, denying or subordinating the art of civil religion as it emerged from the French Revolution and continued to be controlled by French state patronage throughout the nineteenth century.

Art and the Republic

We are strongly disposed today to speak of "art" and of "religion" as if they were two discrete cultural forms, rather like timeless categories of human behavior, each with its own history, each identifiable as such at any time and in any place. The tendency to regard "art" and "religion" as self-contained forms bears in some significant sense the epistemological imprint of modern political economy. This is the mental habit that attends the modern polity of the nation-state. Before the modern era the world consisted largely of kingdoms and heaven-sent realms whose

sovereignty rested in the person of the monarch or emperor. In such a world there were often only two kinds of religions: ours (usually the king's) and theirs—the real one and the false ones. After the eighteenth century, however, the world came increasingly to be composed of sovereign nations, that is, organic units of peoples separated by land, language, history, and culture. Empires, monarchies, kingdoms, and dynasties gave way to peoples, parliaments, democracies, and sovereign nations. The ruling family was replaced by the national family as the touchstone to collective identity and sovereignty. Artifacts were gathered up and placed in museums, public institutions formed—in the most famous case of the Louvre—from former palaces. The wealth, luxuries, antiquities, and collected curios of the royal family became patrimony of the nation. The state museum became the repository of national memory and achievement—the people's record of its descent through the ages.[33]

The passage from dynasty to demos was effected by rounds of imaginative remembering in which art and religion came to stand as vital, constitutive agencies of the national soul. Herder, for instance, and later Romantic writers inspired by his example, took German, Czech, or British art and poetry from the status of minor folk or provincial art to the much grander stature of national art and style, regarding it as the treasure house as well as the engine of national identity. In his *Observations on the Feeling of the Sublime and Beautiful* (1764), Immanuel Kant had included a discussion of the aesthetic disposition of various European nations and extended his remarks to include Arabs, American Indians, Greeks, and Romans.[34] Each "people" exhibited certain feelings for the sublime or the beautiful as an aspect of their "national characteristics." The premier theorist of German Romanticism, Friedrich Schlegel, in a series of essays on the history of European painting published in 1803, assumed that nationality and artistic individuality were the two enduring frameworks of all painting. Just as each nation possessed "its determinate physiognomy in manners and lifestyle, feelings and shape, so also its own music, architecture, and sculpture; and how could it be any other way?"[35] In the spirit of his historicism of Mind evolving over time, Hegel claimed that every work of art "belongs to its age, to its nation, and to its environment."[36]

Benedict Anderson has famously defined nationalism as a form of imagined community.[37] To this compelling thesis may be added the way in which art and religion, conceived in the nationalizing imagination as discrete forms of cultural activity, become the sovereign means of expressing the essence of the nation, the people, and therewith come to play a principal role in bearing nationhood. Art and religion have served as indices of nationhood, and have, accordingly, adopted the shape of nations, bearing the national characteristics in the arts. By the same token, exhibitions, college courses, textbooks, and scholarship since the nineteenth century have used nationhood as a primary measure for parsing the history of art and religion.[38] But the bind forged between nationhood, art, and religion does not end there.

Modern Western nationhood is deeply tied to modern democracy. And modern democracies have universally fostered the need for "art"—that is, art as a non-sectarian treasury of moral and ultimately theological capital. Taste, the eighteenth-century notion of a refined sensibility to recognize moral and aesthetic worth, to judge rightly,

and to act accordingly, was a public source of goodness or virtue that needed to be cultivated in the modern republic in order to benefit a public that was increasingly understood as an aristocracy of the middle-class. Self-rule, it was widely believed, relied upon a tasteful body politic. Republican ideology grounded civic virtue in a literate, morally upright, tastefully refined citizenry, and often looked to the visual rhetoric of neoclassicism as the fitting style for promoting the national ideal of republican taste. It is no mistake that this style was used by ideologues like Thomas Jefferson and city planners such as Pierre L'Enfant. The style has fossilized in banks, post offices, and public schools as the imprimatur of national authority and continuity, the visual register of security and reliability.

The search for a collective style to represent national unity in the sacred spaces of a civil religion had its secular counterpart in the longing to establish a singular diction and orthography in American English. Noah Webster tirelessly pursued the publication of an American dictionary and American common school books to this end: teaching his new countrymen how to speak and write promised to deliver the new republic from corruption and tyranny and the divisive forces of an uneven and locally determined literacy. Liah Greenfeld has gone so far as to define the modern conception of the nation as "the idea of a homogeneously elite people." Nationality, she claims, "elevated every member of the community which made it sovereign."[39] To be a national means to enjoy the privilege of native status. Democracy heightens the status by undermining class distinctions (at least, in theory), making equality a primary value. But this comes at the risk of exploitation: a society without class is a society without taste, without distinction, and therefore in threat of vulgarity and the influence of the lower domain of humanity. Early national moralists repeatedly expressed this anxiety and looked to the arts, to public education, and to civil religion as the necessary antidote.

The elevation of public taste was constantly on the minds of the writers, moralists, and artists of the early republic in the United States. The promotion of poetry, literature, and the visual arts was considered vital in this enterprise. A moral theory of art charged the work of art with a solemn task of uplift and moral education, a task that was not unreligious, and became a fundamental part of American civil religion in the countless monuments, public buildings, and eventual public collections of art in the nation's capital.[40] The moral theory of art identified art as a refiner of the popular soul. Art and letters were necessary for the formation of a citizenry capable of upholding the ideals of the new American republic.

The civic function of art regarded it as a moral force that was decoupled from institutional religion. One of the most widely read advocates of the aesthetic education of modern humanity for citizenship in a state grounded in the Enlightenment's ideal of human freedom was the German poet Friedrich Schiller. In the context of the de-railed French Revolution, a tragic foiling of the European longing for a democratic state grounded in reason and liberal sentiment, as Schiller interpreted it, he argued in a famous set of letters published in 1795 that humanity could learn to live as free in the modern world only by undergoing an aesthetic tutelage. "If man is ever to solve that problem of politics in practice," Schiller claimed, "he will have to

approach it through the problem of the aesthetic, because it is only through Beauty that man makes his way to Freedom."[41] In a series of sweeping Idealist mediations of opposites typical of German thought at the time, Schiller reasoned that beauty combines the two natures of humankind—the sensuous and the rational—into a higher unity. "By means of beauty the sensuous man is led to form and to thought; by means of beauty the spiritual man is brought back to matter and restored to the world of sense." Class warfare was mediated by the poet and artist. Freed from the brute state of mere physicality and force, humanity is enabled to recognize moral freedom; likewise, beauty reconciles an alienated class of bourgeois and aristocratic leaders and owners to the world of the body and senses. The state or kingdom (he used the political terms *Staat* and *Reich* interchangeably) of force and the state of laws or governance, naturally at war with one another, are reconciled in what Schiller called the "aesthetic state," which constitutes a higher state of freedom, or play, the domain of appearance or representation. In this aesthetic state, according to Schiller, humans are "relieved of the shackles of circumstance, and released from all that might be called constraint, alike in the physical and in the moral sphere."[42] Art could teach people how to be free by inwardly reconciling the opposite aspects of human nature that Schiller felt were the source of enmity and strife in social life. The liberated soul would, he believed, live a liberated social existence. Schiller's hope was that art would elevate humanity to a true state of freedom, one person at a time. If freedom could not be legislated (and no political setting in the German territories of his day suggested it could be; matters in France were hardly more encouraging), it could be realized aesthetically, inwardly, in the grip of the beautiful.

The Spiritualization of Art
To do justice to the topic of the modern spirituality of art, one would have to examine a vast sum of material from eighteenth- and nineteenth-century France, Britain, the United States, Switzerland, the Netherlands, Spain, Russia, and Germany. I have neither the space nor the expertise to do so. Therefore I will select a national tradition in Europe that has contributed greatly to this discourse, assuming that it is in many respects representative of the larger development.

German philosophers, theologians, poets, art critics, and art historians from the mid-eighteenth century to the mid-twentieth generated a dense and enormous literature that accorded to the conjunction of art and religion a privileged status and lead toward the spiritualization of art. Indeed, it could be argued that for many of them the "spiritual in art" replaced "religion" to create a new nexus that has deeply colored most subsequent attempts to think about art and religion. For practical reasons, but not without some historical justification, I shall focus my attention in the following discussion on German sources. I do so, however, with full knowledge that there are very significant non-German (not to mention non-Christian and non-Western) scholars, artists, and theorists who have done much to shape the history of thought on art and religion. Those who peruse the notes to this essay will find many citations of non-Germanic studies and subjects that may serve as the point of departure for further reading.

Friedrich Schiller held up as the model for artistic inspiration the classical ideal of ancient Greek art, regarding it as "the source of all beauty." In this he followed the example set for Europeans in the eighteenth century by Johann Joachim Winckelmann, who helped inaugurate a cult or revival of classical antiquity— appropriately religious terms—that swept across Northern Europe and the New World in the second half of the century. The writings of Johann Winckelmann were perhaps the most widely read and highly regarded medium in this new art enthusiasm, which is what it must be called, since Winckelmann and many of his admirers sought to elevate Greco-Roman art to an unparalleled stature as the model for renewal of taste and as the object of a way of seeing that plunged the viewer into an almost ecstatic regard for the works of ancient genius. Consider Winckelmann's description of the Laocoon (fig. 1) in his manifesto of feeling, *Reflections on the Imitation of Greek Works in Painting and Sculpture* (1755). The subject of the ancient sculptural group, drawn from Virgil's *Aenid*, was a priest of Apollo at Troy, who vainly attempted to thwart the deception of the Trojans. Before he could convince his countrymen of treachery in the wooden horse left on the Trojan shore by Odysseus and the apparently departed Greeks, Laocoon was snatched, along with his sons, by a giant serpent sent from the sea by Athena, patroness of the invading army. Winckelmann beheld the sculpture as a model for antique achievement and modern emulation. He picked out the face and body of the dying priest for special admiration, describing the figure in terms that recall the devotionalism of Pietist spirituality in eighteenth-century Germany.[43] Winckelmann's prose recalls the attitude and visual piety of a devout viewer beholding the Passion of Christ, focusing on the pain and suffering of Jesus, but identifying with his resignation and sweetness in the face of anguish. His term for the mode of feeling achieved in the Laocoon and all Greek masterpieces was "noble simplicity and quiet grandeur." This "soul" (*Seele*) was, he claimed,

> reflected in the face of Laocoon—and not in the face alone—despite his violent suffering. The pain is revealed in all the muscles and sinews of his body, and we ourselves can almost feel it as we observe the painful contraction of the abdomen alone without regarding the face and other parts of the body. This pain, however, expresses itself with no sign of rage in his face or in his entire bearing...[H]is pain touches our very souls, but we wish that we could bear misery like this great man.[44]

Winckelmann went on to praise Raphael's Sistine Madonna in like manner: "Behold this Madonna, her face filled with innocence and extraordinary greatness, in a posture of blissful serenity! It is the same serenity with which the ancients imbued the depictions of their deities." In the case of Raphael as with ancient artists, Winckelmann believed that "the artist had to feel the strength of this spirit in himself and then impart it to his marble." "Inner feeling" (*die innere Empfindung*), he insisted, "forms the character of truth" and must be placed by the artist in the work of art.[45] It has been pointed out that this idea of an inner feeling and a subdued grandeur or sublimity in Winckelmann's aesthetic of "noble simplicity and quiet grandeur" was

Figure 1
Roman copy, perhaps after
Agesander, Athenodorus, and
Polydorus of Rhodes
The Laocoon Group, 1st century
Marble

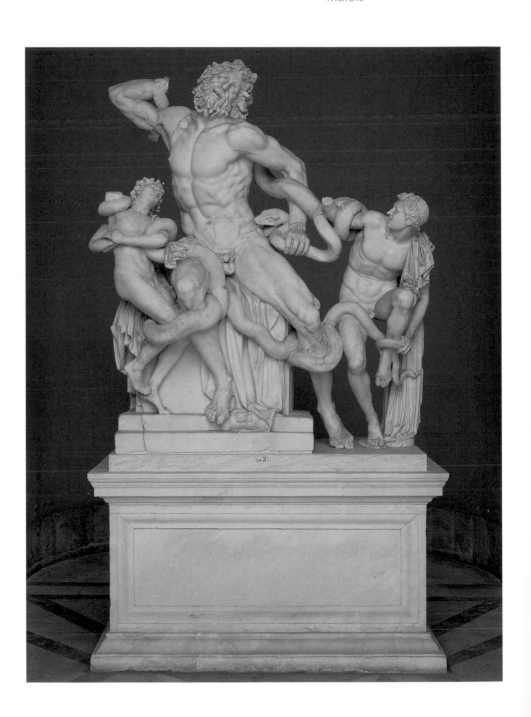

informed by Pietism's cultivation of an inner state of quiet, keyed to the contemplation of sublime subjects such as the passion and death of Jesus.[46] (Winckelmann attended the University of Halle, a vibrant center of Pietist thought and practice in eighteenth-century Germany.) Pietist contemplations of Christ's passion, traceable to Luther and to late medieval spirituality before him, cultivated an intense inner life, a private devotionalism, and an empathy keyed to visuality.[47]

Implicit in Winckelmann's cult of antiquity was a spiritualized response to art, an enrapt visual piety in which the work of art emerged as an expression of genius and the act of viewing as its epiphany experienced empathetically by whomever had cultivated the taste or aesthetic capacity for such rapture. Winckelmann inaugurated a strong disposition in European cultural history to spiritualize art, to recognize in it a powerful cultivation of inner life and taste. He regarded the art and artists of his day as degenerate and in desperate need of refinement, for which he offered his rhapsodic responses to antique art. Belief in the power of art to redeem a culture or society attended his sacralization of art and aesthetic experience and paved the way for the Romantic cult of art.

The impact of Pietism on the spirituality of art was not limited to Winckelmann. Broadly speaking, Pietism contributed importantly to German thought in the eighteenth century by stressing feeling as an intuitive discernment and an autonomous judgment. The philosopher Alexander Baumgarten, who coined the term "aesthetic" in 1739, had been educated in a Pietist orphanage and university (Halle). And one of the most important aesthetic theorists of the century, Karl Philipp Moritz, was raised in a devout Pietist home. Moritz developed the concept of disinterested contemplation in a series of brilliant essays in the 1780s, in which he defined the work of art as something that is complete in itself. Useful things have their purpose outside of themselves, namely, in the person who uses them. "But in the contemplation of the beautiful," Moritz wrote in 1785,

> I return the purpose from myself to the object itself: I behold it as something per-fected in itself, not in me. [This perfectedness] constitutes a whole in itself, and grants enjoyment to me of its own will, inasmuch as I extend to the beautiful object not so much a relation to me as much as my relation to it.[48]

This perception of what Moritz called "inner purposiveness" (several years before Kant borrowed the idea) led the viewer to a "forgetting" of the self in the contemplation of the work of art. It was this loss of the self, according to Moritz, that was "the highest degree of the pure and selfless enjoyment that the beautiful provides us. In that moment we offer up our individual, circumscribed existence for a kind of higher existence."[49] Engrained in this understanding of aesthetic experience is an ethics of encounter that seems unabashedly mystical. Aesthetic contemplation is a form of transcendence and revelation, a communion with a higher being.

The spirituality of art became one of the primary concerns of philosophers, theorists, and artists around 1800 in Europe and North America. In a celebrated series of lectures delivered in 1801 in Berlin, August Wilhelm Schlegel affirmed the

view taken by Moritz and others regarding the uselessness of art. Its reason for being is not practical. Schlegel then developed a definition of beauty indebted to his friend, the idealist philosopher Friedrich Schelling: beauty is the infinite depicted in the finite. How can this happen? "Only symbolically," Schlegel replied, "in images and signs." His notion of beauty hinged on a concept of revelation that rendered the human passive and disinterested before an experience of the world as unfinished, restless, and dynamic. "The unpoetic view of things is that which holds everything with the observations of the senses and the determinations of the understanding as settled; the poetic view is that which forever interprets and sees in all things a figural inexhaustibility."[50] Art is how human beings participate in the divine life at work in nature. Art is the visualization of the invisible inwardness of all things.

This idea of a material expression of a spiritual force was taken up by Hegel and formed the basis of his reflections on aesthetics. The idea of a *Zeitgeist* informing a work of art appealed very much to the Romantic imagination as well as the subsequent historicism that Hegel did so much to inspire. In the later eighteenth century and first decades of the nineteenth, art and religion came to be seen as powerful and historically distinctive activities of souls and cultures. An organic theory of art emerged among Romantic thinkers, which held that works of art were expressions of the soul; they drew for their unity from the genius of the artist and generated their structure from within rather than drew it from without. M. H. Abrams remains the great explicator of this Romantic aesthetic.[51] The implications for the history of the arts and critical thought about the arts were portentous because Romanticism established as a critical norm for taste the notion that the work of art was sacrosanct. It did not owe its formal structure to the superficial appearances of the natural world or to the dictates of taste or criticism or artistic convention, but to the inner governance of the artistic imagination. This empowered the work of art as a privileged revelation of genius. As such, the idea developed that art is a distillation of a culture, a microcosm that contains the spiritual depth and yearnings of a nation, a society, an epoch, an entire civilization.

The Romantic theory of art as a self-contained, self-normed organic structure could lead toward very private self-communion, where artistic experience was akin to a kind of mysticism, a transcendentalism that sacralized art, leading to what the art critic and connoisseur Bernard Berenson called the "aesthetic moment":

> In visual art the aesthetic moment is that flitting instant, so brief as to be almost timeless, when the spectator is at one with the work of art he is looking at, or with actuality of any kind that the spectator himself sees in terms of art, as form and colour. He ceases to be his ordinary self, and the picture or building, statue, landscape, or aesthetic actuality is no longer outside himself. The two become one entity; time and space are abolished and the spectator is possessed by one awareness. When he recovers workaday consciousness it is as if he had been initiated into illuminating, exalting, formative mysteries. In short, the aesthetic moment is a moment of mystic vision.[52]

Such passages are not hard to find in Romantic art theory in the nineteenth century. Arthur Schopenhauer, for instance, had developed a theory of art that was grounded entirely in the momentary transcendence of the here-and-now in the contemplation of works of art. Schopenhauer's revival in late nineteenth-century France contributed to Symbolist thought and the cult of art and informed Expressionist art and aesthetics in early twentieth-century Germany.[53]

Loosening the attachment to material appearances and the restrictive criteria of realist art in order to allow the "pure" elements of color and composition to speak more directly to the soul was the overriding concern of Wassily Kandinsky. In his epochal discussion of the "spiritual" aspect of art, Kandinsky spoke of the "language of form and color" and their immediate effect on the viewer, operating like music rather than text or representations.[54] In *Improvisation 28* (fig. 2), for example, whose very title conveys the musical dissolution of subject matter, we see the material world transfigured into a dance of forms and colors that clearly respond to a pictorial logic of rhythm and visual analogy that owes little to the extra-pictorial subject, although the features of a landscape remain discernible. The work is about itself, realizing with increasing concentration the organic unity postulated during the Romantic period. Kandinsky believed that the artist was a kind of prophet who led the larger society upward into greater spiritual refinement by virtue of his work, beyond the material vulgarities of the day. The British art critic Clive Bell echoed both Kandinsky's and Schopenhauer's belief in the redemptive power of art: "Art and religion are…two roads by which men escape from circumstances to ecstasy. Between aesthetic and religious rapture there is a family alliance. Art and Religion are means to similar states of mind."[55] The conviction that art operates as an independent source of spirituality remained strong among late twentieth-century advocates of a tradition of art and thought which they considered a vital alternative to major trends of modern art in the twentieth century.[56]

Although Friedrich Schleiermacher had remained unconvinced that art and religion could be collapsed into one another and still be genuine religion, many of his contemporaries and countrymen championed the "religion of art."[57] Moreover, the very feeling Schleiermacher described as the essential datum of religion—the feeling of absolute dependence on God—was configured in aesthetic terms as the "sublime," and has enjoyed a cult-status among certain artists and critics ever since the late eighteenth century. Robert Rosenblum traced the visual trajectory of an important aspect of the visual aesthetic of the sublime over the course of the nineteenth century in what he called the "Northern Romantic Tradition," running from the dark and brooding landscapes of Caspar David Friedrich through the paintings of Van Gogh, Kandinsky, and Mondrian to Mark Rothko and Barnett Newman.[58] The course plots the development of abstraction as a spiritually charged visual strategy that culminates in painterly gestures toward transcendence and sublimity that dematerialize representation and infuse it with a heroic, mythical stature that readily recalls the discussion of the "sublime" by Schleiermacher, the "numinous" by Otto, and the "ultimate" by Tillich.[59] A number of artists including Anselm Kiefer and Bill Viola in the late twentieth century explored similar ground.

Informed by a Romantic concept of the sublime, which defined self-transcendence as the nature of spirituality, a practice and theory of painting that stressed self-effacement in various forms of aesthetic experience—grandeur, darkness, emptiness, solitude—remains a compelling aim for many artists today.[60]

If one aspect of European Romanticism acclaimed the autonomy of art as a mode of spirituality, another did not. The appeal of the sublime for some lay in its ability to create spiritual sensations that were more commanding than the constraints and warrants of institutional belief. The sublime made individual experience the measure of spirituality. Schleiermacher contended that religion without the deeply felt response to the infinite is no religion at all. The imagination was the primary human faculty for intuiting the divine.[61] But for others, art that operated beyond the pale of the community of belief and the tradition that historically informed it, art that indulged the imagination for its own sake, was not Christian. Art could not be elevated to an autonomously religious stature, but must work with institutional religion for the renewal and refinement of the broader public. For Christian artists from the German Nazarenes, who briefly occupied a monastery in Rome, to Ruskin and the Pre-Raphaelite Brotherhood in England to artists in France who gathered at the Abbey of Créteuil, art and religion were not equals.[62] Art was charged with the task of serving religion, of seeking out and celebrating pure religious spirit.

The proper relationship between art and religion was broadcast by programmatic allegorical murals by the Nazarene painters Friedrich Overbeck and Philipp Veit, who

Christliches Kunstblatt

für Kirche, Schule und Haus.

1. Juni 1860. №. 11 u. 12.

spent much of the 1830s decorating the Städel, a new art institute in Frankfurt, dedicated to the training of fine artists. Overbeck produced a monumental canvas entitled *Religion Glorified by the Fine Arts* (1831–40) and Veit a large fresco called *The Introduction of the Arts into Germany by Christianity* (1834–36).[63] In both instances the artists sought to champion the arts as servants of the faith and to instill the lesson in Germany's future artists studying at the Städel. To make his point about the priority of faith, Overbeck refused to portray any artists in his image who had not dedicated their art to religion, which, in his view, meant no one after the sixteenth century with the exception of himself and two fellow Nazarene painters, Cornelius and Veit. If this subordination of art to religion went against the grain of the spiritualization of art that earlier Romanticism had fostered and Symbolist and Expressionist artists would later pursue, the Nazarenes and likeminded contemporaries nevertheless considered their cause a progressive one with respect to their self-appointed task of convincing the Church and fellow Christians of the importance of the visual arts.[64]

Julius Schnorr von Carolsfeld, who had been a Protestant associate of the Nazarenes in Rome and is today remembered for his *Pictorial Bible (Die Bibel in Bildern*, 1851), went on to co-publish a biweekly journal on religious art and architecture, whose masthead he illustrated (fig. 3). The image portrays the allegorical figure of Art gazing into a mirror that reflects light shed by the Holy Spirit above her. Two putti assist her in this act of sacred inspiration and transcription. The benefactor

of her traffic with the holy sits at her knee, the Church, pictured in the medieval revival style that the journal promoted and celebrated in its pages. Art is privy to the Sacred in a way that iconographically recalls Luther himself, who was shown in much the same way in a popular sixteenth-century print used as a frontispiece to his translation of the New Testament (fig. 4).[65] Luther appears as St. Matthew, writing his Evangel with the help of an intervening angel who holds a mirror reflecting the effulgence of the Holy Spirit, a dove (or something closer to a species of water fowl) floating above as in Schnorr's illustration.[66] One imagines that the visual assertion of Art's ultimate authority as divine revelation would have left some Protestant clergy in Schnorr's day a bit uncomfortable. The "Word" of God is nowhere to be seen. But Lutherans had generally been much less bothered by images than the Calvinists or Anabaptists. In its own way, Schnorr's illustration reminds us that even conservative Protestants in the nineteenth century were coming to find an important place for imagery in religious worship and devotion. By the end of the century, devotional images of Christ could be found in Protestant churches throughout the United States and evangelical curricula for the teaching of the Bible with sacred art was circulating among Baptists as well as Methodists, Presbyterians, and Congregationalists.[67]

Interest in the study of religious art has increased in recent years. A surprising number of exhibitions have been dedicated to religious art; the amount of scholarship on the subject is only increasing, and financial support for research projects has been generous and helped produce original studies.[68] But of no less note, interest in the arts among American religious people is very high. In fact, social survey data indicate that those Americans who attend religious services most frequently are also those who visit art museums most often. They are also the group that says more than any other that art brings people closer to God.[69] And the latter-day inheritors of Romanticism's religion of art—now the religion of media entertainment as well as fine art—are also very likely to accord an important place to art in their self-crafted spiritualities.[70] In a very real sense, the two wings of Romanticism have met and agreed to the centrality of art in religious life (if not the identity of the two). In this moment of neo-national civil religion and the triumph of art in religious and spiritual life, scholars of art and religion should recognize the relevance of their work no less than the need for sober thinking and historical perspective. If an organized field of inquiry is emerging into view, it arrives bearing an ideological freight that should be carefully assayed.

Figure 4
Lucas Cranach the Elder
The Evangelist Matthew
Woodcut, 1530
New Testament, Wittenberg

[1] An insightful study of the role of library classification and college survey textbooks for the disciplinary practice of art history is Robert S. Nelson, "The Map of Art History," *The Art Bulletin* 79, no. 1 (March 1997), 28–40.

[2] Perhaps the most celebrated source for the iconographical study of Christian art is the Index of Christian Art at Princeton University, founded in 1917 by art historian Charles Rufus Morey (see: http://ica.princeton.edu/history. html). A brief sampling of the large variety of other, published resources available is: Diane Apostolos-Cappadona, *Dictionary of Christian Art* (New York: Continuum, 1994); Beverly Moon, ed., *An Encyclopedia of Archetypal Symbolism*. The Archive for Research in Archetypal Symbolism (Boston: Shambhala, 1991); Gertrud Schiller, *Iconography of Christian Art*, 2 vols., tr. Janet Seligman (Greenwich, CT: New York Graphic Society, 1971); Louis Réau, *Iconographie de l'art chrétien*, 3 vols. (Paris: *Presses universitaires de France*, 1955–59); Karl Künstle, *Ikonographie der christlichen Kunst*, 2 vols. (Freiburg im Breisgau: Herder, 1926–28).

[3] A brief list of such works, chosen for their subject, authors, nationality, and publishers, and chronologically arranged over 150 years, indicates the wide-ranging nature and scope of publications that would constitute the primary materials for such a study: Lord Lindsay, *Sketches of the History of Christian Art*, 2 vols., 2nd ed. (London: John Murray, 1885 [1846]); Mrs. [Anna] Jameson, *The History of Our Lord as Exemplified in Works of Art*, 2 vols., 3rd ed. (London: Longmans, Green & Co., 1872); Henri Grimouard de Saint-Laurent, *Guide de l'art chrétien: études d'esthétique et d'iconographie*, 5 vols. (Paris: Librarie archéologique de Didron, 1872–74); Heinrich Detzel, *Christliche Ikonographie. Ein Handbuch zum Verständniß der christlichen Kunst*, 2 vols. (Freiburg im Breisgau, 1894); Franz Xaver Kraus, *Geschichte der christlichen Kunst*, 2 vols. (Freiburg im Breisgau, 1908); Beda Kleinschmidt, O.F.M., *Lehrbuch der christlichen Kunstgeschichte* (Paderborn: Ferdinand Schöningh, 1910);

Alessandro della Seta, *Religion and Art: A Study in the Evolution of Sculpture, Painting, and Architecture*, tr. Marion C. Harrison (London: T. F. Unwin, 1914); F. Pijper, *Handboek tot de geschiedenis der Christelijke Kunst* (S-Gravenhage: Martinus Nijhoff, 1917); Abel Fabre, *Pages d'art chrétien* (Paris: Bonne Press, 1927); Percy Gardiner, *The Principles of Christian Art* (London. John Murray, 1928); Louis Bréhier, *L'art chrétien: son développment iconographique des origins à nos jours* (Paris: Henri Laurens, 1928); Juan Plazaola, *Historia y sentido del arte cristiano* (Madrid: Biblioteca de autores cristianos, 1996); Helen de Borchgrave, *A Journey into Christian Art* (Minneapolis: Fortress, 2000).

[4] Because of the immense scope of the subject, it seems virtually impossible to do for the study of art and religion in general what art historian Sally M. Promey has recently done so well for the history of American art and religion—a comprehensive assessment of major research, themes, and methods of study. See Promey, "The 'Return' of Religion in the Scholarship of American Art," *The Art Bulletin* 85, no. 3 (September 2003): 581–603.

[5] Read, *Art and Society* (New York: Macmillan, 1937), 85; G. W. F. Hegel, *Aesthetics: Lectures on Fine Art*, 2 vols., tr. J. M. Knox (Oxford: Clarendon, 1998); Lucien Lévy-Bruhl, *How Natives Think*, tr. Lilian A. Clare (Princeton: Princeton University Press, 1985); original: *Les fonctions mentales dans les sociétés inférieures*, 1910. The list of studies dedicated to this approach is long, but centered largely in the early twentieth-century: Walter Isard, *Commonalities in Art, Science, and Religion: An Evolutionary Perspective* (Aldershot, Engl.; Brookfield, VT: Avebury Ashgate Publishing Ltd., 1996); John E. Pfeiffer, *The Creative Explosion: An Inquiry into the Origins of Art and Religion* (New York: Harper and Row, 1982); Herbert Read, *Icon and Idea: The Function of Art in the Evolution of Human Consciousness* (Cambridge, MA: Harvard University Press, 1955); Read, *Art and Society*, 77–130; Wilhelm Worringer, *Abstraktion und Einfühlung*

(Munich: Reinhold Piper, 1908); Moriz
Carriere, *Die Kunst im Zusammenhang der
Culturentwickelung und die Ideale der
Menschheit*, 5 vols. (Leipzig: F. A. Brockhaus,
1863–74). The philosophical origin for this
approach is Hegel's *Aesthetics*, which exerted a
large and persistent influence, as noted below.

[6] Margaret R. Miles, *Image as Insight: Visual
Understanding in Western Christianity and
Secular Culture* (Boston: Beacon Press, 1985), 4.
Herbert Read drew importantly on the profound
work of Conrad Fiedler (see Read, *Icon and
Idea*, 5, 17), who developed a sophisticated
understanding of the constructivist epistemo-
logical function of art. Miles relies on Suzanne
Langer, who drew extensively from Ernst
Cassirer's monumental work on the "philosophy
of symbolic forms." The American scholar
most responsible for developing the cognitive
theory of art is Rudolf Arnheim. Miles
productively applies her work to the history
of Christian thought about images.

[7] A magisterial study of the deployment and
redeployment of religious images is Richard H.
Davis, *Lives of Indian Images* (Princeton:
Princeton University Press, 1997). For studies
of the material culture of various religions see:
John Kieschnick, *The Impact of Buddhism on
Chinese Material Culture* (Princeton: Princeton
University Press, 2003); Gretchen Buggeln,
*Temples of Grace: The Material Transformation of
Connecticut's Churches, 1790–1840* (Hanover,
NH: University Press of New England, 2003);
J. David Lewis-Williams, *A Cosmos in Stone:
Interpreting Religion and Society through Rock Art*
(Walnut Creek, Calif.: Alta Mira Press, 2002),
esp. 133–61; Erika Doss, "Death, Art, and
Memory in the Public Sphere: The Visual and
Material Culture of Grief in Contemporary
America," *Mortality* 7, no. 1 (2002): 63–82;
Albert C. Moore, *Arts in the Religions of the
Pacific: Symbols of Life* (London: Pinter, 1995);
Kevin M. Sweeney, "Meetinghouses, Town
Houses, and Churches: Changing Perceptions
of Sacred and Secular Space in Southern New
England, 1720–1850," *Winterthur Portfolio* 28
(Spring 1993): 59–93; Colleen McDannell,

*Material Christianity: Religion and Popular
Culture in America* (New Haven: Yale University
Press, 1995); Gregory Schopen, "Archeology
and Protestant Presuppositions in the Study of
Indian Buddhism," *History of Religions* 31, no. 1
(1991): 1–25; Stanley Jeyaraja Tambiah,
*The Buddhist Saints of the Forest and the Cult of
Amulets: A Study in Charisma, Hagiography,
Sectarianism, and Millennial Buddhism*
(Cambridge: Cambridge University Press,
1984). John E. Cort, "Art, Religion, and
Material Culture: Some Reflections on
Method," *Journal of the American Academy of
Religion* 64, no. 3 (Fall 1996): 613–32, exhibits
a common conceptual obstacle that is best
avoided. Cort does not understand "material
culture" as a method of study, but simply as
another term for objects. For discussion
of material culture *as method*, see Jules David
Prown, "Mind in Matter: An Introduction
to Material Culture Theory and Method," in
his *Art as Evidence: Writings on Art and Material
Culture* (New Haven: Yale University Press,
2001), 69–95; and Susan M. Pearce, ed.,
Interpreting Objects and Collections (London:
Routledge, 1994).

[8] An important aspect of the display of religious
artifacts and their interpretation is the role of
the museum, both as an interpreter of objects
and as institution that disseminates teachings
and presents objects to broad and diverse
publics. Very thoughtful work has appeared in
recent years on this subject, see especially essays
by Chris Arthur and David Goa in Crispin
Paine, ed., *Godly Things: Museums, Objects and
Religion* (London: Leicester University Press,
2000); and Ronald L. Grimes, "Sacred Objects
in Museum Spaces," *Studies in Religion/Sciences
Religieuses* 21, no. 4 (1992): 419–30.

[9] Examples of or reflection on the visual culture
approach to religious imagery are: David
Morgan, *The Sacred Gaze: Religious Visual
Culture in Theory and Practice* (Berkeley:
University of California Press, forthcoming,
2005), chapters 1 & 2; Allen F. Roberts and
Mary Nooter Roberts, *A Saint in the City: Sufi
Arts of Urban Senegal* (Los Angeles: UCLA

Fowler Museum of Cultural History, 2003);
David Morgan and Sally M. Promey,
"Introduction," in Morgan and Promey, eds.,
The Visual Culture of American Religions
(Berkeley: University of California Press,
2001), 1–24; David Morgan, "Visual Religion,"
Religion 30 (2000): 41–53; Erika Doss, *Elvis
Culture: Fans, Faith, and Image* (Lawrence, KA:
University Press of Kansas, 1999); David
Morgan, *Visual Piety: A History and Theory of
Popular Religious Images* (Berkeley: University
of California Press, 1998); Jeffrey F. Hamburger,
*Nuns as Artists: The Visual Culture of a Medieval
Convent* (Berkeley: University of California
Press, 1997); and Sally M. Promey, *Spiritual
Spectacles: Image and Vision in Mid-Nineteenth-
Century Shakerism* (Bloomington: Indiana
University Press, 1993).

[10] Jane Dillenberger, "Reflections on the Field
of Religion and the Visual Arts," in Doug
Adams and Diane Apostolos-Cappadona, eds.,
Art as Religious Studies (New York: Crossroad,
1987), 14. The method is practiced at length in
Dillenberger's textbook, *Style and Content in
Christian Art* (New York: Crossroad, 1986).
For further resources on iconographical study,
see note 2 above.

[11] John W. Dixon, Jr., "Reckonings on Religion
and Art," *Anglican Theological Review*, vol. 74,
no. 2 (Spring 1992): 267–75. Dixon has produced
a number of fascinating and original studies
on art and religion. See, for instance, "What
Makes Religious Art Religious," *Cross Currents*
(Spring 1993): 5–25, and "Art as the Making of
the World: Outline of Method in the Criticism
of Religion and Art," *Journal of the American
Academy of Religion*, vol. 51, no. 1 (March 1983):
15–36. Dixon's major work is *The Christ of
Michelangelo* (Atlanta: Scholars Press, 1994).

[12] Dixon, "Reckonings," 274–75.

[13] For example, in a fascinating theory of religious
imagery a few years ago, Staale Sinding-Larsen
considered the act of viewing as constitutive or
productive of the sacred. By analyzing the ritual
process and the dynamics of communication
involved in Byzantine, Roman Catholic, and
Islamic forms of piety—icon devotion, the
Eucharist, and prayer—the author developed a
taxonomy of 'focalization,' that is, visual or
mental focus on text, image, or object. Staale
Sinding-Larsen, "*Créer des images: remarques
pour une théorie de l'image,*" in Françoise
Dunand, Jean-Michel Spieser, and Jean Wirth,
eds., *L'image et la production du sacré* (Paris:
Méridiens Klincksieck, 1991), 36–71. A very
helpful study of the constructive operation of
seeing in religious practice is Diana L. Eck,
Darśan: Seeing the Divine Image in India
(Chambersburg, PA.: Anima Books, 1981).
I have taken a constructivist approach to visual
piety in *Visual Piety*, 1–20. None of these
studies and theorizations of devotional seeing
ignores iconography; they focus instead on the
embodied act of seeing images.

[14] Gerardus van der Leeuw, *Sacred and Profane
Beauty: The Holy in Art*, tr. David E. Green
(New York: Holt, Rinehart and Winston, 1963);
original: *Vom Heiligen in der Kunst*, 1932.
Another well-known phenomenological
scholar of religion who took interest in the arts
was Mircea Eliade; see a compilation of his
diverse discussions in *Symbolism, the Sacred,
and the Arts*, Diane Apostolos-Cappadona, ed.
(New York: Crossroad, 1986).

[15] Rudolf Otto, *The Idea of the Holy: An Inquiry into
the Non-Rational Factor in the Idea of the Divine
and its Relation to the Rational*, tr. John W. Harvey
(London: Oxford University Press, 1950).
Schleiermacher defined religion as follows:
"Religion's essence is neither thinking nor
acting, but intuition and feeling. It wishes to
intuit the universe, wishes devoutly to overhear
the universe's own manifestations and actions,
longs to be grasped and filled by the universe's
immediate influences in childlike passivity,"
Friedrich Schleiermacher, *On Religion: Speeches
to Its Cultural Despisers*, tr., Richard Crouter
(Cambridge, Engl.: Cambridge University
Press, 1988), 102. In a later work, *The Christian
Faith*, Schleiermacher defined religion as
"the feeling of utter dependence." The idea
is foreshadowed in his youthful work, *On
Religion*. The legacy of German Romanticism

persisted in the twentieth century in such other figures as the theologian Paul Tillich, who was especially indebted to the Romantic philosopher, F. W. Schelling. For a compilation of Tillich's discussion of art, see Paul Tillich, *On Art and Architecture*, tr. Robert P. Scharlemann, John Dillenberger and Jane Dillenberger, eds. (New York: Crossroad, 1987).

[16] Anna J. Bonshek, *Mirror of Consciousness: Art, Creativity, and Veda* (Dehli: Motilal Banarsidass, 2001); Jonneke Bekkenkamp, ed., *Missing Links: Arts, Religion, and Reality* (Münster: LIT, 2000); Earle Coleman, *Creativity and Spirituality: Bonds between Art and Religion* (Albany: State University of New York Press, 1998); John W. Dixon, Jr., *Images of Truth: Religion and the Art of Seeing* (Atlanta: Scholars Press, 1996); Nicolas Berdyaev, *The Meaning of the Creative Act* (New York: Collier, 1962); John Macmurray, *Religion, Art, and Science: A Study of the Reflective Activities in Man* (Liverpool: Liverpool University Press, 1961); Robert H. Lowie, *Primitive Religion* (New York: Liveright, 1948 [1924]), 259–76.

[17] Wendy Beckett, *The Mystical Now: Art and The Sacred* (New York: Universe, 1993); Frederick Frank, *Art as a Way: A Return to the Spiritual Roots* (New York: Crossroad, 1981); Carl C. Jung et al., *Man and His Symbols* (Garden City, NY: Doubleday, 1964); Rudolf Steiner, *The Arts and Their Mission* (New York: Anthroposophic Press, 1964); C. Jinarajadasa, *Karma-less-ness: Theosophical Essays on Art* (Madras: Theosophical Publishing House, 1932); William Lethaby, *Architecture, Mysticism, and Myth* (London: Percival & Co., 1892).

[18] S. Brent Plate, ed., *Religion, Art, and Visual Culture: A Cross-Cultural Reader* (New York: Palgrave, 2002); Rosalind I. J. Hackett, *Art and Religion in Africa* (London: Cassell, 1996); Moore, *Arts in the Religions of the Pacific*; John R. Hinnells, "Religion and the Arts," in Ursula King, ed., *Turning Points in Religious Studies: Essays in Honour of Geoffrey Parrinder* (Edinburgh: T. & T. Clark, 1990); Adams and

Apostolos-Cappadona, eds., *Art as Religious Studies*; Miles, *Image as Insight*; Thomas Martland, *Religion as Art: An Interpretation* (Albany: State University of New York Press, 1981); F. David Martin, *Art and the Religious Experience: The "Language" of the Sacred* (Lewisburg, PA: Bucknell University Press, 1972); van der Leeuw, *Sacred and Profane Beauty*.

[19] Two examples are Mark C. Taylor, *Disfiguring: Art, Architecture, Religion* (Chicago: University of Chicago Press, 1992) and Dixon, *The Christ of Michelangelo*.

[20] Eamon Duffy, *The Stripping of the Altars: Traditional Religion in England 1400–1580* (New Haven: Yale University Press, 1992); Tessa Watt, *Cheap Print and Popular Piety 1550–1640* (Cambridge, Engl.: Cambridge University Press, 1991); R. W. Scribner, *For the Sake of Simple Folk: Popular Propaganda for the German Reformation* (Oxford: Clarendon Press, 1984); Johan Huizinga, *The Autumn of the Middle Ages*, tr. Rodney J. Payton and Ulrich Mammitzsch (Chicago: University of Chicago Press, 1996 [1919]).

[21] Anthropologists and archaeologists concern themselves with the objects, not the "art," that cultures fabricate and use, and with the cultural structures of thought and practice that make the objects meaningful. For consideration of the difference in aim and method between anthropology and art history, see Shelly Errington, "Introduction," and the following essays, in Lavin, ed., *Meaning in the Visual Arts: Views from the Outside*, 27–31.

[22] Critical awareness of the historical relationship of art and religion is a carefully made point in two of the most important recent studies by art historians: Hans Belting, *Likeness and Presence: A History of the Image Before the Era of Art*, tr. Edmund Jephcott (Chicago: University of Chicago Press, 1994) and David Freedberg, *The Power of Images: Studies in the History and Theory of Response* (Chicago: University of Chicago Press, 1989). On the cultural construction of visuality in several pre-modern and non-Western religious contexts,

see Robert S. Nelson, ed., *Visuality Before and After the Renaissance: Seeing as Others Saw* (Cambridge, Engl.: Cambridge University Press, 2000).

23 Elizabeth Netto Calil Zarur and Charles Muir Lovell, eds., *Art and Faith in Mexico: The Nineteenth-Century Retablo Tradition* (Albuquerque: University of New Mexico Press, 2001); Cauvin A. Bailey, *Art on the Jesuit Missions in Asia and Latin America, 1542–1773* (Toronto: University of Toronto Press, 1999); Sally M. Promey, *Painting Religion in Public: John Singer Sargent's Triumph of Religion at the Boston Public Library* (Princeton: Princeton University Press, 1999); Jeffrey F. Hamburger, *The Visual and the Visionary: The Image in Late Medieval Monastic Devotions* (New York: Zone Books, 1998); Michael Paul Driskel, *Representing Belief: Religion, Art, and Society in Nineteenth-Century France* (University Park: Pennsylvania State University Press, 1992); Andrée Hayum, *The Isenheim Altarpiece: God's Medicine and the Painter's Vision* (Princeton: Princeton University Press, 1989); Rona Goffen, *Piety and Patronage in Renaissance Venice: Bellini, Titian, and the Franciscans* (New Haven: Yale University Press, 1986).

24 A classic example of a formalist art historical approach is Henri Focillon, *The Life of Forms in Art*, tr. Charles B. Hogan and George Kubler (New York: Zone Books, 1989); original, *La Vie des Formes*, 1934. Jean Molino's introduction to this translation defends Focillon's approach and polemicizes against "the relativisms and sociologisms currently in fashion" (12). For an important discussion of "aesthetic emotion" as the basis of art and criticism, see Clive Bell, *Art* (New York: Capricorn Books, 1958), 16–17: "The starting point for all systems of aesthetics must be the personal experience of a peculiar emotion. The objects that provoke this emotion we call works of art...This emotion is called the aesthetic emotion." This emotion, according to Bell, is stirred by what he called "significant form," the combination of lines and colors that constitutes the essential feature of a work of art. The idea of an autonomous

faculty of aesthetic judgement, which enables Formalist criticism and art history, emerged in the eighteenth-century concept of taste and was developed in one of its most influential philosophical forms in Immanuel Kant's *Critique of Judgement* (1790). For an illuminating consideration of the impact of the autonomy of art on the practice of art history in the twentieth century see Robert Nelson's essay in this volume. While it is clearly true that Formalist art history is a thing of the past and that the best practitioners of art history today work far beyond the limits of Formalism, it remains true that most art history survey texts rely heavily on stylistic analysis and formal concerns; and that many exhibition catalogues today still emphasize formalist descriptions of objects. In other words, the primary means of public education today—exhibitions and textbooks—remain strongly shaped by the legacy of Formalism. For a new study that argues for the critical legitimacy of Formalism, see Denis Donoghue, *Speaking of Beauty* (New Haven: Yale University Press, 2003).

25 John W. De Gruchy, *Christianity, Art, and Transformation: Theological Aesthetics in the Struggle for Justice* (Cambridge, Engl.: Cambridge University Press, 2001); Frank Burch Brown, *Good Taste, Bad Taste, Christian Taste: Aesthetics in Religious Life* (New York: Oxford University Press, 2000); George Pattison, *Art, Modernity, and Faith: Towards a Theology of Art* (New York: St. Martin's Press, 1991); John Dillenberger, *A Theology of Artistic Sensibilities: The Visual Arts and the Church* (New York: Crossroad, 1986); Roger Hazelton, *A Theological Approach to Art* (Nashville: Abingdon, 1967); David Bailey Harned, *Theology and the Arts* (Philadelphia: Westminster, 1966).

26 Doug Adams and Michael E. Moynahan, eds., *Postmodern Worship and the Arts* (San Jose: Resource Publications, 2002); John Witvliet, "Toward a Liturgical Aesthetic: An Interdisciplinary Review of Aesthetic Theory," *Liturgy Digest* 3:1 (Winter 1996): 4–86; James F. White, *Christian Worship in North America,*

A Retrospective: 1955–1995 (Collegeville, MN: Liturgical Press, 1997).

27 William A. Dyrness, *Visual Faith: Art, Theology, and Worship in Dialogue* (Grand Rapids, MI: Baker Book House, 2001); George S. Heyer, *Signs of Our Times: Theological Essays on Art in the Twentieth Century* (Grand Rapids, MI: Eerdmans 1980); Masao Takenaka, *Christ Art in Asia* (Kyoto: Kyo Bun Kwan with Christian Conference of Asia, 1975); H. R. Rookmaaker, *Modern Art and the Death of a Culture* (London: Intervarsity Press, 1970); Andrew J. Buehner, ed., *The Church and the Visual Arts* (Saint Louis, MO: Lutheran Academy for Scholarship, 1968); Richard Egenter, *The Desecration of Christ*, tr. Edward Quinn, Nicolete Gray, ed., (Chicago: Franciscan Herald Press, 1967); Johan B. Hygen, *Morality and the Muses: Christian Faith and Art Forms*, tr. Harris E. Kaasa (Minneapolis: Augsburg Publishing House, 1965); Hans Sedlmayr, *Verlust der Mitte: die bildende Kunst des 19. und 20. Jahrhunderts als Symptom und Symbol der Zeit* (Salzburg: O. Müller, 1948; translation: *Art in Crisis: The Lost Center*, tr. Brian Battershaw [Chicago: H. Regnery, 1958]); Celso Costantini, *L'Art chrétien dans les missions: manuel d'art pour les missionaires* (Paris: Desclée de Brouwer, 1949); Ralph Adams Cram, *The Catholic Church and Art* (New York: Macmillan, 1930); Albert E. Bailey, *The Use of Art in Religious Education* (New York: Abingdon Press, 1922).

28 Alain Besançon, *The Forbidden Image: An Intellectual History of Iconoclasm*, tr. Jane Marie Todd (Chicago: University of Chicago Press, 2000); Richard Viladesau, *Theological Aesthetics: God in Imagination, Beauty, and Art* (New York: Oxford University Press, 1999); Patrick Sherry, *Spirit and Beauty: An Introduction to Theological Aesthetics* (Oxford: Clarendon Press, 1992); James Alfred Martin, Jr., *Beauty and Holiness: The Dialogue between Aesthetics and Religion* (Princeton: Princeton University Press, 1990); Frank Burch Brown, *Religious Aesthetics: A Theological Study of Making and Meaning* (Princeton: Princeton University Press, 1989); Nicholas Wolterstorff, *Art in Action:*

Toward a Christian Aesthetic (Grand Rapids, MI: Eerdmans, 1980); John W. Dixon, Jr., *Nature and Grace in Art* (Chapel Hill: University of North Carolina Press, 1964). For a review essay of several recent studies of sacred space, see Peter W. Williams, "Sacred Space in North America," *Journal of the American Academy of Religion* 70, no. 3 (September 2002): 593–609.

29 The art historical approach is obviously object-centered; the visual culture and cognitive approaches are practice-centered; and the evolutionary and phenomenological approaches are engaged in the intellectual history of religion and aesthetics.

30 Among the most influential studies in recent years in this initiative has been Freedberg's *Power of Images*. Other studies of religious imagery that have underscored the importance of reception, that is, the experience of those who view images, include: Jeffrey Chipps Smith, *Sensuous Worship: Jesuits and the Art of the Early Catholic Reformation in Germany* (Princeton: Princeton University Press, 2002), 77–101; Morgan, *Visual Piety*; Hinnells, "Religion and the Arts"; Albert C. Moore, *Iconography of Religions: An Introduction* (Philadelphia: Fortress Press, 1977), esp. 32–7; and S. G. F. Brandon, *Man and God in Art and Ritual: A Study of Iconography, Architecture and Ritual Action as Primary Evidence of Religious Belief and Practice* (New York: Charles Scribner's Sons, 1975), 1–14.

31 A short list of works: Joachim Konrad, *Religion und Kunst: Versuch einer Analyse ihrer prinzipiellen Analogien* (Tübingen: J. C. B. Mohr, 1929); G. F. Hartlaub, *Kunst und Religion: Ein Versuch über die Möglichkeit neuer religiöser Kunst* (Leipzig: Kurt Wolff Verlag, 1919); Ernst Linde, *Religion und Kunst* (Tübingen: J. C. B. Mohr, 1905); Konrad Lange, *Das Wesen der Kunst: Grundzüge einer realistischen Kunstlehre*, 2 vols. (Berlin: G. Grote, 1901), 2: 112–44; Gustav Portig, *Religion und Kunst in ihrem gegenseitigen Verhältniss*, 2 vols. (Iserlohn: J. Bädeker, 1879–80); Charles Lévêque, *Le spiritualisme dans l'art* (Paris: Germer Bailliere, 1864).

43

The line of philosophical reflection extends back to Hegel through Victor Cousin and Théodore Jouffroy in France and Friedrich Theodor Vischer in Germany.

32 On art for art's sake in France, see John Wilcox, "The Beginnings of *l'art pour l'art*," *Journal of Aesthetics and Art Criticism* 11 (June 1953): 360–77; in Germany and England, the old but enormously informative essay by Rose Frances Egan, "The Genesis of the Theory of 'Art for Art's Sake' in Germany and in England," Part One, *Smith College Studies in Modern Languages* 2, no. 4 (July 1921): 5–61; Part Two, vol. 5, no. 3 (April 1924): 1–33.

33 See, for instance, Andrew McClellan, *Inventing the Louvre: Art, Politics, and the Origins of the Modern Museum in Eighteenth-Century Paris* (Berkeley: University of California Press, 1999); and Christophe Loir, *La sécularisation des oeuvres d'art dans le Brabant (1773–1842): la création du musée de Bruxelles* (Bruxelles: Éditions de l'Université de Bruxelles, 1998).

34 Immanuel Kant, *Observations on the Feeling of the Beautiful and Sublime*, tr. John T. Goldthwait (Berkeley: University of California Press, 1960), 97–116.

35 Friedrich Schlegel, "Dritter Nachtrag alter Gemählde," *Europa*, vol. 2 (1803), 117.

36 G. W. F. Hegel, *On Art, Religion, Philosophy: Introductory Lectures to the Realm of Absolute Spirit*, J. Glenn Gray, ed. and tr. (New York: Harper Torchbooks, 1970), 38.

37 Benedict Anderson, *Imagined Communities: Reflections on the Origin and Spread of Nationalism*, rev. ed. (London: Verso, [1983] 1991).

38 Thomas M. Lekan, *Imagining the Nation in Nature: Landscape Preservation and German Identity, 1885–1945* (Cambridge, MA: Harvard University Press, 2003); Brian Keith Axel, *The Nation's Tortured Body: Violence, Representation, and the Formation of a Sikh "Diaspora"* (Durham: Duke University Press, 2000); Harry Harootunian, "Memory, Mourning, and National Morality: Yasukuni Shrine and the Reunion of State and Religion in Postwar Japan," in Peter van der Veer and Hartmut Lehmann, eds., *Nation and Religion: Perspectives on Europe and Asia* (Princeton: Princeton University Press, 1999), 144–60; George L. Mosse, *The Nationalization of the Masses: Political Symbolism and Mass Movements in Germany from the Napoleonic Wars through the Third Reich* (Ithaca: Cornell University Press, 1975), 47–99; Fernand Benoît, *Art et Dieux de la Gaule* (Paris: Artaud, 1969); Josef Strzygowski, *Spuren indogermanischen Glaubens in der Bildenden Kunst* (Heidelberg: C. Winter, 1936).

39 Liah Greenfeld, *Nationalism: Five Roads to Modernity* (Cambridge, MA: Harvard University Press, 1992), 487.

40 For a study of the range of traditional arguments for the benefit of art on the American public, see Joli Jensen, *Is Art Good for Us? Beliefs about High Culture in American Life* (Oxford: Rowman & Littlefield, 2002). An important, still unsurpassed discussion is Neil Harris, *The Artist in American Society: The Formative Years 1790–1860* (Chicago: University of Chicago Press, 1966). A recent study of the material culture of American civil religion is Jeffrey F. Meyer, *Myths in Stone: Religious Dimensions of Washington, D.C.* (Berkeley: University of California Press, 2001). Classic, modern statements of the moral theory of art include John Ruskin, *The True and the Beautiful in Nature, Art, Morals, and Religion*, Mrs. L. C. Tuthill ed. (New York: John Wiley & Sons, 1870), and Leo Tolstoy, *What is Art?*, tr. Charles Johnston (Philadelphia: H. Altemus, 1898 [1896]).

41 Friedrich Schiller, *On the Aesthetic Education of Man in a Series of Letters*, Elizabeth M. Wilkinson and L. A. Willoughby, ed. and tr. (Oxford: Clarendon Press, 1967), 9.

42 Ibid., 123; 215.

43 A development of Lutheranism that stressed the cultivation and discernment of subjective states of feeling as the primary datum of religious

commitment, Pietism reacted against the scholastic emphasis placed on doctrine by Lutheran orthodoxy in Northern European countries during the seventeenth and eighteenth centuries. For a discussion of the significance of Pietism for modern aesthetics, see David Morgan, "Aesthetics," *Encyclopedia of Protestantism*, 4 vols., Hans Hillerbrand, ed. (New York: Routledge, 2003).

44 Johann Joachim Winckelmann, *Reflections on the Imitation of Greek Works in Painting and Sculpture*, tr. Elfriede Heyer and Roger C. Norton (La Salle, IL: Open Court, 1987), 33, 35.

45 Ibid., 41, 35, 13.

46 Moshe Barasch has discussed Winckelmann and the discernment of Pietist influence, see *Modern Theories of Art, 1: From Winckelmann to Baudelaire* (New York: New York University Press, 1990), 115–16.

47 A superb study of late medieval visual piety is Henk van Os et al., *The Art of Devotion in the Late Middle Ages in Europe, 1300–1500* (Princeton: Princeton University Press, 1994).

48 Karl Philipp Moritz, "Versuch einer Vereinigung aller schönen Künste und Wissenschaften unter dem Begriff des in sich selbst Vollendeten," 1785, reprinted in Moritz, *Schriften zur Ästhetik und Poetik*, ed. Hans Joachim Schrimpf (Tübingen: Max Niemeyer, 1962), 3, emphasis in original: "Bei der Betrachtung des Schönen aber wälze ich den Zweck aus mir in den Gegenstand selbst zurück: ich betrachte ihn, als etwas, nicht in mir, sondern *in sich selbst Vollendetes*, das also in sich ein Ganzes ausmacht, und mir *um sein selbst willen* Vergnügen gewährt; indem ich dem schönen Gegenstande nicht sowohl eine Beziehung auf mich, als mir vielmehr eine Beziehung auf ihn gebe. Da mir nun das Schöne mehr um sein selbst willen, das Nützliche aber bloß um meinetwillen, lieb ist; so gewähret mir das Schöne ein höheres und uneigennützlicheres Vergnügen, also das bloß Nützliche."

49 Ibid., 5.

50 A. W. Schlegel, *Vorlesungen über schöne Literatur und Kunst*, Bernhard Seuffert, ed. (Stuttgart: G. J. Göschen, 1884), 91.

51 M. H. Abrams, *The Mirror and the Lamp: Romantic Theory and the Critical Tradition* (Oxford: Oxford University Press, 1953). For an extended discussion of the organic theory of art applied to the visual arts more than the literary, as in the case of Abrams, see August Wiedmann, *Romantic Roots in Modern Art: Romanticism and Expressionism: A Study in Comparative Aesthetics* (Surrey, Engl.: Gresham Books, 1979), 147–93.

52 Bernard Berenson, *Aesthetics and History* (Garden City, NY: Doubleday, [1948] 1954), 93.

53 Arthur Schopenhauer, *The World as Will and Representation*, tr. E. F. J. Payne, 2 vols. (New York: Dover, 1969 [1818]), 1: 195–200; on Symbolist thought, see Naomi E. Maurer, *The Pursuit of Spiritual Wisdom: The Thought and Art of Vincent van Gogh and Paul Gauguin* (Madison, NJ: Fairleigh Dickinson University Press; London: Associated University Presses, 1998) and Patricia Townley Mathews, *Aurier's Symbolist Art Criticism and Theory* (Ann Arbor: UMI Research Press, 1986).

54 Wassily Kandinsky, *Concerning the Spiritual in Art*, tr. M.T.H. Sadler (New York: Dover, 1977); original: *Über das Geistige in der Kunst*, 1912.

55 Bell, "Art and Religion," in *Art*, 68.

56 Suzi Gablik, *The Reenchantment of Art* (London: Thames and Hudson, 1991); Roger Lipsey, *An Art of Our Own: The Spiritual in Twentieth Century Art* (Boston: Shambhala, 1989); Kathleen J. Regier, ed., *The Spiritual Image in Modern Art* (Wheaton, IL: Theosophical Publishing House, 1987); Andreas C. Papadakis, ed., *Abstract Art and the Rediscovery of the Spiritual* (London: Art & Design, Academy Group Ltd., 1987); Kathy Brew, ed., *Concerning the Spiritual: The Eighties* (San Francisco: San Francisco Art Institute, 1985); Maurice Tuchman, et al., *The Spiritual in Art: Abstract Painting 1890–1985* (Los Angeles: Los Angeles County Museum of Art, 1986).

[57] Schleiermacher, *On Religion*, 158: "Religion and art stand beside one another like two friendly souls whose inner affinity, whether or not they equally surmise it, is nevertheless still unknown to them."

[58] Robert Rosenblum, *Modern Painting and the Northern Romantic Tradition: Friedrich to Rothko* (New York: Harper & Row, 1975).

[59] An enthusiastic supporter and sympathetic interpreter of this work and thought and its flowering in the abstract canvases of the New York School is John Dillenberger, along with a number of his students and colleagues; see Dillenberger, *The Visual Arts and Christianity in America*, expanded edition (New York: Crossroad, 1989), 188–95.

[60] For a discussion of this, see David Morgan, "Secret Knowledge and Self-Effacement: The Spiritual in Art in the Modern Age," in Richard Francis, ed., *Negotiating Rapture*, exhibition catalog (Chicago: Museum of Contemporary Art, 1996), 34–47, John Hallmark Neff, "Reading Kiefer," *Anselm Kiefer: Bruch und Einung*, New York: Marion Goodman Gallery, 1987: 7–15.

[61] Schleiermacher, *On Religion*, 138: "You will not consider it blasphemy, I hope, that belief in God depends on the direction of the imagination. You will know that imagination is the highest and most original element in us, and that everything besides it is merely reflection upon it; you will know that it is your imagination that creates the world for you, and that you can have no God without the world."

[62] Cordula Grewe, *Painting Religion: Art and the Sacred Imaginary in German Romanticism* (Burlington, VT: Ashgate, forthcoming); Keith Andrews, *The Nazarenes: A Brotherhood of German Painters in Rome* (Oxford: Clarendon Press, 1964); Christopher Wood, *The Pre-Raphaelites* (New York: Viking, 1981); Daniel Robbins, "From Symbolism to Cubism: The Abbaye of Créteuil," *Art Journal* 23, no. 2 (Winter 1963): 112–16. It is difficult to over-emphasize the impact of Ruskin's work in

nineteenth-century America. For a good discussion see Roger B. Stein, *John Ruskin and Aesthetic Thought in America, 1840–1900* (Cambridge, MA: Harvard University Press, 1967). For studies of French religious imagery, see Bruno Foucart, *Le Renouveau de la peinture religieuse en France (1800–1860)* (Paris: Arthena, 1987) and Joyce C. Polistena, "The Religious Paintings of Eugène Delacroix: Romantic Religion and Art," work in progress.

[63] For Overbeck's own description of his painting, see Margaret Howitt, *Friedrich Overbeck. Sein Leben und Schaffen*, 2 vols. (Bern: Herbert Lang, 1971), 2: 55–74. On Veit's fresco program at the Städel, see Norbert Suhr, *Philipp Veit (1793–1877). Leben und Werk eines Nazareners* (Weinheim: VCH Verlagsgesellschaft, 1991), 89–103, 245–47.

[64] For further discussion of the artistic and philosophical significance of the Nazarenes with regard to early Romanticism, see Grewe, *Painting Religion*.

[65] See the entry by Elfriede Starke for *Dat Nye Testament Düdesch*, Wittenberg: Hans Lufft, 1530, in Stefan Strohm, ed., *Die Bibelsammlung der Württembergischen Landesbibliothek Stuttgart* (Stuttgart: Fromann-Holzboog, 1984), Zweite Abteilung, Erster Band, E 232, p. 134.

[66] See F. W. H. Hollstein, *German Engravings and Woodcuts, ca. 1400–1700*. New Series, 5 vols. (Roosendaal: Royal Van Poll Printers, 1993), vol. 4, p. 34.

[67] David Morgan, *Protestants and Pictures: Religion, Visual Culture, and the Age of American Mass Production* (New York: Oxford University Press, 1999).

[68] See Friedhelm Menneckes, S.J., "Between Doubt and Rapture—Art and Church Today: The Spiritual in the Art of the Twentieth Century," *Religion and the Arts* 4, no. 2 (2000): 165–83, for a review of several recent exhibitions. To those exhibitions which Menneckes discusses may be added a short list of catalogues that represent a range of other recent exhibitions produced by variety of

kinds of institutions: Margaret Bendroth and Henry Luttikhuisen, eds., *The House of God: Religious Observation within American Protestant Homes* (Grand Rapids, MI: Calvin College, 2003); Ena Giurescu Heller, ed., *Icons or Portaits? Images of Jesus and Mary from the Collection of Michael Hall* (New York: The Gallery at the American Bible Society, 2002); Theodore Prescott, ed., *Like A Prayer: A Jewish and Christian Presence in Contemporary Art* (Charolotte, NC: Tryon Center for Visual Art, 2001); Andrew Ladis and Shelley E. Zuraw, *Visions of Holiness: Art and Devotion in Renaissance Italy* (Athens, GA: Georgia Museum of Fine Art, University of Georgia, 2001); David Morgan and Sally M. Promey, *Exhibiting the Visual Culture of American Religions* (Valparaiso, IN: Brauer Museum of Art, Valparaiso University, 2000); Gabriele Finaldi, ed., *The Image of Christ* (London: National Gallery, 2000); James Clifton, *The Body of Christ in the Art of Europe and New Spain, 1150–1800* (Munich: Prestel, 1998); Rosemary Crumlin, ed., *Beyond Belief: Modern Art and the Religious Imagination* (Melbourne: National Gallery of Victoria, 1998).

[69] Peter V. Marsden, "Religious Americans and the Arts in the 1990s," in Alberta Arthurs and Glenn Wallach, eds., *Crossroads: Art and Religion in American Life* (New York: New Press, 2001), 87; Robert Wuthnow, *All in Sync: How Art and Music Are Revitalizing American Religion* (Berkeley: University of California Press, 2003). Wuthnow's title might have read "How Art and Music are Revitalizing American Christianity" since that particular religion is the focus of his study.

[70] See, for instance, Lynn Schofield Clark, *From Angels to Aliens: Teenagers, the Media, and the Supernatural* (New York: Oxford University Press, 2003).

the state of the arts and religion: some thoughts on the future of a field

S. Brent Plate

D̲avid Morgan's contribution to this volume queries whether there actually is a history of "art and religion." And if that is not questionable enough, I must begin by querying whether there is a *future* to this interdisciplinary field that is already under suspicion. I am also further challenged by the lack of resources available to make a case for the future. How does one reference the future? One would need some labyrinthine library from a Borges story to do such research. Nonetheless, I have been asked here to outline a number of theories and themes that are currently at the forefront of religion and the arts scholarship and that will help define the field for the future. So, with such a charge, and without a visit to a library of the future, in the following I will point toward several trajectories that are currently shaping the interdisciplinary field and that, based on my most informed hypotheses about the field to come, are worth pursuing.[1]

First I will briefly consider the importance of visual culture as a vital approach to the future of the field, arguing for its further consideration in relating art to religion, and vice versa. Then, in the remainder of this article I hope to be somewhat provocative by highlighting several theoretical emphases that are current in humanistic and social-scientific discourse, and that might help stimulate new studies in the field. This is not simply a rephrasing or recapping of the hottest new dialogues in the academy today, but I have specifically pointed toward a few themes that are especially pertinent for the interrelation of art and religion in ways that challenge traditional studies of both art history and religious studies. This is to suggest a strong role for art and religion research that would situate itself as a vital, productive mode of study and not remain sidelined to the often secondary role it plays today.

THE VISUAL CULTURE APPROACH

I should state up front that I am primarily a religious studies scholar and am interested in the art and religion relation from the perspective of comparative theories of religion. (This is in distinction to the other contributors to this volume who work from theological or art historical fields.) From this vantage point, the most promising of the current approaches to the field is that of visual culture studies.[2] Because religious studies seeks to describe the ways people live and believe, their behaviors and meaning-making activities, and the ways they ritualize and mythologize, visual culture's emphasis on the *reception* of visual images and the ways they are put into practice is enlightening. This is certainly not to exclude the production of images, for that too is, or can be,

a religious practice—one thinks of the spiritual and physical training an Islamic calligrapher undertakes in the creation of the Quran, or the purifying rites necessary to create a Hindu icon, or even of Mark Rothko's recounting of the religious experiences he had while painting non-representational oil on canvas. In any case, the emphasis here is on the ways in which images are *used* in religious devotion and ceremony. This is, then, to take the image away from its modern "art-for-art's-sake" insularity, and place it within a web of religious symbolic interactions. In this way, formal descriptions of images and their iconological dimensions are important, but they do not exhaust the possibilities of how an image continues to signify. Images take on lives of their own, independent of their original intention and creation. Interpreting viewers will often change the meaning and status of a work of art, re-ascribing it with a new and previously unforeseen force and value within a community.

Another critical component to the visual culture approach is its mode of examining images in a manner that resists judgments about the beauty and aesthetic value of an image, getting away from the traditional art historical bifurcation of "high" art and "low" art. In his book *The Object Stares Back: On the Nature of Seeing*, art theorist and historian James Elkins tells the story of being in a church in Italy and witnessing the power of images in ways that confounded his own critical judgments as an art historian:

> ...a crowd of townspeople gathered in front of an altar that had a cheap, Holiday Inn-style painting and a plastic baby-doll Jesus draped with Christmas lights. Less than twenty feet away was one of the masterpieces of Western art, supposedly full of noble and uplifting religious feeling. In both chapels the Christ Child glowed with the light of the new Sun: in the "important" painting, his body was mysteriously luminescent, and it cast a daunting cold light on Mary and Joseph. The plastic doll in the other chapel had a bulb inside it that made it look like a tacky novelty light. On the afternoon I was there, the worshipers ignored the painting as completely as the tourists ignored the plastic doll.[3]

Just as a profane object is made sacred because people believe in it and act upon it in particular ways, so is an image invested with special powers according to the image's viewers. An art historian invests certain images with power for particular reasons, and the pious invest other images with power for other reasons. Because of its emphasis on the reception of images, visual culture studies greatly expand the range of what can be evaluated, from the kitsch to the masterpiece.

Paralleling the rise in visual culture studies within art history, recent works within religious studies (for example, those by Robert Orsi, Diana Eck, and Stephen Prothero, among others)[4] indicate the ways the academic study of religion is now shifting beyond the primary methodologies used in its first century and a half of existence (loosely dating its origins to the mid-nineteenth century and the work of F. Max Müller). Earlier work in the discipline betrayed its Protestant Christian orientation by approaching other religious traditions through texts and doctrines, reflecting the logocentric logic of Protestantism. In other words, since Protestantism

valued the scriptures so highly and put a great deal of stress on theological doctrine, then the analogic was that other traditions could be understood by studying their scriptures and doctrines. Yet what we have found is that different traditions place varying values on their sacred texts, and studies of doctrines prove to have limited value in understanding religions. Many forms of Buddhism, for example, radically downplay doctrinal positions, focusing instead on the practice of religion; religion is something experienced, not known intellectually. Coupled with the fact that vast majorities of religious people in the history of the world have been illiterate, the shift in religious studies from a focus on texts and doctrine to include all manner of visual and material objects, and studies of performances and practices, makes sense. I would not pretend that visual and material culture approaches solve all the problems of a hermeneutics of religion—offering the great universal passkey to unlock all other traditions—for it too is a historically and culturally situated approach. Nonetheless, it does offer new modes of enquiry and opens new perspectives for the relations between art and religion in global, cross-cultural settings.

Along these lines, then, a visual culture orientation offers itself as a vital approach, not only to the subfield of art and religion, but to religious studies as a whole. David Morgan has strongly suggested the role that might be played:

> The opportunity at hand is to elucidate the role that visuality plays in the social construction of reality. The desired outcome is that historians and scholars of religion will come to see images and visual practices as primary evidence in the study of religion and not merely as incidental illustrations or cover art for augmenting book sales. The new study of religious visual culture begins with the assumption that visual artifacts should not be segregated from the experience of ceremony, education, commerce or prayer. Visual practices help fabricate the worlds in which people live and therefore present a promising way of deepening our understanding of how religions work.[5]

With the visual culture approach as a backdrop, I turn now to outline what I have heuristically delineated as four themes and foci for continued work in the inter-disciplinary field. I will outline some of the key theoretical ideas, and then offer examples from both "artistic" and "religious" dimensions.

INTERMEDIALITY AND TRANSMEDIALITY

These two terms may be over-laden with prefixes and suffixes, but at the heart of each is an emphasis on *media*. To claim intermediality and transmediality as important dimensions to the study of art and religion is not to triumph some avant-gardist or postmodernist notion of the field, but instead to more fully display the continuities of tradition and to revive some understandings of the ways religious traditions have been handed down through time.

The emphasis in both intermediality and transmediality is on the fact that a *medium* is a dynamic entity, not solely an empty transmitter of communication; media actively shape and reshape religions and cultures. From cultures in which

orality is the primary mode of communication, to highly literate book-bound cultures, to contemporary multimediated cultures, religion is morphed by, adapts to, and affects the media with which it is engaged. Indeed, myths, rituals, and symbols are only existent *as* media: A myth must be transmitted, whether by "word of mouth" or through the technologies of television; a ritual must be enacted, whether involving readings from sacred, printed texts or by processions through architectural space; a symbol must be shared, whether it is a colorful banner in a synagogue or a piece of bread. We thus must presume that religion—however oriented toward the "invisible," the "spiritual," the "wholly other," it may be—is nonetheless also always material and mediated.

Intermediality is a term that has been used in a number of theoretical works—especially theatre studies, music studies, and literary studies—for the past few decades, particularly in Europe.[6] The emphasis here is not on a synthesis of media but on what happens "in-between" conventionally situated media as they are brought together in a single artistic production: visuality meets textuality meets musicality. We might see this in a number of contemporary dance and theater productions that project large motion picture images onto a screen on stage in the midst of dancing; or in a film, in the midst of a "motion" picture we see a painting or a photograph, a "still" image interrupting the motion. Intermedial works thus challenge the purity of individual media as understood in specific theories of modernism, particularly that running from Lessing's split between poetry and painting in his 1766 *Laocoon* to one of the twentieth century's most prominent art critics, Clement Greenberg, who championed abstract art by suggesting that the goal of modern art is "to eliminate from the specific effects of each art any and every effect that might conceivably be borrowed from or by the medium of any other art."[7] By working across and between media, intermediality expands the range of meanings in a work of art, particularly due to the resulting multisensory experience had by the observers.

A related term is that of transmediality, which is, simply put, the translation of a work of art from one medium to another. This would include L. Frank Baum's novel being made into the film *The Wizard of Oz*[8]; or Wassily Kandinsky's 1912 album of poems and woodcuts, *Sounds*, based on Arnold Schoenberg's music. In these transmediazations there is always a question as to what is preserved in the new form, and what cannot survive the translation process. To claim the "book was better than the film" is to miss a fundamental point about differences in media. Films do things books can never do, and vice versa.

That being the case, one of the more interesting intermedial forms of recent years is that of the comic book. A relatively "low-tech" production, the comic book has had something of a revival since the 1990s, a fact not lost on persons concerned with the creation and maintenance of identity, the importance of memory, and the continuation of religion and culture, especially since its mixing of words and images makes it a powerful conveyor of tradition.[9] The work of Art Spiegelman in his award-winning *Maus* series ably displays the power of the comic book to retell history.[10] From another angle, artist Kerry James Marshall's recent work in the *Rythm Mastr* series mixes contemporary urban life with ancient

African stories, creating a new sense of identity for African-Americans. Marshall says of the project:

> I thought what I would do with this project would be to take a form that is, in some ways, already undervalued in America, take a subject that's under-represented, and try to develop a comic strip with a set of characters that had cultural significance but also allowed for a kind of imaginative play and inspiration. What I hit on as a subject was this idea that, for black people, the set of super heroes we come to know anything about have a lot to do with West African religious gods in a sense.[11]

In other religious traditions, the power of this intermedial format has recently been picked up on by the Vatican, who recently approved the comic book, "Karol Wojtyla: Pope of the Third Millennium." The four-part biographical series immediately sold out in Italy and the publisher is currently translating it into other languages. It is also found in South Asian traditions, where the *Amar Chitra Katha* ("Immortal Picture Stories") series was created by Anant Pai for modern, especially English-speaking Indians. As South Asian scholar John Stratton Hawley suggests of the comic books, "Almost every story is in some way intended to show how India's shared and for the most part premodern past can provide these children with guidelines for right living."[12] The *Amar Chitra Katha* series has become a ubiquitous form for the transmission of Indian history and mythology to young children, not only in India, but also for the millions of non-resident Indians living throughout the world.

In the realm of "high-tech" production, video art has been a key new medium that has helped push issues of intermediality and transmediality. The work of Mona Hatoum, Janice Tanaka, Shirin Neshat, Woody Vasulka, Gary Hill, and Bill Viola, among others, have raised issues of both transmediality and intermediality, meanwhile exploring how these productions enable us to reconceive identity, history, and the frail but necessary work of memory.

Viola has become particularly adept at transforming the medium from its early roots in documentary and closed circuit installations toward meditative spaces not dissimilar to the paintings of Rothko and Newman, and his work in the last decade has often explicitly reworked painterly formulations. For instance, in *The Greeting* (fig. 1) we see a kind of *tableau vivant* in reverse. A transmediated video of the Mannerist painting *The Visitation* (1528–29) by Jacopo Carucci (named Pontormo), Viola's video puts paint in motion. And yet, this is not done merely to somehow "animate" a painting. Instead the video is projected at 168 × 258 × 306 inches in extreme slow motion, stretching a 45-second real-time video into a ten-minute loop, with environmental sounds playing in the background. Viola's rendition of the meeting of Mary and Elizabeth evokes a contemplative reception, emphasizing the activities of human movement, emotion, and exchange not visible to the naked eye. Meanwhile, the use of extreme slow motion is something of a bold move for a medium that has worked in a documentary style, on one hand, and is cousin to the much faster paced MTV-style videos, on the other. As Viola has suggested, "Video

Figure 1
Bill Viola
The Greeting, 1995
Video/sound installation; color video projection
on large vertical screen mounted on wall
in darkened space; amplified stereo sound

is a documentary medium. That's its power. It's the power of the 'objective eye.' But it can be so much more than that—a subjective, speculative medium. Leave the 'truth' to CNN. Magnification and subtle distortions allow me to get at a more subjective truth."[13] Like religious myths that often function by telling "lies in order to create truth,"[14] the transmediated nature of much video art reveals certain "truths" about the world not visible outside of artistic mediated forms.

THE VISUALITY AND PERFORMATIVITY OF TEXTS

Perhaps this category can be seen as a subset of intermediality and/or transmediality, but I separate it here to indicate its particular importance within the study of art and religion, and perhaps as a self-conscious gesture toward the fact that this volume stands at the end of The Gallery at the American Bible Society's three-year project on the subject of "art and religion." Indeed, when Thomas Boomershine was working with the American Bible Society as part of its project in the 1990s to translate the bible into video and CD format, he claimed that the first step in each new media age is to "put the biblical tradition into the new medium, a 'transmediazation' of texts." This new electronic translation would be, he suggests, "the correlate for an electronic age of Codex Vaticanus, the Masoretic text, the King James Bible, and whatever translation one thinks is best."[15] What Boomershine realizes is that, in order to survive, religious traditions must be transmediated in new eras and in light of new technological developments. One of the critical media translations to be rethought in the contemporary age is the movement away from the printed book, a movement that is, as I will suggest, both a postmodern and a premodern one.

55

Along these lines, attention to the visuality and performativity of texts in future studies within the arts and religion can shed light on a phrase that has become popular among some of the reactions to September 11. The phrase, "people of the book," taken from the Quran,[16] has suggested itself to many as an exhortation to realize the commonality of the three Abrahamic, monotheistic, Western traditions: Islam, Judaism, and Christianity. However, the desire to link the traditions, while understandable, can wind up reducing the traditions to their lowest common denominator, and perhaps even an inaccurate one. The problem is that the phrase, "people of the book," is understood from within a modern, highly literate society that has a massive production and distribution system for books. And these "books" are very specific: handheld objects, produced by the thousands and hundreds of thousands, intended for individual readers to be comprehended alone and silently.

Further, as Walter Ong suggests of the medium of the printed book: "Print encourages a sense of closure, a sense that what is found in a text has been finalized, has reached a state of completion."[17] Importantly, this sense of closure is a *visual* sense, especially provoked by the technology of type. As Ong relates: "typographic control typically impresses more by its tidiness and inevitability: the lines perfectly regular, all justified on the right side, everything coming out even visually."[18] The modern book is a finalized book, appearing complete unto itself. Ironically, there is a great deal of recent discussion that attempts to pit the "image vs. the word,"[19] however, it is with the modern, mass-produced book that we find the distinction

Figure 2
Gary Hill, Disturbance (among the jars), *1988*
Seven-channel video-sound installation
Installation: Musée d'art Moderne, Villeneuve d'Ascq, France, 1989

between the image and the word to be broken down like never before. The printed book, with or without illustrations, is a visual creation. It is one thing to note the word-image relation going on in Gustave Doré's illustrations for the Bible, or in medieval manuscripts with their images in one place and text in another, but it is another thing altogether to approach the most literate component as itself being highly visual, something any typesetter knows.

If we look more closely at what the religious traditions of Islam, Christianity, and Judaism have understood by "text," we get a wonderful array of possibilities. To take but one example, the visuality and performativity of texts is not lost in Islam, a tradition with a marvelous history of calligraphy. Especially when used for Quranic production, calligraphic lettering is created in fine styles that are pleasing to look at—there is even an intermedial, synaesthetic metaphor that suggests calligraphy is "music for the eyes." The scholar of Islamic calligraphy, Martin Lings, clearly brings out the notion of the visuality of texts when he says:

> It is a wide-spread practice in Islam to gaze intently at Quranic inscriptions so as to extract a blessing from them, or in other words so that through the windows of sight the soul may be penetrated by the Divine radiance of the 'signs of God,' as the verses are called. Questions as to how far the object is legible and how far the subject is literate would be considered irrelevant to the validity and to the efficacy of this sacrament.[20]

Words, written or printed in books, have always been visual objects, and even if very few (if any) people would claim to receive a blessing from gazing on a printed book, they are nonetheless objects that are seen in specific ways.

Sacred texts are also performed, something quite evident in the Islamic tradition as well where we understand that the Quran is ultimately not intended to be "read," but to be "learned by heart" and recited—the term Quran itself means "recitation." But we also can see this, for example, in East Asian modes of storytelling such as the Chinese *zhuanbian*, the Japanese *etoki*, and Korean *p'ansori* forms. In an article relating these textual performances to contemporary Korean films, Francisca Cho notes,

> In all three, a storyteller narrates, sings, and acts out a tale, accompanied by musical instruments. The Chinese and Japanese traditions have the added element of picture scrolls that are used as visual aids. The addition of painting augments the creation of a total audio-visual experience.[21]

While a text may serve as an anchor to the other dimensions (music, acting, images), it nonetheless has a life beyond its embodiment as a written "book" (or even as a scroll).

To switch to a drastically different time and place, I want to return to video art, specifically "video installation art," for yet another example of the visuality and performativity of texts, this time with Gary Hill's 1988 piece *Disturbance (among the jars)* (Fig. 2). Here Hill, as in many of his works, raises questions regarding the relation between words and images, and between orality and literacy. Yet even as the words may seem to be pitted against the image, Hill simultaneously uses the technology of video to return texts to what might be called a "second orality", as Walter Ong has phrased it. Second orality, like primary orality, is participatory, invites communal relations, and concentrates on the present moment even as it is more self-conscious as a medium than is primary orality, since it is understood in hindsight through the media of writing and print.[22] This is particularly significant since the video installation takes as its primary texts the Gnostic texts found in the Nag Hammadi library.

Hill's installation is a complex of seven video monitors, with images transposed across screens, sometimes in tandem with each other, sometimes creating a dissonant relation. Mixing the spoken word (with readers reciting Gnostic texts in German, French, and English) heard on speakers, with images of printed words on screen, Hill brings to light the variety of ways a "text" can be perceived: They are heard and/or seen, in multiple languages, sometimes in whole forms, but oftentimes only as fragments that must be pieced together. Hill suggests of this piece:

> Literally and figuratively, the texts were reconstructed and deconstructed in the work to suggest open possibilities for their relevance today.... The adaptation arranges the texts to allow the viewer to experience a multiplicity of meanings that resonate structurally within an open field. The performers, including actors, persons off the street, poets and writers, brought their own spoken language to the performance of the texts. They were encouraged to develop their own sense of the texts' meanings through the manner in which they read them.[23]

To describe a "people of the book" as being focused on a printed, handheld object, is certainly to miss the point of the religious traditions themselves, and here too is where the interdisciplinary relation of art and religion can highlight and correct mistakes about what precisely it might mean to be "of the book." In religious traditions, as well as artistic ones, these texts are open, ready to be read, spoken out loud, looked at, performed as music, and acted out. There is little interest in the perceived split between the image and the word, as we find in modern times; often they are one and the same.

SYNOPTICISM

In light of recent postcolonial studies and theories of hybrid identities, the religious term "syncretism" is on the verge of making a comeback. The term has an "objectionable but nevertheless instructive past,"[24] due to centuries of claims to "purity" and a denigration of anything that is mixed: races, ethnicities, religions. Yet once we realize that religious traditions (or races) have no single origin, we can revive a term like syncretism for useful comparative studies. For our purposes here, though, I should like to move a little further and focus on a related term that is already prevalent in certain segments of religious studies, namely synopticism. Biblical scholars working on the first three gospels have used this term, suggesting that "Matthew," "Mark," and "Luke" all *saw* the life of Jesus in similar ways (while John's account was markedly different). My intent is to "steal" the term from the literary orientations of biblical scholars working on the gospels and place it within a visual framework;[25] to think about the ways religious traditions get crossed and mixed up (sometimes purposely, sometimes accidentally) because symbols, icons, and designs often look alike even when they come from differing places. With a deeper understanding of synopticism, we can see the ways religions morph and merge, even when the image precedes the word.

Among other places we can see synopticism at work is in the Cuban hybrid religious traditions usually known as Santería, where we find strong visual identifications made between African (especially Yoruban) deities and Roman Catholic saints. As West Africans were enslaved and taken to the New World, they brought with them their religious traditions, which then got mixed up with the Roman Catholicism of their enslavers. This mixing occurred since both religious traditions emphasize sacred personages, and both utilize iconic representations of these holy figures. Because Catholic shrines would be filled with images of saints, West Africans could hide their own pantheon of deities (*Effa Orisha*) among the cluster.

Eventually, iconographic analogies began to be drawn between the Catholic saints and Yoruba *orishas*, and many of the holy figures have become what I would call synopticized figures. "Thus, Changó, the Yoruba *orisha* of fire and thunder, for example, was identified with Santa Bárbara, the patroness of Spanish artillery, due to her iconographic representation in chromolithographs in which she is dressed in red—Changó's symbolic color—and her identification with the thundering artillery cannons."[26] (Fig. 3) The mixing here is parallel to many syntheses within Santería; visual relations are made before and beyond any recourse to parallel beliefs, myths, or doctrines. It is visual practices that primarily stir the mixtures.

Figure 3
Artist unknown
Santa Barbara, *synopticized*
with Changó.

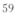

Alternatively, many artworks have appeared in the last two decades in the
United States and Europe in which traditional and highly recognizable "religious
images" (I use that term loosely) are "synopticized" to fit contemporary issues and
often personal visions. A short list would include: Alma Lopez's *Our Lady* (1999), in
which Lopez herself stands naked in the place of the Virgin of Guadalupe; Renée
Cox's *Yo Mama's Last Supper* (1999), in which Cox stands in (again, naked) for Jesus
Christ in an Afro-American rendition of da Vinci's *Last Supper*; and Chris Ofili's *Holy
Virgin Mary* (1996), where the popular subject of western religious art has a lump
of elephant dung fashioned onto the painting.

There are a few issues surrounding each of these works that are particularly
intriguing for the relation of art and religion. First, they underscore the power of images
due to the fact that they have each caused a fair amount of controversy, with religious
leaders, politicians, and journalists waging a war of words over each of the images.
Yet we must be careful not to jump to the a-historical conclusion that somehow
"modern art" is insistent on shock, for we find examples of the power of images and
related controversies throughout the history of art and religion: Michelangelo's
Pietà was condemned, among other reasons, for portraying Mary to look the same
age as Christ; and as Leo Steinberg has shown, Renaissance artists produced hundreds
of paintings portraying a naked Jesus, whose genitalia was later painted over by an
uneasy church and public.[27] From premodern to postmodern times, images have
held power, perhaps especially when they touch on religious dimensions.[28]

Also important to note, and I believe not at all to be dissociated from the recent controversies, is the fact that each of these contemporary artists are people "of color" and are working as minorities in the Western art world. They each seem to have an interest in the religion-art connection as a way to draw attention to, speculate on, and display mixed identities. There is thus a political dimension involved in the interrelation of art and religion that cannot be ignored, and a number of questions should be raised, such as: Why is "religious art" attractive to artists seeking to show some form of otherness and hybrid identity? Are the politicians and religious leaders reacting to the display of identity, or to the use of identifiable "religious images" to make the point, or to some combination of the two? Such questions get us thinking further about how the art-religion connection is not merely an academic pursuit, for it is often deeply bound to identity.

Further explorations of synopticism and syncretism will be increasingly vital as Christianity moves toward the southern hemisphere, adapting the expressions, attitudes, and beliefs of local cultures there, or as Buddhism continues its immigration into North America and Western Europe. Icons will change appearance, artists will borrow from the past and create with the future in mind, meanwhile always attempting to make relevant connections across and between cultures and traditions.

EPHEMERALITY

History is made of hard materials: metal, wood, and stone that last through the ravages of time. We know about previous, now-lost civilizations because we have durable material remnants from cultures that are no longer directly accessible; fragile, soft materials seldom survive. Hard things not only create our sense of history, they have also helped establish our religions, for as Mircea Eliade notes, "The hardness, ruggedness, and permanence of matter was in itself a hierophany in the religious consciousness of the primitive."[29] Anyone who has been to a city like Washington, DC, with its monuments in stone, might question the exclusively "primitive" dimension; nonetheless, permanence itself has often been sanctified in modern and ancient worlds.

Yet, here too an approach such as visual and material culture will alter the ways we see the relation between art and religion, and hopefully stir us to look more closely at that which is not created or intended to last, that which is temporary or ephemeral. Ephemeral religious/artistic creations are made for a specific time and occasion, but are quickly washed away by natural occurrences (e.g., wind, water), or destroyed (deconsecrated) by ritual participants. They therefore tell us something about the ways gods, goddesses, and spirits interact in the world (they must be evoked), as well as something about the key relation of nature to religious belief and practice. In order to study and understand such arts, it is necessary to expand the interdisciplinary field even further and use the tools of anthropology, reliant on an observer to somehow "record" what was.

One striking example of ephemeral religious arts would be Navajo (Dineh) sand paintings. The Navajo word for sandpainting, *Iikááh*, means the "place where the gods come and go." As with Haitian voudou ceremonies in which a *veve* is

drawn in the sand (or made with flour, coffee grounds, or sand on the ground), or Tibetan sand mandalas, the *likáʼáh* design must be created in exact proportions and precise detail. The images take many hours to complete and are guided by a singer/chanter who is actually the key conduit to the Holy People (immortal, supernatural beings), yet works in tandem with the creation of the visual images. If the ritual is performed correctly—the chants intoned right and the lines drawn straight—the Holy People come to bless a person or persons, bestowing their power on the people. The image itself is only part of the significance here; rather, there is a multimedia, interactive dimension involved and formalist and iconographical approaches to the subject matter barely scratch the surface of the meanings possible.

Interestingly, above I mentioned the reliance on anthropology for an understanding of such creations, and indeed I could not be writing about these ephemeral works without the work of anthropologists. Yet, because of the presence of such outside observers, the Navajo have had to slightly alter the sand paintings, making them "inaccurate" and thus without the power to invoke the deities, just as they have made them more permanent by securing them to some surface with epoxy. These "false," permanent images are what are ubiquitously found for sale throughout the U.S. southwest.[30]

British artist Andy Goldsworthy has visited the lands near Navajoland, and many other landscapes of the western world, and has become interested in the effects of nature and time on created images and objects. He creates beautiful temporary sculptures from leaves, sticks, ice, and sand, natural sculptures that are transitory, lasting for an hour, maybe a day at most, and then they are gone. He says,

> I was always interested in seeing work change and decay, but usually as a spectator. Lately the challenge has been not simply to wait for things to decay, but to make change an integral part of a work's purpose so that, if anything, it becomes stronger and more complete as it falls apart and disappears. I need to make works that anticipate, but do not attempt to predict or control, the future. In order to understand time, I must work with the past, present, and future.[31]

As an artist, of course, Goldsworthy cannot make a living out of invisible objects that used-to-be, so he records these in photographs which are then shown in the media of books, or in gallery/museum installations. As with the Navajo sand paintings, the ephemeral is caught in another medium that both transforms the meaning of the event itself, even as this transformation generates new meanings. To notice the ephemeral entails a redirected gaze—not looking for the classic definitions of classic art as that which lasts—and a necessary reliance on the transmediated, "captured" event of art.

Finally, by "the ephemeral," I also mean to strike its opposite, that of the collection, conservation, and even restoration of works of art and culture from within the institutions of museums.[32] To think about material objects and images that do not last should also stimulate some reflection on how and why things are preserved, how they are displayed within modern institutions such as museums

(built environments with carefully controlled temperature, humidity, and lighting), including all the ideologies of exhibition.

CONCLUSION

Through the preceding four theoretical foci, I have used (in an admittedly, highly subjective way) examples ranging from video art to comic books, from sand painting to oil painting, from religious ritual objects to manipulations of nature. At the very least, then, what I suggest for a future of art and religion will be the necessity to expand upon definitions of both art and religion. The term "art" can no longer be understood solely in its modern guise as autonomous, without purpose, and bounded by the museum. There is a strong argument for dropping the word altogether and instead using something like visual culture, but that too is not without its problems. One way or other, our notions of art will need to be expanded if they are to continue to have relevance to whatever we might call religion. Likewise, the study of religion too must be understood beyond *its* modernist, Protestant background that emphasized texts and doctrine when approaching other religious traditions. To study religions we will need to be attendant to the multifarious dimensions of differing traditions— intellectual doctrines as well as bodily practices, sacred texts as well as sacred icons—moving beyond the worn-out idea that religion is at heart a "set of beliefs" and everything else is merely an appendage to a core, religious reality. Instead, religion *is* its media, its performances, its corporal movement, its objects that are preserved, and its objects that are lost.

62

So the study of art and religion as two separate but interpenetrating dimensions to human social and cultural life can help to reinvigorate both fields of study. And in the midst of this interdisciplinarity, the mixing of high art and low, the lasting and the temporary, and various media, what we will be provoked to rethink are two of the most critical terms in religious studies: the sacred and the profane.

[1] My "hypotheses" are informed primarily by my work as co-chair of the American Academy of Religion's "Arts, Literature, and Religion" section; my work with the International Society for Religion, Literature, and Culture; and editorial work with the journals *Literature and Theology* and the *Journal of Religion and Film*. Each of these professional engagements has put me in touch with scholars around the world working in the broad area of the "arts and religion," and many of my ideas in this article have been inspired by reading proposals, reviewing manuscripts, and in conversations with scholars and students in many places. In many ways, these are not so easily referenced (and why I refer to the Borgesian library), but it should be clear that I am not working in a vacuum.

[2] David Morgan's contribution to this volume makes note of several of the other ways to see the relation between art and religion. These primarily show an art historical orientation or a theological one, but generally are deficient in the ways they *describe* religious practice or suggest how the arts are part and parcel of the creation of religious worlds. Thus also, the "cognitive approach" Morgan outlines overlaps with the visual cultural one, particularly as it takes on the creation of religious worlds.

[3] James Elkins, *The Object Stares Back: On the Nature of Seeing* (New York: Simon and Schuster, 1996), 40.

4 For example, see Robert Orsi's *The Madonna of 115th Street: Faith and Community in Italian Harlem, 1890–1950*, 2nd ed. (New Haven: Yale University Press, 2002), and his edited, *Gods of the City* (Bloomington: Indiana University Press, 1999); Diana Eck, *Encountering God: A Spiritual Journey from Bozeman to Banaras*, 2nd ed. (Boston: Beacon Press, 2003); Stephen Prothero, *American Jesus: How the Son of God Became a National Icon* (New York: Farrar, Straus, and Giroux, 2003). While there are many other works that could be cited here, one intriguing new work that looks at the relations between belief and practice in relation to a girl's high school basketball team is Julie Byrne's *O God of Players: The Story of the Immaculata Mighty Macs* (New York: Columbia University Press, 2003).

5 David Morgan, "Visual Religion," *Religion* 30 (2000): 51.

6 See, for example, Dick Higgins, *Horizons: the Poetics and Theory of the Intermedia* (Carbondale, IL: Southern Illinois Univ. Press, 1984); Ladislaus Semali and Ann Watts-Pailliotet, eds., *Intermediality: The Teachers' Handbook of Critical Media Literacy* (Boulder, CO: Westview, 1999); Wolf Werner, *The Musicalization of Fiction: A Study in the Theory and History of Intermediality* (Amsterdam: Rodopi, 1999); Erik Hedling and Ulla-Britta Lagerroth, eds., *Cultural Functions of Intermedial Exploration* (Amsterdam: Rodopi, 2002); and Peter M. Boenisch, "coMEDIA electrONica: Performing Intermediality in Contemporary Theatre," *Theatre Research International* 28.1 (2003): 34–45.

7 Clement Greenberg, "Modernist Painting," in *The Collected Essays and Criticism*, vol. 4 (Chicago: University of Chicago Press, 1993), 86. In contrast to Greenberg's purity of media, the force of intermediality is similar to that of "intertextuality" brought forth by Mikhail Bakhtin and taken up by Julia Kristeva, who suggests that intertextuality is "the passage from one sign system to another" that involves the "destruction of the old position and the formation of a new one" (Kristeva, *Revolution in Poetic Language*, tr. Leon Roudiez [New York: Columbia University Press, 1984], 59).

8 There are many interesting works in film studies on the subject of adaptation, of which see especially Dudley Andrew, "The Well-Worn Muse: Adaptation in Film History and Theory," in *Narrative Strategies: Original Essays in Film and Prose Fiction*, Sydney M. Conger and Janice R. Welsh, eds. (Macomb, IL: Western Illinois University Press, 1980). Looking at the specifics of adaptation with a religious focus see the forthcoming volume edited by Darren J. N. Middleton, *Scandalizing Jesus?: Reappreciating Kazantzakis's 'The Last Temptation of Christ'* (Harrisburg, PA: Trinity Press International, forthcoming, 2005). In Middleton's volume, a number of essays relate the reception of Kazantzakis's novel with the reception of Scorsese's filmic adaptation.

9 See, for example, Vicky A. Clark, Barbara J. Bloemink, et al., *Comic Release! Negotiating Identity for a New Generation* (New York: Distributed Art Publishers, 2003).

10 See Art Spiegelman, *Maus I: A Survivor's Tale Volume 1: My Father Bleeds History* (New York: Pantheon, 1986) and *Maus II: A Survivor's Tale: And Here My Troubles Began* (New York: Pantheon, 1991).

11 Interview with Kerry James Marshall on the PBS show *art:21*. Interview online at: [http://www.pbs.org/art21/artists/marshall/clip2.html].

12 John Stratton Hawley, "The Saints Subdued: Domestic Virtue and National Integration in *Amar Chitra Katha*," in Lawrence A. Babb and Susan S. Wadley, eds., *Media and the Transformation of Religion in South Asia* (Philadelphia: University of Pennsylvania Press, 1995), 107.

13 Bill Viola, in an interview with Michael Auping, published in *Modern Art Museum of Fort Worth, 110* (London: Third Millenium Publishing, 2003), 313.

[14] Lynda Sexson, *Ordinarily Sacred* (Charlottesville, VA: University of Virginia Press, 1992), 29.

[15] Thomas E. Boomershine, "A New Paradigm for Interpreting the Bible on Television," in Tyron Inbody, ed., *Changing Channels: The Church and the Television Revolution* (Dayton, OH: Whaleprints, 1990), 66, 68.

[16] The Arabic phrase, *ahl al-kitab*, more literally means "people of an earlier revelation" (see especially Surah 3) and refers to Jews, Christians, and Zoroastrians, particularly those monotheistic traditions that place some emphasis on a particular sacred text.

[17] Walter Ong, *Orality and Literacy* (London: Routledge, 1982), 132.

[18] Ibid., 122.

[19] In recent years popular books such as Leonard Shlain's *The Alphabet Versus the Goddess: The Conflict Between the Word and the Image* (New York: Viking, 1998) and Mitchell Stephens's *The Rise of the Image, The Fall of the Word* (New York: Oxford University Press, 1998) have worked with idea that the image and word are in battle. In distinction, there are a few books that explore the nature of the alphabet, with many references to its visuality. See Johanna Drucker's *The Alphabetic Labyrinth: The Letters in History and Imagination* (New York: Thames and Hudson, 1995); John Man's *Alpha Beta: How 26 Letters Shaped the Western World* (New York: John Wiley & Sons, 2000); and Marc-Alain Ouaknin's *Mysteries of the Alphabet* (New York: Abbeville Press, 1999).

[20] Martin Lings, *The Quranic Art of Calligraphy and Illumination* (London: World of Islam Festival Trust, 1976), 74.

[21] Francisca Cho, "The Art of Presence: Buddhism and Korean Films," in S. Brent Plate, ed., *Representing Religion in World Cinema: Filmmaking, Mythmaking, and Culture Making* (New York: Palgrave, 2003), 108. For more on the Koren *p'ansori*, see Marshall Pihl, *The Korean Singer of Tales* (Cambridge: Harvard University Press, 1994).

[22] Walter Ong, *Orality and Literacy*, 136.

[23] Gary Hill, *Gary Hill: Selected Works and catalogue raisonné* (Wolfsburg: Kunstmuseum Wolfsburg, 2002), 135.

[24] See Charles Stewart, "Syncretism and Its Synonyms: Reflections on Cultural Mixture" *Diacritics* 29.3 (1999): 40–62 (39).

[25] Cf. Doug Adams's essay in this volume on "Changing Perceptions of Jesus' Parables Through Art History" for more on the "intertextual/intermedial" approach.

[26] Margarite Fernández-Olmos and Lizabeth Paravisini-Gebert, *Creole Religions of the Caribbean* (New York: New York University Press, 2003), 34–36. See also Arturo Lindsay, ed., *Santería Aesthetics in Contemporary Latin American Art*, (Washington, DC: Smithsonian Institution Press, 1996). Notable recent studies that would contribute to a theory of "synopticism" with reference to Latin America include Carolyn Dean's *Inka Bodies and the Body of Christ* (Durham, NC: Duke University Press, 1999), and Serge Gruzinski's *Images at War: Mexico from Columbus to Blade Runner (1492–2019)*, tr. Heather MacLean (Durham, NC: Duke University Press, 2001).

[27] See Leo Steinberg, *The Sexuality of Christ in Renaissance Art and in Modern Oblivion*, 2nd ed. (Chicago: University of Chicago Press, 1996).

[28] For more on the "power of images," see David Freedberg, *The Power of Images: Studies in the History and Theory of Response* (Chicago: University of Chicago Press, 1989); also James Elkins, *Pictures and Tears: A History of People Who Have Cried in Front of Paintings* (New York: Routledge, 2001).

[29] Mircea Eliade, *Patterns in Comparative Religion*, tr. Rosemary Sheed (New York: Sheed and Ward, 1958), 216.

[30] This consequence has been the topic of many debates, as it has desacralized a sacred activity,

yet it has also proven economically viable, as
well as allowed women to be the artists—in the
religious ceremonies it is men who do the
painting. For a good overview of the sand-
paintings themselves, as well as the debates,
see Nancy J. Parezo, *Navajo Sandpainting: From
Religious Act to Commercial Art* (Albuquerque,
NM: University of New Mexico Press, 1991).

[31] Andy Goldsworthy, "Time, Change, Place," in
Time: Andy Goldsworthy (New York: Harry N.
Abrams, 2000), 7.

[32] For relations of the museum to religion and
practice see, variously, Crispin Paine, ed.,
Godly Things: Musems, Objects, and Religion
(London: Leicester University Press, 2000);
Carol Duncan, *Civilizing Rituals: Inside Public
Art Museums* (New York: Routledge, 1995); and
Richard Davis, *Lives of Indian Images*
(Princeton: Princeton University Press, 1997).

art and religion: facets of dialogue

changing perceptions of jesus' parables through art history: polyvalency in paint

Doug Adams

T his essay uses intertextuality, a literary and biblical method of comparing how one story is told in terms of previously known stories[1]. I apply this method to discern the meanings in *The Return of the Prodigal Son* (fig.1) by Rembrandt van Rijn, and its relationship to the drawing of *Isaac Blessing Jacob* (fig. 2).[2]

One complication of finding artworks dealing with parables is that most art historians categorize indices according to artists or media. The *Dictionary of Art*, for example, the state of the art tool for art history, has no references to parables in the index.[3] Another usually good source, the Index of Christian Art at Princeton University, goes comprehensively only to 1400 (although it has been extended to 1600 with respect to resources at The Morgan Library and Princeton University); and most parables were not depicted in the first thousand years. The earliest artistic representations of the parable of the Prodigal Son occur in an eleventh-century Bible and a twelfth-century capital at St. Nectaire, Puy-de-Dome, France.[4] For the first millennium of Christian art, Christ's miracles are often depicted stressing the powerful divinity of Christ. The parables appear more frequently in the last thousand years as the humanity of Jesus Christ is explored more fully.

Another complicating factor of finding art works dealing with parables is that while many art works carry titles, those titles do not necessarily parallel the titles of biblical parables. Many artists, moreover, did not give fixed titles to their art works; and curators or collectors tended to title the works as they came into major collections, private or public museums, and often only in the last couple hundred years. Also, while some museums title the works to reveal their biblical connections, other museums obscure those connections for reasons of their own. A major Rembrandt painting dating from circa 1635–36 is entitled, by a number of Rembrandt scholars, *The Prodigal Son Squanders His Inheritance*; but the museum in Dresden where the work hangs calls it *Self Portrait with the Artist's Wife*.[5] Both are true; but the biblical allusions are lost if one sees only the latter title.[6]

I first briefly explain the method of intertextuality, which I will then use in relation to Rembrandt's *The Return of the Prodigal Son* and his drawing of *Isaac Blessing Jacob*. Through intertextuality, biblical studies examine how a story in the gospels is told in terms of an already known story in Hebrew Scriptures. For example, the Gospels of Matthew and Mark present Jesus as the new Moses by telling the stories of Jesus in terms of the stories of Moses from Exodus and Deuteronomy.

Figure 2
Rembrandt van Rijn
Isaac Blessing Jacob
C. 1652
Pen and bistre

At the time of the birth of each one, the rulers order the death of Hebrew male children, for they fear their reigns will be overthrown by a new one who might be a king or a leader. Both Moses and Jesus spend time in Egypt, and both later experience the wilderness before undertaking their missions. As Moses parts the waters of the Red Sea so people safely reach the other shore, Jesus stills the waters so the boats reach the other side of the Sea of Galilee. As the sea drowns Pharaoh's army, so the sea drowns the pigs into which the demon called "Legion" enters with Jesus' permission. Both Moses and Jesus feed the people in the wilderness. As Moses receives the Ten Commandments on the mountain, Jesus gives the Sermon on the Mount. Moses leads the twelve tribes as Jesus leads the twelve disciples. Moses is associated with the establishment of the Passover Seder meal, as Jesus is associated with the institution of Communion. Moses strikes the rock, while Jesus curses the fig tree.[7] Miriam heralds the triumph of Moses in the Exodus from Egypt as Mary Magdalene heralds the resurrection of Jesus.

Intertextuality attends to the differences as well as the similarities. For example, the miracles of Jesus are less productive than the miracles of Moses; and Jesus becomes less willing or less able to perform miracles throughout Mark's Gospel. New Testament scholar William Countryman discerns Mark's purpose: to make Christianity less attractive to those who wished to gain powerful magic, at a time when growing numbers wanted such power.[8] So by portraying Jesus as not using or not having that power, Mark would disabuse them of joining Christianity for that reason. For example, according to tradition, Moses parted the Red Sea so hundreds of thousands of his people could reach safety on the other shore; but Jesus stills the Sea of Galilee so just a few boats can safely cross to the shore. Moses drowns Pharaoh's legions to save hundreds of thousands of Hebrews, but Jesus drowns two thousand pigs to save one person from being possessed by demons. Moses feeds hundreds of thousands for forty years in the wilderness, but Jesus feeds five thousand one-sack lunches in Mark 6:35–44, and then only four thousand in Mark 8:1–10 as his miracles taper off.

Applying intertextuality to our main subject, Rembrandt's *Return of the Prodigal Son* (Luke 15.11–32), we note that the artist appropriated established iconography of Jacob stealing Isaac's blessing (Genesis 27.1–46).[9] In Rembrandt's own drawing of *Isaac Blessing Jacob*, Jacob's mother Rebecca, who had instructed him in the way to steal his brother Esau's birthright by covering his hands and shoulders with hair so his nearly blind father will mistake him for his hairy brother, stands in the upper left background; and her son Jacob kneels in the foreground to receive Isaac's blessing. In Rembrandt's painting *Return of the Prodigal Son*, a woman stands in the background in the upper left corner, presiding over the father's embrace of the kneeling son.[10] The shape of the heads of the sons, Jacob and the prodigal, are strikingly similar.

Those positions of Jacob and Rebecca may have been inspired by Flemish tapestries of Rembrandt's time. In sixteenth-century Flemish tapestries such as *Jacob Receiving the Blessing Intended for Esau* (fig. 3), we see this positioning of Rebecca, behind the scene of Isaac blessing the kneeling Jacob.[11] Flemish tapestries of the

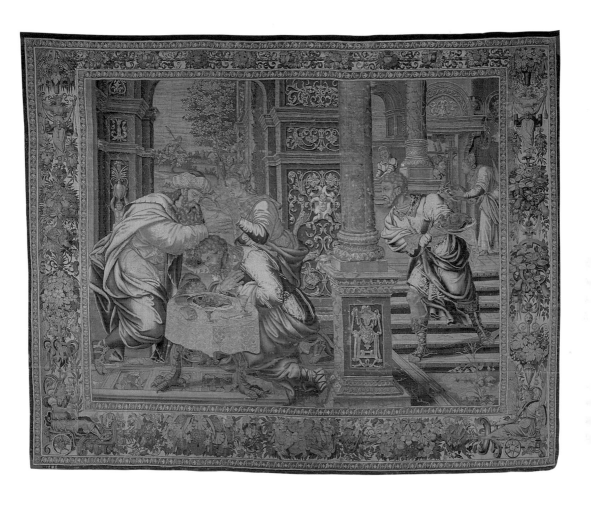

Figure 3
Anonymous, Flemish
Jacob Receiving the Blessing
Intended for Esau
(from Moses and Aaron Series)
Early 16th century
Wool, cotton, silk

time presented more than one episode in the story. Typically there are three or four episodes depicted, as seen in *Jacob Receiving the Blessing Intended for Esau*. Rebecca counsels Jacob at the upper right; at the lower right, Jacob brings the food which she had told him to prepare and bring. Finally, Jacob receives his father's blessing with Rebecca presiding over the event at the lower left. Similarly, one may read multiple episodes in Rembrandt's *The Return of the Prodigal Son*. One could interpret the two figures at the right not as characters in addition to the father and younger son, but rather, as that father and younger son earlier in the story, before the son left home. This interpretation is supported by the similarity of the father's garb, the color of his robe, and his facial features. Rembrandt's depiction suggests the passage of time occurring in the parable: at the right the younger father has darker hair; to the left, he is shown with white hair, indicating that time has elapsed. The other figure at the right could be the prodigal son before he left home.

Other interpretations are surely possible, but to me less convincing. For example, the standing figure could be the older son and the sitting one a servant. The best case for such a view cites a tradition by artists and biblical scholars who connect the parable of the prodigal son with the parable of the Pharisee and the publican or tax collector (Luke 18.9–14). In such a view, the standing figure at the right would be seen as the unforgiving elder brother who acts like the self-righteous Pharisee in the other parable while the seated figure would be seen as a steward or servant who acts like the repentant publican or tax collector in the other parable.[12] I am more inclined to see the older son as the figure in the center background of Rembrandt's painting.[13] In artistic depictions of the Jacob story, the older brother Esau is sometimes pictured in the background hunting as he is seen in the upper left background of the tapestry *Jacob Receiving the Blessing Intended for Esau*.

The woman in the upper left corner and the son kneeling are present in the painting of *The Return of the Prodigal Son* by Rembrandt; but in that parable of Jesus, no woman is present, and the son does not kneel. In both Jewish and Early Christian traditions, the normative mode of prayer was standing with the hands raised as in the *orantes* position, or, less often, total prostration. Kneeling, which was common practice before rulers in ancient Rome, comes into Christian worship only in the fourth century as Christianity becomes the official religion and the church adopts customs from the emperor's court.[14] By Rembrandt's time, however, kneeling had long been part of the liturgical practice.

Furthermore, in the text of the parable, the son does not even come to the house. Rather, the father runs to the son while he is yet at a distance, and embraces him, and kisses him, while the son most likely is standing as shown in twentieth century renderings such as the 1976 sculpture and 1990 drawing *The Prodigal* by Leonard Baskin. Another example of the father embracing the son with both standing is the sculpture *The Prodigal Son* (fig. 4) by Netherlandish artist Britt Wikstrom. In these examples, the figures almost merge in that embrace. There are similarities to Rembrandt's composition in that we do not see the face of the son, only the side of the cheek, as the focus is much more on the father than on the son.

Figure 4
Britt Wikstrom
The Prodigal Son, *1990*
Bronze

By portraying the return of the prodigal in ways which remind the viewer of Jacob stealing his father's blessing, Rembrandt's painting illuminates the deceitfulness of the prodigal son, even at the moment when he is being embraced. Thus the unearned graceful action of the father is emphasized: the father faces us in a most engaging frontal presentation while only the back of the son and the side of his face are visible.

We easily overlook the prodigal son's continuing self-centeredness when he decides to return home. This overlooking or downplaying of the prodigal's selfishness is common in nineteenth and twentieth-century preaching. Nineteenth-century American preaching was so intent on converting people and having them repent, it read repentance into that gesture of the prodigal returning home. Yet the repentance is not there in the parable; in fact, quite the opposite. Alone in the foreign land and having lost everything, the prodigal "comes to himself"—a neutral term in the Greek, which can mean, among other things, getting an idea. It could be a good idea or it could be a bad idea. "Coming to himself" does not mean repentance. When he comes to himself, it is indeed selfishness, not repentance, which motivates his decision to return home. He is hungry. And what does he remember when he comes to himself? If he'd been truly repentant, he might remember that "I hurt my father" and that "I must go home to be with my father and my brother." Instead, when he comes to himself he says, "How many of my father's servants have bread enough to spare, but I languish here with hunger." So he devises a very clever speech, which concludes with the line, "Treat me as one of the hired servants." That means, "give me the bread!" That speech is hardly repentance, but reveals his continuing self-concern. When the father later embraces him, before the son can give his clever speech, the son drops off that last line which he had intended to say, "treat me as one of the hired servants," for he realizes that he is welcomed home unconditionally and gets the fatted calf without working for it.

Rembrandt thus portrays the prodigal son as undeserving and unrepentant, and as deceitful as Jacob when he knelt before his father. By linking the prodigal's deceitfulness to Jacob's deceit, Rembrandt emphasized the Reformation insight that God's acceptance of us is not deserved by any merit of ours, but is a gift of God's grace and God's faith in us—however unjustified we are by our own actions or unfaithfulness. Justification by faith through grace does not refer to our faith, but rather the faith that God has and that Christ has in God.[15]

To counter Protestant interpretation, the Catholic Counter Reformation Council of Trent (1545–63) urged artists to portray the prodigal son parable in art and to portray him as genuinely repentant when he returns home.[16] A portrayal of him as genuinely repentant was a way to encourage the sacrament of penance, a sacrament that Protestants disputed. *Return of the Prodigal Son* (fig. 5) was painted between 1667–70 by Bartolomé Esteban Murillo a century after Tridentine reforms, and at the same time as Rembrandt's painting. The focus in the Murillo work and in Catholic art in general is much more on the son. In Murillo's depiction, instead of seeing the back of the son's head, one sees him in striking profile. This is in contrast to Rembrandt's depiction in which one sees only the back of the son's head and a bit

Figure 5
Bartolomé Esteban Murillo
The Return of the Prodigal Son
1667/1670
Oil on canvas

Figure 6
E.B. & E.C. Kellogg
The Prodigal Son Returned to His Father
1845–46
Lithograph

of the side of his face. Rembrandt's frontal depiction of the father engages the viewer as does the frontality of a Byzantine Christ-Pantocrator in the church's dome or of a saint in icons.[17] Murillo's father is not presented frontally but is turned toward the son to heighten the viewer's attention to the son, an attention increased by the son's naked flesh-toned upper back and shoulders and white tattered shirt. The white dog touching the son's knee further underscores an assertion of the prodigal's repentance as the dog is often a symbol of faith. Here the dog calls attention to the son's penitent kneeling, which is further reinforced by his hands clasped in a gesture of prayer.

In nineteenth-century America, one of the largest producers of lithographs for the Catholic market was the firm of *E.B. & E.C. Kellogg* in Hartford, Connecticut. Their 1845–46 lithograph *The Prodigal Son Returned to His Father* (fig. 6) follows the Catholic scheme with the son in profile. Here the initiative is clearly with the son and not the father who does not even touch the son; but then, a Victorian father might not readily run and embrace and kiss his son.

In twentieth-century American art, intertextuality comes full circle. Consider *Abraham's Farewell to Ishmael* (1987) (fig.7) by George Segal. In this life-size sculpture, Abraham embraces Ishmael. The work was first displayed in the Janis Galleries in New York. If one viewed it from the entrance to the room, then Sarah, who was in the background to the right of the rock, appeared to be coming between Hagar at the right in the foreground and Abraham embracing Ishmael to the left. If one walked around to the right, then Hagar appeared to be in the middle between Sarah at the right and Abraham embracing Ishmael to the left. Sculpture affords multiple interpretations depending where one is standing.[18]

According to the stories involving Hagar (Genesis 16 and 21), Sarah, much like Rebecca, orchestrates the scene, but in this case in order to have Abraham send Hagar and Ishmael away into the desert. In Segal's interpretation, Hagar's arms are very poignant. Her arms are around her own body in a way that echoes the way Abraham's arms embrace Ishmael, while also reminding us that Abraham once embraced Hagar. As Sarah's maidservant, Hagar was sent to Abraham to produce an heir and gave birth to Ishmael. Later, when Sarah's son Isaac was born, Hagar and Ishmael appear as rivals to Sarah and Isaac. As in Rembrandt's *Return of the Prodigal Son*, one sees mainly the back of the barefooted son and only a little of one side of his face. When one goes around to the side of the rock, one sees little of Ishmael. The father is positioned frontally; thus the focus is much more on the father in both works.

Segal's indebtedness to Rembrandt's work is evident also in Abraham's hands. (Figs. 8 & 9). One hand is very finely sculpted, but the other is roughly rendered. Rembrandt's father similarly has two very differently rendered hands. Theologian Henri Nouwen makes much of the hands as being the feminine and masculine sides of the father and ultimately of God.[19] In both the Rembrandt and the Segal works, the wife of the father stands at one side in the background and could be interpreted as orchestrating the event in the foreground. Rebecca arranges for Isaac to bless Jacob; and Sarah arranges for Abraham to bid farewell to Ishmael and Hagar.

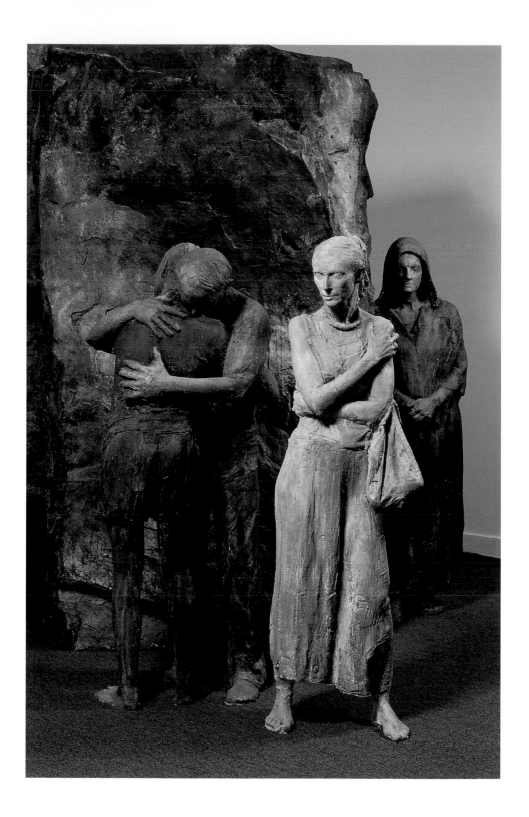

In sum, a study of intertextuality contributes to our understanding of an art-work. Rembrandt's treatment of the *Return of the Prodigal Son* uses the iconography of *Isaac Blessing Jacob*, and in so doing, the artist emphasizes the deceptive character of the prodigal. The prodigal acts like the deceitful Jacob, who steals his older brother Esau's birthright at the very moment that his father embraces him. This is a deception carried out under the inspiration and supervision of Rebecca in *Isaac Blessing Jacob* or of a female figure in *The Return of the Prodigal Son*. Such a rendering of the prodigal son's return in Rembrandt's work is congenial not only with biblical text, which reveals that the son's return was prompted by selfish desire to be fed as well as the father's hired servants rather than by repentance, but also with Protestantism's emphasis on the grace of God rather than on the good works of the person's beliefs or actions. In other words, repentance does not come before forgiveness. Forgiveness comes first; and then repentance may or may not follow. God forgives whatever we have done. God forgives whatever we are now doing. God forgives whatever we will do.

APPENDIX 1
The Parable of the Lost Son
Luke 15.11–32 (King James Version)

And he [Jesus] said, A certain man had two sons: and the younger of them said to *his* father, Father, give me the portion of goods that falleth to *me*. And he divided unto them *his* living. And not many days after the younger son gathered all together, and took his journey into a far country, and there wasted his substance with riotous living. And when he had spent all, there arose a mighty famine in that land; and he began to be in want. And he went and joined himself to a citizen of that country; and he sent him into his fields to feed swine. And he would fain have filled his belly with the husks that the swine did eat: and no man gave unto him. And when he came to himself, he said, How many hired servants of my father's have bread enough and to spare, and I perish with hunger! I will arise and go to my father, and will say unto him, Father, I have sinned against heaven, and before thee, and am no more worthy to be called thy son: make me as one of thy hired servants. And he arose, and came to his father. But when he was yet a great way off, his father saw him, and had compassion, and ran, and fell on his neck, and kissed him. And the son said unto him, Father, I have sinned against heaven, and in thy sight, and am no more worthy to be called thy son. But the father said to his servants, Bring forth the best robe, and put *it* on him; and put a ring on his hand, and shoes on *his* feet: and bring hither the fatted calf, and kill *it*; and let us eat, and be merry: for this my son was dead, and is alive again; he was lost, and is found. And they began to be merry.

Now his elder son was in the field: and as he came and drew nigh to the house, he heard music and dancing. And he called one of the servants, and asked what these things meant. And he said unto him, Thy brother is come; and thy father hath killed the fatted calf, because he hath received him safe and sound. And he was

angry, and would not go in: therefore came his father out, and entreated him. And he answering said to *his* father, Lo, these many years do I serve thee, neither transgressed I at any time thy commandment; and yet thou never gavest me a kid, that I might make merry with my friends: but as soon as this thy son was come, which hath devoured thy living with harlots, thou hast killed for him the fatted calf. And he said unto him, Son, thou art ever with me, and all that I have is thine. It was meet that we should make merry, and be glad: for this thy brother was dead, and is alive again; and was lost, and is found.

Jacob Obtains Isaac's Blessing
Genesis 27.1–46 (King James Version)

And it came to pass, that when Isaac was old, and his eyes were dim, so that he could not see, he called Esau his eldest son, and said unto him, My son: and he said unto him, Behold, *here am* I. And he said, Behold now, I am old, I know not the day of my death: now therefore take, I pray thee, thy weapons, thy quiver and thy bow, and go out to the field, and take me *some* venison; and make me savory meat, such as I love, and bring *it* to me, that I may eat; that my soul may bless thee before I die.

And Rebekah heard when Isaac spake to Esau his son. And Esau went to the field to hunt *for* venison, *and* to bring *it*. And Rebekah spake unto Jacob her son, saying, Behold, I heard thy father speak unto Esau thy brother, saying, Bring me venison, and make me savory meat, that I may eat, and bless thee before the LORD before my death. Now therefore, my son, obey my voice according to that which I command thee. Go now to the flock, and fetch me from thence two good kids of the goats; and I will make them savory meat for thy father, such as he loveth: and thou shalt bring *it* to thy father, that he may eat, and that he may bless thee before his death. And Jacob said to Rebekah his mother, Behold, Esau my brother *is* a hairy man, and I *am* a smooth man: my father peradventure will feel me, and I shall seem to him as a deceiver; and I shall bring a curse upon me, and not a blessing. And his mother said unto him, Upon me *be* thy curse, my son: only obey my voice, and go fetch me *them*. And he went, and fetched, and brought *them* to his mother: and his mother made savory meat, such as his father loved. And Rebekah took goodly raiment of her eldest son Esau, which *were* with her in the house, and put them upon Jacob her younger son: and she put the skins of the kids of the goats upon his hands, and upon the smooth of his neck: and she gave the savory meat and the bread, which she had prepared, into the hand of her son Jacob.

And he came unto his father, and said, My father: and he said, Here *am* I; who *art* thou, my son? And Jacob said unto his father, I *am* Esau thy firstborn; I have done according as thou badest me: arise, I pray thee, sit and eat of my venison, that thy soul may bless me. And Isaac said unto his son, How *is it* that thou hast found *it* so quickly, my son? And he said, Because the LORD thy God brought *it* to me. And Isaac said unto Jacob, Come near, I pray thee, that I may feel thee, my son, whether thou *be* my very son Esau or not. And Jacob went near unto Isaac his father; and he felt him, and said,

The voice is Jacob's voice, but the hands *are* the hands of Esau. And he discerned him not, because his hands were hairy, as his brother Esau's hands: so he blessed him. And he said, *Art* thou my very son Esau? And he said, I *am*. And he said, Bring *it* near to me, and I will eat of my son's venison, that my soul may bless thee. And he brought *it* near to him, and he did eat: and he brought him wine, and he drank. And his father Isaac said unto him, Come near now, and kiss me, my son. And he came near, and kissed him: and he smelled the smell of his raiment, and blessed him, and said,

> See, the smell of my son *is* as the smell of a field which the LORD hath blessed:
> therefore God give thee of the dew of heaven,
> and the fatness of the earth,
> and plenty of corn and wine:
> let people serve thee,
> and nations bow down to thee:
> be lord over thy brethren,
> and let thy mother's sons bow down to thee:
> cursed *be* every one that curseth thee,
> and blessed *be* he that blesseth thee.

And it came to pass, as soon as Isaac had made an end of blessing Jacob, and Jacob was yet scarce gone out from the presence of Isaac his father, that Esau his brother came in from his hunting. And he also had made savory meat, and brought it unto his father, and said unto his father, Let my father arise, and eat of his son's venison, that thy soul may bless me. And Isaac his father said unto him, *Who art thou?* And he said, I *am* thy son, thy firstborn Esau. And Isaac trembled very exceedingly, and said, Who? where *is* he that hath taken venison, and brought *it* me, and I have eaten of all before thou camest, and have blessed him? yea, *and* he shall be blessed. And when Esau heard the words of his father, he cried with a great and exceeding bitter cry, and said unto his father, Bless me, *even* me also, O my father. And he said, Thy brother came with subtilty, and hath taken away thy blessing. And he said, Is not he rightly named Jacob? for he hath supplanted me these two times: he took away my birthright; and, behold, now he hath taken away my blessing. And he said, Hast thou not reserved a blessing for me? And Isaac answered and said unto Esau, Behold, I have made him thy lord, and all his brethren have I given to him for servants; and with corn and wine have I sustained him: and what shall I do now unto thee, my son? And Esau said unto his father, Hast thou but one blessing, my father? bless me, *even* me also, O my father. And Esau lifted up his voice, and wept. And Isaac his father answered and said unto him,

> Behold, thy dwelling shall be the fatness of the earth,
> and of the dew of heaven from above;
> and by thy sword shalt thou live, and shalt serve thy brother;
> and it shall come to pass when thou shalt have the dominion,
> that thou shalt break his yoke from off thy neck.

Jacob Flees from Esau

And Esau hated Jacob because of the blessing wherewith his father blessed him: and Esau said in his heart, The days of mourning for my father are at hand; then will I slay my brother Jacob. And these words of Esau her elder son were told to Rebekah: and she sent and called Jacob her younger son, and said unto him, Behold, thy brother Esau, as touching thee, doth comfort himself, *purposing* to kill thee. Now therefore, my son, obey my voice; and arise, flee thou to Laban my brother to Haran; and tarry with him a few days, until thy brother's fury turn away; until thy brother's anger turn away from thee, and he forget *that* which thou hast done to him: then I will send, and fetch thee from thence: why should I be deprived also of you both in one day?

And Rebekah said to Isaac, I am weary of my life because of the daughters of Heth: if Jacob take a wife of the daughters of Heth, such as these *which are* of the daughters of the land, what good shall my life do me?

[1] This presentation is a small part of a book I am writing on changing perceptions of Jesus' parables throughout art history—a polyvalency, i.e. multiple interpretations, through paint. This volume explores how throughout history, each parable has been interpreted differently by different artists.

[2] Intertextuality differs from topologies (which have long been used in studies of visual art to associate two or more biblical characters) in that it tells a story in terms of a preexisting one. In topology, the association was often made in view of similarities of characters or story lines: thus Old Testament and New Testament characters or stories would be grouped together on the same day in lectionaries, for instance the three men in the fiery furnace (Daniel 3) and the Wisemen (Matthew 2). To the best of my knowledge, intertextuality has not played a role in the interpretation of the visual arts so far.

[3] Only major religious subjects like "Crucifix" appear in the index. Fortunately *The Dictionary of Art* (Jane Turner, ed., London and New York: Grove, 1996) is online, so a search is possible for works of art with titles of parables.

[4] The eleventh-century Bible is mentioned without further specifications in the entry on

"Prodigal Son" in Peter and Linda Murray, *Dictionary of Christian Art* (New York: Oxford University Press, 2001), 448. The 12th century capital is referred to in the Index of Christian Art at Princeton University.

[5] Staatliche Kunstsammlungen Gemäldegalerie, Dresden, Germany.

[6] During my own graduate studies in the 1970s, I took one Rembrandt course taught by a leading art history scholar at a major secular university. We went through the course without ever seeing an image that had biblical subject matter. I thought that omission of works with religious subject matter might have stemmed from the professor's personal disinterest or even antagonism towards religion (an antagonism which we sadly often find in art history departments or even in religious studies departments of secular universities). However, when I inquired about the avoidance of works with religious iconography, the professor responded simply that such works would spark controversy which was better avoided. Of course, avoiding Rembrandt's religious works omits a large part of his oeuvre from the classroom.

[7] These, and many other similarities, are thoroughly noted by Edward Hobbs's work "The Gospel of Mark and the Exodus," Ph.D. dissertation, University of Chicago, 1958.

[8] William Countryman, William Countryman, "How Many Basketsful: Mark 8.14–21 and the Values of Miracles in Mark," *Catholic Biblical Quarterly* 47 (Oct. 1985): 643–55. Countryman's study, as well as Hobbs's dissertation (cited in note 7), are useful starting points for scholars wishing to explore intertextuality as used in biblical studies.

[9] See *Appendix 1* for the relevant biblical passages (in the King James Version).The Statenbijbel was the Dutch language Bible read in Reformed Churches in the Netherlands for over thirty years before Rembrandt painted *The Return of the Prodigal Son*. Translated from the Hebrew and Greek in 1637, it was the accepted text until 1951 in Dutch Reformed Churches.

[10] Reproductions often fail to reveal the woman standing in that upper left corner as she is less vividly painted than the figures in the foreground.

[11] See Anna G. Bennett, *Five Centuries of Tapestries from the Fine Arts Museum of San Francisco* (San Francisco: The Fine Arts Museum of San Francisco, 1976; revised edition Fine Arts Museum of San Francisco: Chronicle Books, 1992).

[12] For that interpretation, see Barbara Joan Haeger's "The Religious Significance of Rembrandt's Return of the Prodigal Son: An Examination of the Picture in the Context of the Visual and Iconographic Tradition," Ph.D. dissertation, University of Michigan, 1983.

[13] In reading over my viewing notes on the painting from the days I spent at the Hermitage in 2001, I am reminded that I could see only the head distinctly, and much less so the rest of his body. This may account for the fact that much of the body tends to disappear completely in reproductions. One could argue that this treatment of the body (not articulated strongly, and fading off from view) is consistent with the narrative of both stories.

[14] See Doug Adams and Diane Apostolos-Cappadona, *Dance as Religious Studies* (New York: Crossroad, 1990), and Doug Adams, *Congregational Dancing in Christian Worship* (Austin: The Sharing Company, 1971).

[15] John Dillenberger, ed., *Martin Luther: Selections from His Writings* (Garden City, NY: Doubleday, 1961); and John Dillenberger, ed., *John Calvin: Selections from His Writings* (Garden City, NY: Anchor Books, 1971). In his recent book *Images and Relics: Theological Perceptions and Visual Images in Sixteenth-Century Europe* (London and New York: Oxford University Press, 1999), John Dillenberger discerns how Reformation artists and theologians were exploring primarily not that faith made a difference, but rather the difference that faith makes.

[16] See *Canons and Decrees of the Council of Trent*, tr. Henry John Schroeder (St. Louis, MO: B. Herder, 1941).

[17] Recognizing the power of frontality to engage attention, contemporary artist Stephen De Staebler (b.1933) presents his works frontally. He explains that frontality results in a transcendence of self as one becomes aware of the other person. The frontal form suggests also an engagement or commitment with another person such as occurs at a dinner party through face-to-face conversation. De Staebler contrasts such a dinner engagement with the uncommitted talk at a cocktail party where a face-to-face stance is often avoided in favor of standing at oblique angles to be able to look beyond the person to see if someone more interesting is coming. De Staebler expands on this imagery saying, "The ground rule of the cocktail party is never to become engaged or never to be cornered so that you can't slip away before a situation becomes less than enjoyable or threatening; whereas at a dinner party, you can't very well edge your chair over and sit next to the other guy." See Doug Adams, *Transcendence with the Human Body in Art: George Segal, Stephen De Staebler, Jasper Johns, and Christo* (New York: Crossroad, 1991), 58.

[18] Freestanding sculptures in the nave of churches
invited multiple interpretations as persons
saw the work from different sides. Putting
a sculpture in a wall niche limits the interpre-
tations, as one does not see it from the back,
or even very well from the sides. Great art,
however, undermines our best attempt to
control the interpretation because it is
ambiguous and has many windows or doors
of interpretation. I have been presenting one
way of looking at Rembrandt's painting.
There are numerous other interpretations.
What I am attempting here is to open one or two
more doors or windows of interpretation,
adding them to the ones readers already have.

[19] Henri J.M. Nouwen, *The Return of the Prodigal
Son: A Story of Homecoming* (New York:
Doubleday, 1992).

if there is
no jewish art,
what's
being taught
at the seminary?

Vivian B. Mann

The belief that there is no Jewish art, whether made for or by Jews, is an invention of the nineteenth century based, in part, on a misunderstanding of the Second Commandment, which reads:

> You shall have no other gods besides Me. You shall not make for yourself a sculptured image, or any likeness of what is in the heavens above or on the earth below, or in the waters under the earth. You shall not bow down to them or worship them. (Exodus 20.3–6)

> With Me, therefore, you shall not make any gods of silver, nor shall you make for yourselves any gods of gold. (Exodus 20.20)

The prohibition is twofold: not to worship other gods, and not to make images of God. In antiquity, the strict observance of this ban lasted only as long as idolatry was a potent threat to monotheistic Judaism. By the third century CE, when the threat was thought to have passed, the rabbis permitted the production of visual imagery.

As Margaret Olin has noted, the widespread assumption among both rabbis and scholars of Judaism, and among art historians that the Torah proscribes the practice of the visual arts was but one factor that led to the neglect of Jewish art in both the religious and secular academies.[1] Another factor in academic neglect was the heterogeneous nature of Jewish art, whose categories were united more by their use in the practice of Judaism or by having been made by Jewish artists, than by being products of a distinct stylistic development or geographic area. This last point led to the exclusion of Jewish art from the canon of art history, when the discipline began to develop around 1840 in the context of nationalism. Ancient Jewish art was included in early surveys; later Jewish art, lacking a basis in a single style, history or nation, was excluded from the history of art. Apologists sought the greatness of the Jewish people in other fields. Martin Buber declared that because of racial characteristics, "the ancient Jew had no visual art." [The quintessential art form of the ancient Jew was] "acoustic, music being barely adequate means of expression; the lyrical poetry of the prophets was [the] capstone of Jewish achievement in the arts."[2]

Gradually, in the twentieth century, Jewish achievement in the visual arts came to be acknowledged due to the large numbers of Jewish artists making contemporary art (fig. 1), and because of the discovery of older art. Numerous archaeological

Figure 1
El Lissitzky
Had Gadya Suite
(Tale of a Goat),
"Then Came a Stick
and Beat the Dog"
1919
Colored lithograph
on paper

Figure 2
Ostia, Synagogue
Detail of Mosaic Floor
4th century CE

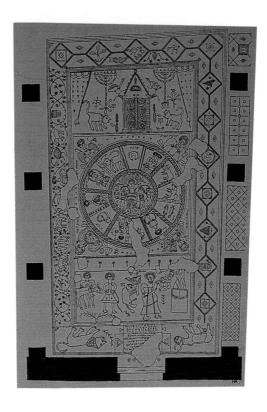

Figure 3
Bet Alpha, Synagogue
Plan of Mosaic Floor
Early 6th century

excavations, together with the increased publication of older works of Jewish art, have broadened the available evidence of Jewish involvement in the visual arts through the centuries.[3] The eventual result was the establishment of Jewish art history as an academic discipline and, in the case of The Jewish Theological Seminary of America, the founding of its still unique Master's Program in Jewish Art and Material Culture in 1995. How can the presence of this new discipline affect older forms of discourse at the Seminary? First, knowledge of Jewish art can deepen our understanding of traditional texts. For example, only two passages in the Talmud discuss the decoration of synagogues. "In the days of Rabbi Yoḥanan, they began to paint on the walls and he did not prevent them."[4] Rabbi Yoḥanan lived from c. 180 to 279 and was the outstanding scholar of his generation. Despite his support of a ban on studying secular knowledge or "Greek wisdom," he allowed the painting of synagogues. The second passage from the Talmud was discovered in a manuscript in St. Petersburg: "In the days of Rabbi Abun they began to create designs on mosaics and he did not prevent them."[5] Another commentary on the same passage is somewhat more descriptive: "A mosaic pavement of designs and forms you may set up on the floor of your places of worship, as long as you do not bow down to it."[6] This translation implies that some forms on the floors of synagogues were in some ways idolatrous but still permissible, as long as worshipers did not bow down to them. Nothing in these passages, however, prepares the reader for the reality of ancient synagogue decoration. After all, painting the wall could mean monochromatic colors, and

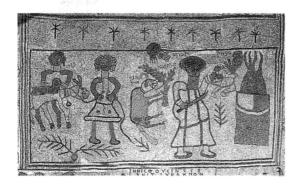

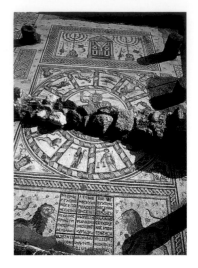

Figure 4
Bet Alpha, Synagogue
Detail of Mosaic Floor:
The Offering of Isaac
Beginning of the 6th century

Figure 5
Hammath near Tiberius
Synagogue
Mosaic Floor, 4th century

mosaics can be abstract, as illustrated by a portion of the floor of the synagogue at Ostia, near Rome, built in the first century CE and renovated in the fourth century (fig. 2).

Two momentous discoveries made a year apart were the first to demonstrate that synagogue decoration was in reality far richer and more extensive in the talmudic period than indicated by textual evidence and, in fact, consisted of sophisticated compositions and scenes involving human forms. The first was the excavation of the Bet Alpha Synagogue in 1928/9 (fig. 3).[7] Its floor mosaic is tripartite: the Binding of Isaac near the door (fig. 4); a calendrical cycle in the middle, and a representation of the Torah ark and its surrounding implements placed immediately before the niche in which the actual ark was situated. Although the figures in the Bet Alpha mosaic are schematic and lacking in volume, more naturalistic representations of the same theme appear on other synagogue floors like that of Hammath Tiberius, dated to the early fourth century, whose subtly modeled forms approximate the highest levels of Roman art (fig. 5). In all there are seven synagogue floors with the same basic pictorial scheme that have been discovered. That is, they have one or more biblical scenes, a representation of the calendar, and a depiction of the synagogue ark and its surrounding implements. The most recent discovery is an early fifth-century mosaic at Sepphoris (Zippori), the city where Rabbi Judah haNasi had codified the Mishnah, the earliest compilation of Jewish law, by the end of the second century CE. Sepphoris was home to talmudic scholars for several centuries afterwards. It is

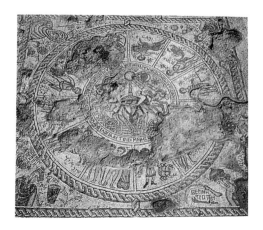

Figure 6
Sepphoris, Synagogue
Detail of Mosaic Floor: Zodiac Circle
5th century

Figure 7
Sepphoris, Synagogue
Detail of Mosaic Floor:
Season Figures
5th century

difficult to imagine that these scholars would have tolerated synagogue decoration they deemed objectionable.

The seven synagogue mosaic floors all include one subject clearly drawn from the repertory of classical art: the calendrical wheel with signs of the zodiac along the circumference and female personifications of the four seasons in the corners (figs. 6 and 7). The central image, *Helios Riding in his Quadriga*, can best be seen in the mosaic from Hammath Tiberius (fig. 8). As noted in the Babylonian Talmud, Helios was thought to leave a palace in the East each morning to travel across the sky; his path through the heavens marking daily time. Together, Helios, the zodiac, and the seasons were a reminder to worshipers of their duties to God that were governed by the calendar: daily prayers and the requirements of Sabbath and festivals.

Excavators from Yale University were responsible for the second momentous archaeological discovery, in 1930. They uncovered the remains of Dura Europos in Syria, buried since its capture by the Parthians in 256 CE.[8] The site is remarkable for the presence of the earliest Christian house church, an early Mithraeum, and for its synagogue built near the city walls in the early third century and renovated in 244–45.

The capture of the city caused rubble from the walls to fill the interior of the synagogue, thereby preserving the walls and their frescoes to the height of the ceiling (fig. 9). These paintings are all biblical scenes, one of the most extensive narrative repertoires in ancient art based on Jewish textual sources (fig. 10). The Dura Europos

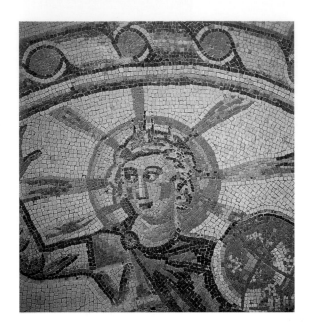

Figure 8
Hammath near Tiberius
Synagogue
Detail of Mosaic Floor: Helios
4th century

At right, Figure 11
Vienna Genesis
Rebecca at the Well
6th century
Silver and gouache
on purple parchment

Figure 9
Dura Europos, Synagogue
Ark Wall, 244/5

Figure 10
Dura Europos, Synagogue
The Vision of the Dry Bones
244/5
Fresco

murals may have depended on a model book or an illuminated manuscript, like the very profusely illustrated Vienna Genesis, written in Greek and thought to be based on a prototype whose text was the Septuagint, the Greek translation of the Bible written for Jews in Alexandria. The Vienna Genesis also includes illustrations drawn from extra-biblical Jewish sources (fig. 11).[9]

At the same time, knowledge of texts may contribute to a history of the visual arts. The scholar Asher ben Yeḥiel was born and educated in Germany, but left for Spain c. 1304, becoming head of the rabbinical court in Toledo, where he died in 1327. One of his legal decisions reads as follows:

> You inquired about the matter of the small mat [i.e. prayer rug] which is called
> sajjada in Arabic, on which it is the custom of the Muslims to pray and that
> bears an image resembling a black weight, whether it is permitted to hang
> it in the synagogue next to the ark, one on each side, and to pray facing them,
> even though God forbid that a single Jew should pray with intention toward
> something forbidden.
>
> I inquired about this matter on your behalf and investigated it, and it became
> clear to me that, in Toledo, they were accustomed to forbid placing such a rug in
> the synagogue in order to sit on it; certainly it is forbidden to hang it at the side
> of the ark.
>
> It is said that the black image formed in it is the depiction of the place to which
> they go [i.e. the kaaba] to celebrate in their land [i.e. Mecca]. There are also those
> who say it contains an image of a markolis, and that it is their custom to pray on it
> and to prostrate on it during prayer. It has also been said to me that the mat is,
> therefore, called a sajjada because they prostrate on it [and he quotes the cognate
> Hebrew verb]. And since this is the case, it appears to me that it is forbidden to
> hang it in the synagogue...certainly on either side of the ark. One must remove it
> from the synagogue so that no memory of it will remain there. Why should we
> place a thing like this in our synagogue that was prepared for their prayers?[10]

In his answer, Rabbi Asher indicates that he had investigated the iconography and use of the prayer rug. His responsum is the earliest evidence for the existence of rugs with Kaaba iconography. Extant examples date only to the late seventeenth or early eighteenth century (fig. 12). This text is also evidence that Rabbi Asher was

willing to seek knowledge concerning the art and religious practices of the "Other" in order to render a correct legal decision to members of the Jewish community.

In the next generation, despite Rabbi Asher's ruling forbidding the hanging of this rug, his grandson came to his uncle, Judah ben Asher, and asked him again about hanging a similar rug in the synagogue:

> My teacher and uncle, Rabbi Judah, enlighten me about the matter of the small rug called a *sajjada*…One such *sajjada* with the image of a weight on it was hung here [in Toledo] in the Synagogue of the Thirteen by its congregants. Rabbi Nathan and I had it removed because of my grandfather's ruling. Some of the congregants grumbled about what we had done. Afterwards, they had the image replaced with that of a flower and rehung the rug in the synagogue. Please enlighten me as to whether it is proper in your eyes for it to remain in the Synagogue of the Thirteen as the image of the weight is not in it.[11]

Despite Rabbi Judah's negative ruling, a questioner asked Rabbi David Amado of Izmir, who was active in the mid-18th-century, a similar question about a rug with a depiction of a *mihrab*.[12]

This chain of *responsa* on rugs illustrates the appeal of the visual arts to the Jewish viewer. Attracted by beautiful colors, designs, and compositions, the Jews of Toledo wanted what their neighbors had, even their ceremonial art. It may have been out of recognition of the human desire for what is beautiful, that once idolatry had been defeated, the rabbis placed few impediments in the way of Jews wishing to share in the artistic culture of people around them.

My final point is that Jewish law encourages an encounter with the artistic culture of the "Other." Judaism is a religion that demands praxis. Throughout the liturgical calendar and the life cycle, actions demanding objects complement the role of prayer. It is impossible, for example, to make *kiddush*, the sanctification over wine, without a cup, a beaker, a tankard, something to hold the liquid.

The forms of only three objects used in the practice of Judaism are completely specified in the Code of Jewish Law, written by Joseph Caro in the sixteenth century. They are the Torah scroll, the scroll of the *mezuzah* (passages from Deuteronomy affixed to the doorposts of Jewish-owned homes and buildings) and *tefillin* (leather boxes contain passages from Deuteronomy worn mostly during morning prayers). All the remaining works of Jewish ceremonial art may be classified into three groups: those whose forms are determined partly by Jewish law, like the Hanukkah lamp; those whose functions are required but whose forms are not specified; and those that were developed because of a patron's commission, but are not required.

The impact of the artistic culture of other peoples on Jewish ceremonial art is in inverse proportion to the strictness of Jewish law governing their fabrication. The lack of legal requirements for most types of ceremonial art means that art made for Jewish ritual is replete with the style, iconography, and compositions of the art made for non-Jews. Judaism allows for this openness to other cultures *ex silencio*, by not demanding specific forms for ritually required works. A Jew was, therefore, free to

seek that which appealed to him or her aesthetically. Occasionally, the donor of a work to the synagogue might run afoul of the community's sense of aesthetics or propriety. Only then did the work of ceremonial art become a matter of legal concern. By allowing an open encounter with the art of others, the rabbis demonstrated a very different attitude than that evinced by the historians cited at the beginning of this essay.

Those of us who study Jewish art have become avid students of texts for the information and historical background they provide to a study of Jewish visual art. Some of my colleagues who deal with texts are becoming aware of what Theodore Rabb and Jonathan Brown have written:

> ...painters, sculptors, architects are able to give us clues and answers about the universe they inhabited that are available nowhere else. In the absence of words, artifacts can point us in directions we could not otherwise imagine.[13]

But I have yet to convert them all.

[1] Margaret Olin, "From Bezal'el to Max Lieberman, Jewish Art in Nineteenth-Century Art Historical Texts," in C. M. Sousselof, ed., *Jewish Identity in Modern Art History* (Berkeley: University of California Press, 1999), 19–20.

[2] Kalman Bland, "Anti-Semitism and Aniconism: The Germanophone Requirements for Jewish Visual Arts," in Sousselof, *Jewish Identity*, 55.

[3] The first volume on Jewish art was a facsimile of the 14th-century Sarajevo Haggadah published by David Heinrich Müller and Julius von Schlosser (Vienna: A. Höler, 1898). Periodicals focused on cultural issues that were published in the early 20th century, for example *Ost und West*, included numerous articles on contemporaneous artists and older forms of Jewish art.

[4] Jerusalem Talmud, Avodah Zarah 3.3.

[5] J. N. Epstein, "Fragments of the Jerushalmi," *Tarbiz* 3, no. 1 (1932), 20 (Hebrew).

[6] Jerusalem Talmud, Avodah Zarah 3, 3, 42d. This translation, and the others following, are from Vivian B. Mann, *Jewish Texts on the Visual Arts* (Cambridge, MA: Cambridge University Press, 2000).

[7] On the synagogue floors with representations of the zodiac, see Rachel Hachili, *Ancient Jewish Art and Archaeology in the Land of Israel* (Leiden: Brill, 1988).

[8] Carl H. Kraeling, *The Synagogue. The Excavations at Dura-Europos. The Final Report, Vol. VIII* (New Haven: Yale University Press, 1956).

[9] Robert G. Calkins, *Illuminated Books of the Middle Ages* (Ithaca: Cornell University Press, 1986), 21–23.

[10] Asher ben Yehiel, *Responsa Asheri* (Jerusalem, 1965), no. 5:2.

[11] Judah ben Asher, *Responsa Zikhron Yehudah* (Berlin, 1846).

[12] David Amado, *Einei David* (Izmir, 1866), no. 2.

[13] Theodore K. Rabb and Jonathan Brown, "The Evidence of Art: Images and Meaning in History," in Robert I. Rotberg and Theodore K. Rabb, eds., *Art and History. Images and Their Meaning* (Cambridge: Cambridge University Press, 1988), 2.

art and religion: ships passing in the night?

Robert L. Nelson

Art and Religion, two separate categories, two distinct disciplines, localized in different institutions, the museum and the church, and preached and professed by individuals with different training and goals. How are they to be connected? Indeed what verbs should be added to begin this paper with a proper sentence?

In a distant past, art and religion were inseparable, but with the rise of the artist during the Renaissance and the increasing secularization of society more generally, art and religion began to diverge, not withstanding the contradictory trends of the Reformation and the Counter-Reformation. During the past two centuries, indifference and antagonism have more commonly characterized the relationship of religion and the art of the avant-garde or the elite. As art has advanced steadily into the ever more secular public sphere, religion has retreated into the personal and private realm, although European and American practices differ in this respect. Today, for example, a great of majority of Americans state, according to Gallup polls, that they believe in God, but at the same time they also consider religion to be a private matter and its public display unseemly, "a breach of public decorum."[1]

Yet recently religion has reasserted itself and joined other social movements in contesting the sovereignty of art in the public sphere.[2] In 1999, Mayor Rudolph Giuliani of New York threatened to withhold funding from the Brooklyn Museum, because it displayed Chris Ofili's painting of the Virgin Mary that some considered blasphemous.[3] Two years later, in spite of the protests of the art world, the Taliban destroyed a colossal Buddha in Afghanistan, a monument of world art.

At times, religious conflicts have focused on the control of sacred space. At Ayodhya in India, animosity between Hindus and Muslims flared after the destruction of a mosque thought to have been built over the site of the birthplace of Lord Rama. In Jerusalem, Jews and Muslims continue to contest the possession of the Temple Mount that is sacred to both religions. In the 1990s Christians in the former Yugoslavia destroyed mosques, and now they fear for the safety of their medieval churches in Muslim territories. As battles over ethnic identity and national self-definition have raged, art history and archaeology have been inevitably drawn into the controversies.[4]

Historically both disciplines have followed contemporary developments, usually at a discrete distance. Thus it is not surprising that some historians of European and American art have begun to pay attention to matters of religion, but they are pioneers.

Heretofore, the finest work on art and religion addressed periods and cultures outside the Western artistic tradition since the Renaissance.[5] Over the course of the twentieth century, discussions of contemporary Christian art, especially painting and sculpture, seldom appeared in mainstream art historical publications, and modern religious art has rarely been exhibited in the principal museums. How can the separation of art and religion be explained? What are the resistances that have kept them apart? Searching for answers leads inevitably to the nature of art, art history, and religion and their positions in the world, problems whose definition, much less solution, have only begun to be explored. By means of case studies, the present essay will dig trial trenches into this largely uncharted terrain and sample the relationships of art, architecture, and art history to religion at approximately fifty-year intervals beginning in 1850. The perspective taken is that of art history in general, not the study of religious art itself, because the goal is to look at larger discourses. The institutional forms of Protestantism and Catholicism, especially the sacred space of churches, will constitute the domain of religion.

To set the stage, Europe during the second quarter of the 19th century witnessed two interrelated developments—the creation and institutionalization of the discipline of art history and the general acceptance in elite circles that medieval styles were the most appropriate for ecclesiastical architecture. At mid century, chairs in art history were beginning to be established first in art schools and academies and later in European universities and would proliferate by the end of the century. France and especially the German speaking countries were the center of the profession; England and America trailed behind.

In the first several decades of the twentieth century, art history became yet more popular in Germany, where the creation of new universities and museums opened the profession to groups outside the traditional social classes of German universities. Many distinguished Jewish scholars received positions, and German art history became a field open to methodological innovation. With the rise of Hitler, Jewish and non-Jewish art historians emigrated to the greatest benefit of the United States.[6] In America, consequently, as one adage went, Jewish professors taught Catholic art to Protestant students, without, as I remember, anyone's personal religion being discussed. Thanks to that immigration, art history in America during the 1950s began to rival the best anywhere, as the United States took over more than just the idea of modern art.[7] Today, like many disciplines, art history is more international and the art world increasingly global.

Turning to religious art, churches in diverse regions of Europe and then America were being built in medieval styles in the mid-nineteenth century. England mainly preferred the Gothic, employing it not only for churches, but also for all types of structures, from train stations to the Houses of Parliament. This elevated status of the Middle Ages was the consequence of the Romantic movement and a desire to flee the Industrial Revolution for the beauty, piety, and imagined social harmony of the Middle Ages.[8] Adopted in America as well, the Gothic was the height of fashion around 1850 for various Protestant denominations.[9] German medieval revival architecture at mid century favored the round-arch style (*Rundbogenstil*) or what we

know today as Early Christian, Byzantine, and Romanesque architecture. Inspired by Victor Hugo's famous novel, *Notre Dame de Paris* (1831), church architecture in France looked back to the Gothic Middle Ages. The followers of Hugo studied and preserved medieval buildings, then in near ruinous states after the French Revolution, and launched journals about medieval art.[10] In the same period, scholars in Germany and elsewhere also assembled archeological evidence and created new publications to support their revivals.[11]

By such means, art and art history expanded the canon of what was considered significant art, a process that by today has become commonplace. With that changed meaning, often the religious nature of the object was lost, and thus it is worthwhile to pause and consider how the aesthetic transformation was accomplished in the early years of art history's professionalization. England may serve as a test case, although similar developments occurred elsewhere.[12]

From the mid-nineteenth century, one of the most influential critics in the Anglo-American world was John Ruskin. Widely read in England and published in American editions of all sorts, Ruskin wrote enough for an entire art history department. An early book, *The Stones of Venice*, published in three volumes in 1851–52, rehabilitated Venetian Gothic for the English and contributed to the acceptance of Byzantine architecture. Published with few illustrations compared to today's art history books, *The Stones of Venice* persuaded by prose alone, especially the carefully wrought descriptions of works of art. Through his rhetoric, Ruskin made the medieval church of San Marco come alive for English audiences. Particularly effective, for example, was his evocative contrast of the joyously colorful Italo-Byzantine façade of San Marco on a bright sunny day (fig. 1) with the somber, gray front of an English cathedral in its native climate.[13]

But before Ruskin could persuade his readers of the merits of this architecture, he first had to address English Protestant prejudices, which he shared. His method is to aestheticize and thus secularize churches, something that today happens so frequently in art history that it goes unnoticed. But in *The Stones of Venice*, the technique is self-conscious, because both the rhetoric and the rhetorician are in formation. Aestheticism in this instance allows Ruskin to banish Catholics and deny Catholicism. Regarding the church at Murano, for example, he advises not to come on the day of a religious feast, when the church would be "filled with woeful groups of aged men and women...fixed in paralytic supplication, half-kneeling, half-crouched upon the pavement," but instead to return on the day after, when "worshippers and objects of worship" are gone, and visitors are left alone with the art and architecture.[14] The "paralyzed Christianity" which he witnesses at San Marco deserves "no more respect than...the devotion of the worshippers at Eleusis, Ellora, or Edfou," referring to ancient shrines in India, Greece, and Egypt. "It must therefore be altogether without reference to its present usefulness, that we pursue our inquiry into the merits and meaning of the architecture of this marvelous building."[15]

Similarly at the medieval church on the island of Torcello, he all but ignores the religious mosaics in favor of the architectural ornament. About the mosaic of the Last Judgment on the inner west wall, Ruskin writes that the "pleading of the

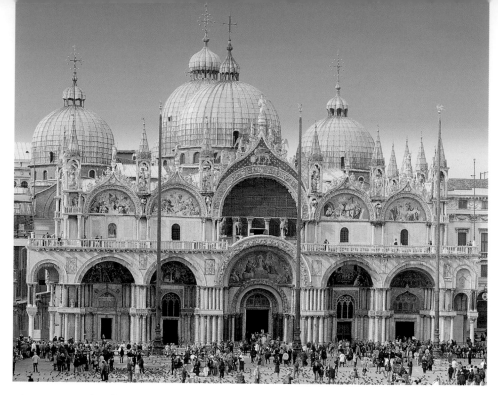

Figure 1. Façade of St. Mark, 13th–15th century, Venice

Virgin…beneath the figure of the Redeemer…in the act of intercession [a standard feature of the medieval iconography] may indeed be a matter of sorrow to the Protestant beholder." About the apse mosaic at Torcello (fig. 2) with its statuesque Virgin and Child on a field of gold above a row of apostles, this writer, so poetic and effusive on other occasions, can only manage a six-word description: "Christ, the Virgin, and the apostles."[16] The reader is thus led to assume that Christ is the most important figure here, and once more the position of the Virgin is demoted for Protestant readers.[17] Moreover, because Ruskin does not illustrate the apse, the visual power of its resplendent mosaic is lost.

Only at the end of the nineteenth century did Byzantine mosaics, such as those at Torcello, come to be regarded as works of great art. In England, Roger Fry was instrumental in this re-evaluation of Byzantine art after a trip to Venice in 1907. Fry saw Byzantine art as aesthetically similar to Post-Impressionism, but already the avant-garde in France had discovered Byzantine art in the 1890s.[18] In 1904, the German critic Julius Meier-Graefe, well versed in contemporary French art, published a developmental history of modern art that was translated into English four years later. Now there is high praise for the Virgin at Torcello:

The artistic effect is indescribable. Everything is so arranged as to bring the principal figure into relief…[T]he slender figure of the Virgin, clad in the traditional deep

Figure 2. Virgin and Child with Apostles, *12th century*
Apse Mosaic, Cathedral of Santa Maria Assunta, Torcello

blue role, stands out from the golden background, her hand and face being the
only passage of light color. The most beautiful ornament would not be so effective
as this simple contrast, the sharp contour against the grandiose gold background,
to which an automatic play of light and shade gives a gentle animation.[19] (fig. 3)

Probably more important for the burgeoning reputation of the standing Virgin and
Child in England was the popular book, *Medieval Art* (1904), written by William
Lethaby, a friend of William Morris and thus a direct intellectual descendant of John
Ruskin. Lethaby respectfully mentions Ruskin's appreciation of the architecture
of Torcello, but like Meier-Graefe finds here "one of the most striking mosaics in
existence, being a single figure of the Virgin, habited in blue, on a gold field."[20]

As the aesthetic importance of this and other Byzantine mosaics rose, their
religious significances disappeared, aided in general by renewed belief that the art
museum was a site for the aesthetic transformation of its collections.[21] Clive Bell, a
member of the English Bloomsbury group, was unstinting in his praise of Byzantine
art in his manifesto, simply titled *Art* (1916): "Since the Byzantine primitives set their
mosaics at Ravenna no artist in Europe has created forms of greater significance
unless it be Cézanne."[22] Bell devoted a chapter to "Art and Religion," yet his hesitant
definition of religion lacks nuance and depth and neglects the corporate: "Religion,
as I understand it, is an expression of the individual's sense of the emotional
significance of the universe." Here religion is defined as personal and private, not

collective and public. While he declares that "art and religion belong to the same world" and are "twin manifestations of the spirit," art for Bell is not "a manifestation of religion."[23] Paintings that merely illustrate dogma are scarcely art: "...in so far as a picture is a work of art, it has no more to do with dogmas or doctrines, facts or theories, than with the interests and emotions of daily life."[24]

By the mid-twentieth century, the abstraction of modern art made it acceptable, if not accessible, to diverse groups. In America, abstract expressionism and the now international style of the Bauhaus received governmental, corporate, institutional, and religious support, because both were thought to be modern, progressive, and ideologically and religiously neutral. Mies van der Rohe's spare, elegant abstraction made it suitable for the Seagram Building (1954–58), a prime corporate address in New York, as well as the campus of the Illinois Institute of Technology in Chicago and its interfaith chapel (fig. 4).[25] This small, rectangular chapel expresses well Modernism's quest for ultimate simplicity and thus the power of form and proportion. At the rear, the curtain behind the altar and cross disguises utilitarian spaces and the glazed exterior wall that repeats the façade. Occidented, not oriented like medieval churches, the chapel comes alive in the later afternoon. From the rear windows, the evening light bathes the side walls, transforming and elevating the simple brick. Such an elegant, spare design makes the chapel suitable for different religious groups and thus appropriate for a private, secular university.

In 1957, Philip Johnson, an associate of Mies van der Rohe on the Seagram Building, created a master plan for the campus of the University of St. Thomas (Houston, Texas), a project initiated and financed by John and Dominique de Menil. In the 1960s, the three collaborated on an ambitious plan to engage Mark Rothko to paint a series of canvases for a chapel that Johnson would design.[26] To some, Rothko might have seemed an odd choice for a Catholic chapel. His color field paintings (fig. 5), though highly regarded, were not in themselves religious. Clement Greenberg, the leading critic of the day, regarded such abstraction as the proper reduction of painting to its pure means and materials, which are "as important as ideas" and more significant than the "myths of religion."[27] As a result, similar work by Rothko could be intended for the Four Seasons Restaurant in the Seagram Building, the Holyoke Center at Harvard University, or the chapel in Houston. In the business of art, each painting is an equivalent commodity.

Yet in contrast to the restaurant or lounge, the chapel and the art within was to be sacred space. Its principal patron, Dominique de Menil, a most discerning collector of modern art, was a convert to Catholicism. During the 1940s and 1950s, her mentor for art and religion had been the Dominican Father Marie-Alain Couturier, a leader of the Art Sacré movement in France. He was also the stimulus for Fernand Léger's windows for a modern church at Audincourt, Le Corbusier's expressionistic chapel at Ronchamp, and Henri Matisse's chapel for a Dominican

Figure 5. Mark Rothko
Rothko Chapel, interior view, 1971, Houston

convent at Vence.[28] Twenty years later, Dominique de Menil envisioned the Rothko Chapel to be the American equivalent of the chapel at Vence. She wrote that it "would not have come into existence had it not been for [Vence] and the revival of sacred art which preceded it."[29]

Within the quiet centralized space of the simple chapel, Rothko's hauntingly dark abstract canvases are indeed successful sites for meditation and the product of a long historical process of aestheticism. The patron described them thusly:

> The black surfaces invite the gaze to go beyond. The chapel is a place conducive to spiritual activity. We are cut off from the world and its suffocating multiplicity, able to wander in the infinite…here we can find a blessed wholeness, a sense of unity.[30]

The Houston panels disguise their initial referent so well, that few would suspect that the apse triptych, the three panels at the rear of the chapel (fig. 5, extreme left, partially seen), was inspired by the mosaic at Torcello (fig. 2), as Rothko reported to Mrs. de Menil.[31] Rothko disliked questions about how his chapel paintings related to the Catholic faith and resisted suggestions that he introduce overt references to the Stations of the Cross.[32] Thus for Rothko to have been inspired by the Torcello mosaic, the experience had to have been purely aesthetic. In this sense, the chapel paintings are the culmination of a process that had begun a century earlier in the case of the Torcello mosaic with John Ruskin's denial of the religious merit of the churches of the Veneto.

Ironically, Rothko's iconographically ambiguous canvases were precisely what was later required. Designed for a Catholic campus and built nearby, the chapel was instead associated initially with the Institute for Religion and Human Development of the Texas Medical Center, an institution devoted to clinical pastoral training. Later it became a separate interfaith center for ecumenicism.[33]

Susan Barnes, writing on behalf of the Rothko Chapel in 1989, avoids discussing why the chapel was not accepted by the University of St. Thomas and reports only that caring for works of art "would be too great a burden" for the university.[34] But given the remarkable generosity of the de Menils, paying for security was surely not the issue. With many of the principals in the project dead, one can only surmise that a movement that began with the union of liberal Catholicism and modern art in France had led, two decades later, to a chapel that did not satisfy the Catholic authorities. An era had passed.

To bring art history into this discussion of religious art at mid-century, one could look at many texts, but I choose to start with a best seller of the period, *The Story of Art*, first published in 1950 by Ernst Gombrich, later the director of the Warburg Institute. A sophisticated accounting of art history, written long before the present age of mediocre textbooks, the volume is well titled a "story," for it is written with a directness and simplicity that engages everyone. Gombrich makes his principles utterly clear. The book "sets out to place the works it discusses in their historical setting and thus to lead towards an understanding of the master's artistic aims." Then comes his ringing assertion: "There really is no such thing as Art. There are only artists."[35] In a book about artists and the art they make, religious art is everywhere to be found in its pages, but seldom discussed as religious.

Gombrich's dissertation and early scholarship were devoted to the Italian Renaissance. At the time, his was regarded as "the favourite field of art history," or at least another Renaissance scholar so declared in 1949.[36] When German émigré art historians came to America, they made the Renaissance the most popular and prestigious period, supplanting the Middle Ages, which had heretofore prevailed, as Christopher Wood has shown in a recent article.[37] In the process, they implanted within the larger profession values born in nineteenth and earlier twentieth century European secularism, *Bildung* without religion. In a famous essay of 1953, Erwin Panofsky described his career and art history in Germany and America, but, like all scholarship of the period, he has nothing to say about religion.[38]

Given what such scholars had seen and experienced in Germany and the horrors of Nazism revealed to everyone after the war, it is not hard to understand how many would wish to avoid religion, and how some might yearn for a distant golden age untroubled by religious strife. This was thought to be the art before the Reformation and that glorious artistic parade across the fifteenth century to the High Renaissance. For those in the nineteenth century threatened by rapid modernization and industrialization, the Middle Ages had served as refuge; now it was a luminous Renaissance, in which the secular values of the Enlightenment triumphed over the dark, religious, superstitious Middle Ages.

Around 1950, art historians also began to work seriously on the nineteenth century and modernism, as modern art and architecture started to penetrate collegiate

Figure 6
André Malraux amidst photographs of art
Paris

Gothic campuses. One study of modern architecture widely read in the period was Sigfried Giedion's *Space, Time and Architecture: The Growth of New Tradition* (1941), which appeared in a number of later editions. It chronicles the modernist revolution in architecture in a way that long seemed canonical and unbiased, but, of course, all narratives are selective.

After an introductory chapter, Giedion begins his story tellingly with Renaissance Florence, "the workshop of modern spirit, " thus ignoring the Middle Ages. As he winds his way through the Baroque, many churches appear before Giedon turns to the nineteenth and twentieth centuries, the book's focus. After Balthasar Neumann's eighteenth-century *Vierzehnheiligen*, no other church is illustrated in the book, save for a ferroconcrete church in Paris to illustrate that technology, and the first example of the balloon frame, the otherwise unknown St. Mary's Church in Chicago.[39] The book indexes bridges, factories, office buildings, parks, private houses, and roofs, but it has no entry for churches, much less synagogues or mosques. "Church" as a category does not even appear in the index of a later edition that amply illustrates and discusses the Priory of La Tourette and the chapel at Ronchamp, both by Le Corbusier, a major protagonist of the book.[40]

A third author, yet more widely read in the period, was André Malraux, later the Minister of Culture in France. His *Les voix du silence* (1951) [*The Voices of Silence*] exemplifies a widely shared attitude toward art and its history during this period of high formalism. Here and in *Le musée imaginaire de la sculpture mondiale* (1952) [*The Imaginary Museum of World Sculpture*], with its hundreds of illustrations of art from around the world, Malraux advances and at the same time enacts the thesis that the modern museum, especially the universal museum that photography made possible, fundamentally alters the nature of objects regarded as art.[41] A contemporary photograph shows Malraux in his spacious and doubtlessly expensive Parisian apartment (fig. 6), working "on the complicated task of laying out the illustrations for one of his books on art," namely *Le musée imaginaire de la sculpture mondiale*.[42] Pondering the photograph in his hand, Malraux presides over the empire of images at his feet.

After a cursory text that ignores religion, the book presents page after page of black and white pictures, chiefly details of heads, all visually equivalent whether a mask from New Guinea, a Cycladic nude, a Buddha of the Gupta period, Christ in Judgment, the miracle-working Volto Santo of Lucca, an angry temple guardian from Japan, President George Washington, or the French king Henri II's sensual mistress in the guise of Diana the huntress. The series begins with a Paleolithic figure found in France and ends with two stout ladies by Maillol, the then contemporary French sculptor. Even though the book breaks new ground conceptually and represents the work of one of France's most celebrated intellectuals and a defender of the new, this strategy of put-ting one's country or culture at the beginning and the end of history had been used for centuries and is frequently encountered in art historical surveys.[43] *Plus ça change...*

By the late twentieth century, much indeed was the same. Modern churches continued to be built, of course, and those regarded as fine architecture still relied on the aesthetics of form and space. Some succeeded visually and managed to combine the modern with the traditional. For example, for the *Air Force Academy Chapel* (1962),

Figure 7
Skidmore, Owings &
Merrill (Walter Netsch)
Air Force Academy Chapel
1956–62
Colorado Springs

Figure 8
Fay Jones
Thorncrown Chapel, 1980
Eureka Springs

Walter Netsch produced something that might be called fighter-plane Gothic (fig. 7). A popular building with the general public, but also honored by the architectural establishment is the *Thorncrown Chapel* (1980) in the Arkansas mountains (fig. 8). This modern Arts and Crafts chapel, designed by Fay Jones, once a student of Frank Lloyd Wright, would have pleased John Ruskin, as the Prince of Wales realized when he presented Jones with the American Institute of Architects' Gold Medal Award: "Fay Jones' buildings speak of what Ruskin termed 'The Poetry of Architecture'— a poetry arising out of buildings in harmony with their natural surroundings."[44] The sentiment is noble and not to be disparaged, but it also is yet another example of the aesthetic transformation that is the mainstay of art history. For a religious building, harmony with liturgy and belief is more important.

Whether either of these chapels is a meaningful religious space is a complex matter that requires the investigation of the local communities. Certainly conservative critics decry the cold anonymity of modern churches, and some advocate a return to the values of nineteenth-century ecclesiastical architecture. The title of one recent polemic is its summary: *Ugly as Sin: Why They Changed our Churches from Sacred Places to Meeting Spaces and How We Can Change Them Back Again*. The author, Michael S. Rose, a latter-day Victor Hugo, argues that Notre Dame in Paris, is "arguably the most famous of Christendom's great cathedral churches" and should be the model for Catholic churches, for it exemplifies the "three natural laws" of successful Catholic architecture: verticality, permanence, and iconography.[45]

But surely the creation of significant religious architecture is more complicated than this. As Episcopal cathedrals in Washington and New York have discovered, reproducing a medieval cathedral in stone is a daunting task financially, and those that devote themselves to its decoration labor in artistic anonymity, as Tom Wolfe has decried.[46] A decade or so ago, one might have thought that the only modern church that could be considered legitimate architecture would be a clever and ironic post-modern combination of traditional religious symbols with quotations from buildings, high, low, historic, and modern. Today another path is suggested by the work of the Japanese architect Tadao Ando, who joins the traditional—the aesthetics of the Japanese house—with the modernist legacies of Frank Lloyd Wright and Louis Kahn.[47] In so doing, Ando revitalizes modernism, and not just for Japan, through a return to its fundamentals: space, light, and materials that are capable of evoking strong responses themselves.

In America, Ando is best known for his museums. His first work here was an often overlooked gallery for Japanese screens in the Art Institute of Chicago. Easily the most peaceful and meditative area of the museum, the gallery is entered through inconspicuous glass doors that reveal nothing of what follows. Walking inside, all is dark at first, ahead a forest of wood piers that screen off the gallery space beyond. Continuing past the dark piers, the visitor reaches an opening, mainly lit by the light directed on the screens. On one side of the space, a not entirely comfortable wood bench provides the necessary low vantage point for the screens resting on the dark wood floor. The gallery is quiet and contemplative, but not somnolent; one is alert to everything in it. After the tragedy of 9/11, such a space was the ideal temporary location

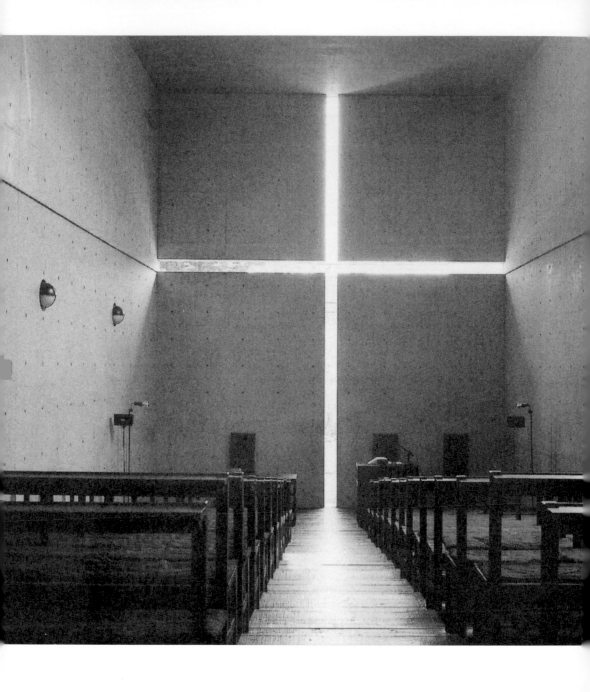

Figure 9
Tadeo Ando
Church of the Light, 1987–89
Osaka, Japan

for the museum's memorial, a series of large photographs of the World Trade Center. Since the Japanese gallery of 1989–92, Ando has received a steady flow of museum commissions. Two are already built in this country in Fort Worth and St. Louis, another has been announced in the summer of 2003 for Williamstown, and one will grace an island in the Seine in a suburb of Paris. Other exhilarating museums await visitors to Japan.

As demonstrated by the Chicago gallery, Ando's museums emphasize boundaries, transitions, light, and darkness so that they become places "where you are allowed to reclaim yourself" and nurture the spirit.[48] Such values are also ideal for churches, and Ando has attracted attention for the several churches and one Buddhist temple that he has built in Japan. All are remarkable achievements, high art that is also profoundly spiritual. With concrete as his medium, Ando erects thick, substantial walls that screen out the world, create darkness, and carefully control light. In the case of the *Church of the Light* (fig. 9), that light bears a symbolic value. Judging from the photographs in recent monographs on Ando,[49] the church is situated in a crowded neighborhood of Osaka. At the rear of this simple rectangular box is a diagonal wall that intersects the rectangle, creating a triangular narthex. The wall continues outside until it meets a boundary wall that runs parallel to the opposite end of the church, the altar side.

Some natural light penetrates the dark interior at the back and on one side, but the principal light source is at the front, a cruciform opening unobstructed by supports. The nave floor slopes down to the altar; the congregation sits on rough-hewn benches that serve as pews. All is dark except for the mesmerizing cross, a cross of light that in this simple, quiet space, can only be the "Light of the World" proclaimed in the Gospels. Instead of the abstract paintings of the Rothko chapel or the carved crucifix of a traditional Catholic church, this congregation of the United Church of Christ contemplates light itself, nature architecturally transformed into symbol, not nature merely in harmony with architecture. As the sun crosses the sky throughout the day, the cross of light moves over the walls, the floor and the pews, sacralizing all and writing itself on everything and every person inside. Inspired by French Romanesque architecture,[50] Ando creates in the *Church of the Light* what he advocates for museums, a space that is perceived from the center out, where that center is not some abstract geometrical point, but the experience of each individual beholder.[51]

In the opinion of this art historian, Ando's churches are successful religious architecture that demonstrate that art and religion may still reinforce each other. Recent painting and sculpture are another matter. If one looks at what curators define as the finest art in America, for example, the Whitney Biennial of 2000, what little that can be considered even partially religious is connected with Asia. The most spiritual is Cai Guo-Qiang's project, "How is your Feng Shui?: Year 2000 Project for Manhattan," which "seeks to provoke people into reexamining their living environment and spiritual destiny."[52] A work that might have inspired political censorship, if the politicians had thought that there were votes to be won, is Michael Joo's "Visible," a headless Buddha in transparent urethane with the internal organs visible. The commentary that the artist wants to "lead viewers to the intersection of the physical

and the metaphysical" scarcely means that the work is religious, however.[53] Neither project approaches the impact and solemnity of the Church of the Light.

Like museums, recent art history has ignored Christian religious art of the present day, but a new discourse about art and religion is emerging that includes studies of the material culture and the architecture of Christian denominations,[54] as well as anthropological and sociological studies of religious communities.[55] Particularly relevant to the present essay is the new work by art historians and religion scholars. David Morgan and Brent Plate are two of the principal contributors to this scholarship, and their articles in our volume ably chart that literature. Because this is a new field, many possibilities and challenges await. The history of modern religious architecture needs to be documented and studied, and more fundamentally, the individual and corporate significance of art and religion must be probed.

Many questions remain. In what ways is the divorce of art and religion only one part of the larger dynamic of modernization, secularization, and differentiation, the process by which modern social entities separated from the religious sphere to create capitalism, the nation state, and a pluralistic society?[56] Just as governments have adapted religious rituals for secular purposes, has the museum become the secular church, an alternative site for the spiritual with ritual spaces of its own, as the Japanese gallery in Chicago would suggest? And is this why Tadao Ando can move so easily, it seems, between church and museum? Or does the museum, like science, the state, or the financial markets, function as if there is no God?[57] The then director of the National Gallery in London seemed to imply as much when he wrote recently that it was a place to look at Christian painting that appears "remote or daunting" to "most visitors of the National Gallery today, [who] like most of the population of Europe and America, are not believing Christians."[58] It is hard to imagine the same statement being made by an American museum director for several reasons, not the least of which is that it is not true.

Should churches become like museums and sponsor and collect what the art world considers significant work? Assuming that this is possible for media other than architecture, would visitors then expect access to the art, as if they were in a museum, thus disrupting the religious function of the building, the situation that already exists for art-filled churches in Italy or famous modernist churches in America?[59] If churches and their contents are acknowledged to be works of high art and thus of benefit to all society, as many are, does this give the state the right to intervene, when a congregation wants to replace a large old church that it can no longer afford to maintain with a smaller structure? In the mid-nineteenth century, monument preservation was often an act of secularization.[60] Need this always be the case, and can state and church create mutually satisfactory processes?

In sum, can the analysis of the rupture between art and religion contribute to both discourses? Do not these large broad concepts require detail and nuance? At present art and religion are accepted categories in the academy, each with its own departments and journals, but are they equivalent? Art is personal expression and social communication that, thanks to modernity, purports to be new, even though it may be traditional; religion is a system of belief and a social organization that claims

to be traditional, even when innovative. Art and religion are not defined and disciplined in the same way. The consequences of dissent and rejection are trivial and ephemeral to the artist, at worst career ending, but profound and perpetual for the religious believer condemned to eternal damnation. Is, therefore, the problem posed by this essay, especially its beginning, a consequence of its basic formulation, the equivalence implied by joining art and religion with the word "and"?

And what of those other categories evoked here, the public and the private, the secular and the religious? Do not both need renewed scrutiny, because they continue to interact in ways that older social science theories of secularization and modernization have not adequately addressed?[61] The problems then are surely challenging, if not daunting, but also potentially rewarding. Working through them will enable history and criticism to move beyond detached analysis and to assist artists and religious groups to find each other and collaborate meaningfully. It also will promote dialogue between the different religions and academic disciplines that share the same question: How does the material manifest the divine?

I thank Margaret Olin and David Morgan for their comments on this essay.

[1] Sally M. Promey, "The Public Display of Religion," in David Morgan and Sally M. Promey, eds., *The Visual Culture of American Religions* (Berkeley: University of California Press, 2001), 27, 31. For the polling data, see R. Stephen Warner, "Work in Progress toward a New Paradigm for the Sociological Study of Religion in the United States," *American Journal of Sociology*, 98 no. 5 (1993): 1046.

[2] More generally see W.J.T. Mitchell, ed., *Art and the Public Sphere* (Chicago: University of Chicago Press, 1992).

[3] S. Brent Plate, in *Religion, Art, and Visual Culture: A Cross-cultural Reader*, S. Brent Plate, ed., (New York: Palgrave, 2002), 1–6. Regarding a similar recent conflict in Moscow, *The New York Times* headline read "Art vs. Religion: Whose Rights Will Come First?", Sept. 2, 2003.

[4] See, for example, Nadia Abu El-Haj, *Facts on the Ground: Archaeological Practice and Territorial Self-fashioning in Israeli Society* (Chicago: University of Chicago Press, 2001); Tapati Guha-Thakurta, "Archaeology and the Monument: An Embattled Site of History and Memory in Contemporary India," in Robert S. Nelson and Margaret Olin, eds., *Monuments and Memory, Made and Unmade* (Chicago: University of Chicago Press, 2003), 233–257.

[5] E.g. Suzanne Preston Blier, *African Vodun: Art, Psychology, and Power* (Chicago: University of Chicago Press, 1995); Richard H. Davis, *Lives of Indian Images* (Princeton: Princeton University Press, 1997); Oleg Grabar, *The Formation of Islamic Art*, Rev. ed. (New Haven: Yale University Press, 1987). It has been suggested that this ascribing of religion to the Other is one aspect of modernism: Erika Doss, "Robert Gober's "Virgin" Installation: Issues of Spirituality in Contemporary American Art," in Morgan and Promey, *The Visual Culture*, 133.

[6] On the history of art history generally, see Heinrich Dilly, *Kunstgeschichte als Institution: Studien zur Geschichte einer Disziplin* (Frankfurt am Main: Suhrkamp, 1979); idem, *Deutsche Kunsthistoriker, 1933–1945* (Munich: Deutscher Kunstverlag, 1988); Udo Kultermann, *The History of Art History* (New York: Abaris Books, 1993); Germain Bazin, *Histoire de l'histoire de l'art de Vasari à nos jours* (Paris: A. Michel, 1986). On immigration in particular, see Karen Michels, *Transplantierte Kunstwissenschaft:*

Deutschsprachige Kunstgeschichte im amerikanischen Exil (Berlin: Akademie Verlag, 1999).

[7] Serge Guilbaut, *How New York Stole the Idea of Modern Art: Abstract Expressionism, Freedom, and the Cold War* (Chicago: University of Chicago Press, 1983).

[8] On the Gothic Revival generally, see Georg Germann, *Gothic Revival in Europe and Britain: Sources, Influences and Ideas* (Cambridge, MA: MIT Press, 1973), Paul Atterbury and Clive Wainwright, eds., *Pugin: A Gothic Passion* (New Haven: Yale University Press, 1994).

[9] Jeanne Halgren Kilde, *When Church Became Theatre: The Transformation of Evangelical Architecture and Worship in Nineteenth-Century America* (New York: Oxford University Press, 2002), 56–83.

[10] E.g. *Annales archéologiques* (1844–1881), *Revue de l'art chrétien* (1857–1914), and the still significant *Bulletin Monumental* (1834–present).

[11] For mid nineteenth-century German journals devoted to the study of Christian art, see Margaret Olin, *The Nation without Art: Examining Modern Discourses on Jewish Art* (Lincoln, NE: University of Nebraska Press, 2001), 209, n. 22. For England see Adele M. Ernstrom, "'Why should we be always looking back?' 'Christian Art' in nineteenth-century Historiography in Britain," *Art History* 22 (1999): 421–435.

[12] For Austria see Margaret Olin, "The Cult of Monuments as a State Religion in late 19th Century Austria," *Wiener Jahrbuch für Kunstgeschichte* 38 (1985): 181–182.

[13] Discussed in my forthcoming book, *Hagia Sophia, 1850–1950: Holy Wisdom, Modern Monument* (Chicago: University of Chicago Press, 2004).

[14] E. T. Cook and Alexander Wedderburn, eds., *The Works of John Ruskin*, vol. 10 (London: George Allen, 1904), 65. Ruskin's verbal transformation of these Catholic churches for Protestant readers is discussed most recently by Michael Wheeler, *Ruskin's God* (New York: Cambridge University Press, 1999), 73–97.

[15] *Works of John Ruskin*, vol. 10, 91–92.

[16] Ibid., 26.

[17] That Ruskin's religious attitudes about Catholicism may then have been more conflicted and changing than he expresses in print is the conclusion of Tim Hilton, *John Ruskin* (New Haven: Yale University Press, 2002), 168–169.

[18] J.B. Bullen, "Byzantinism and Modernism 1900–14," *The Burlington Magazine* 141 (Nov. 1999): 665–666.

[19] Julius Meier-Graefe, *Modern Art Being a Contribution to a New System of Aesthetics*, vol. 1 (New York: G.P.Putnam's Sons, 1908), 20.

[20] W. R. Lethaby, *Medieval Art, from the Peace of the Church to the Eve of the Renaissance, 312–1350* (New York: Nelson, 1904), 93. In yet another indication of the lingering impact of Ruskin, O.M. Dalton also pays tribute to *Stones* in his larger and more scholarly handbook on Byzantine Art: "the fine old Basilica of Torcello. . .is known to many who have never visited it from Ruskin's description in the *Stones of Venice*" (*Byzantine Art and Archaeology* [Oxford: Clarendon Press, 1911], 401).

[21] Carol Duncan, *Civilizing Rituals: Inside Public Art Museums* (New York: Routledge, 1995), 16–17.

[22] Clive Bell, *Art* (London: Chatto & Windus, 1916), 130.

[23] Ibid., 82.

[24] Ibid., 94.

[25] David Spaeth, *Mies van der Rohe* (New York: Rizzoli, 1985), 141–145.

[26] The history of the project is traced by Susan J. Barnes, *The Rothko Chapel: An Act of Faith* (Austin, TX: University of Texas Press, 1989).

[27] Clement Greenberg, *Arrogant Purpose, 1945–1949, The Collected Essays and Criticism,*

John O'Brian, ed., vol. 2 (Chicago: University of Chicago Press, 1986), 233. Greenberg's despiritualization of art is discussed in the important article of Donald Kuspit, "Reconsidering The Spiritual in Art," *Art Criticism* 17, no. 2 (2002): 59. True to his principles, Greenberg did not care for Kandinsky's more spiritual form of abstraction (Kuspit, 64).

28 Barnes, *Rothko Chapel*, 31–35; Sheldon Nodelman, *The Rothko Chapel Paintings: Origins, Structure, Meaning* (Austin, TX: University of Texas Press, 1997), 33–4.

29 Dominique de Menil, in Henri Matisse, M.-A. Couturier, L.-B. Rayssiguier, *The Vence Chapel: The Archive of Creation* (Milan: Skira, 2003), 7.

30 Barnes, 7–8.

31 Nodelman, *Rothko Chapel*, 9, 92–3.

32 Barnes, 44, 67.

33 Ibid., 105–108.

34 Ibid., 106.

35 E.H. Gombrich, *The Story of Art I* (New York: Phaidon, 1950), 2, 5.

36 F. Antal, "Remarks on the Method of Art History: I," *The Burlington Magazine* 91 (1949): 50.

37 Christopher S. Wood, "Art History's Normative Renaissance," in *The Italian Renaissance in the Twentieth Century*, ed. by Allen J. Grieco, et al. (Florence: Olschki, 2002), 65–92.

38 "Three Decades of Art History in the United States: Impressions of a Transplanted European," reprinted in *Meaning the Visual Arts* (Garden City, NY: Doubleday, 1955), 321–346.

39 Sigfried Giedion, *Space, Time and Architecture: The Growth of a New Tradition* (Cambridge, MA: Harvard University Press, 1941), 248, 275, figs. 142, 156.

40 *Space, Time and Architecture*, 5th ed., ninth printing, 1980, 569–78, figs. 337–44.

41 André Malraux, *Les voix du silence* (Paris: NRJ, 1951), 11–14.

42 Pierre Galante, *Malraux* (New York: Cowles Book Co., 1971), between pp. 144 and 145. Jean-Marie Domenach, et. al. [*Malraux* (Paris: Gallimard, 1979), 197] reports that the book being prepared is *Des bas-reliefs aux grottes sacrées*, which is the subtitle of *Le musée imaginaire de la sculpture mondiale* in the edition of 1954.

43 Robert S. Nelson, "The Map of Art History," *The Art Bulletin*, 79 (1997): 36–39. Gombrich criticized the conventionality of other aspects of Malraux's work, preferring "footnotes to fireworks and daylight to dusk": "Malraux on Art and Myth," in his *Reflections on the History of Art: Views and Reviews* (Berkeley: University of California Press, 1987), 218–220.

44 The Prince of Wales, "Accent on Architecture," address to the American Institute of Architects, the National Building Museum, Washington, USA, February 22, 1990, available through the web site for the Prince of Wales: http://www.princeofwales.gov.uk/speeches/architecture_22021990.html

45 Michael S. Rose, *Ugly as Sin: Why They Changed Our Churches From Sacred Places to Meeting Spaces and How We Can Change Them Back Again* (Manchester, NH: Sophia Institute Press, 2001),

46 Tom Wolfe, in Frederick Hart, Homan Potterton, and Tom Wolfe, *Frederick Hart Sculptor* (New York: Hudson Hills Press, 1994), 12–16.

47 Ando's work can be surveyed in Francesco Dal Co, *Tadao Ando: Complete Works* (London: Phaidon, 1995); Tom Heneghan, *The Colours of Light: Tadao Ando Architecture* (London: Phaidon, 1996); Werner Blaser, *Tadao Ando: Architektur der Stille Architecture of Silence* (Boston: Birkhäuser, 2001).

48 Michael Auping, *Seven Interviews with Tadao Ando* (Lingfield, Surrey: Third Millennium Publishing, 2002), 22.

49 Masao Furuyama, *Tadao Ando* (Boston: Birkhäuser, 1996), 148–149; Dal Co, *Tadao Ando*, 318–321; and especially the discussion of Ando's churches by Philip Drew in *Places of Worship* (London: Phaidon, 1999).

[50] Yann Nussaume, *Tadao Andô et la question du milieu: réflexions sur l'architecture et le paysage* (Paris: Moniteur, 1999), 244.

[51] Auping, *Seven Interviews*, 37.

[52] Maxwell L. Anderson, et al., *Whitney Biennial: 2000 Biennial Exhibition* (New York: Whitney Museum of American Art, 2000), 68–69.

[53] Ibid., 136–137. In the Biennial for 2002, a few more works deal with religion or religious subjects. The most religious work, the video of Christian Jankowski, *Holy Artwork*, is about religion, but not actually religious itself, I would argue, even though it was shown as if it were an actual church service. See Lawrence R. Rinder, et al., *2002 Biennial Exhibition* (New York: Whitney Museum of American Art, 2002), 114–115, and 22–23, 206–207 for other relevant material. I thank David Morgan for directing me to the Jankowski's video.

[54] E.g. Colleen McDannell, *Material Christianity: Religion and Popular Culture in America* (New Haven: Yale University Press, 1995); Paul Eli Ivey, *Prayers in Stone: Christian Science Architecture in the United States, 1894–1930* (Urbana, IL: University of Illinois Press, 1999).

[55] E.g. Robert Anthony Orsi, *The Madonna of 115th Street: Faith and Community in Italian Harlem, 1880–1950* (New Haven: Yale University Press, 1985); Robert A. Orsi, ed., *Gods of the City: Religion and the American Urban Landscape* (Bloomington, IN: Indiana University Press, 1999).

[56] See the general discussion in José Casanova, *Public Religions in the Modern World* (Chicago: University of Chicago Press, 1994), 11–39.

[57] Ibid., 40.

[58] Neil MacGregor, *Seeing Salvation: Images of Christ in Art* (New Haven: Yale University Press, 2000), 7.

[59] One example would be the Greek Orthodox Church of the Annunciation in Milwaukee, designed by Frank Lloyd Wright. I have written about a recent dispute between its priest and the architectural community in "Signs of the Times: Modernist Churches in the Greek Orthodox Diocese of Chicago," *Criterion* 40 (2001): 16–23; and in the forthcoming *Hagia Sophia 1850–1950: Holy Wisdom Modern Monument*.

[60] See Olin, "The Cult of Monuments," 177–198.

[61] See, for example, Talal Asad, *Formations of the Secular: Christianity, Islam, Modernity* (Stanford: Stanford University Press, 2003). It is important in this regard to distinguish between Europe and America. Where the art world is now continuous, the religious experience differs sharply. On the evolving study of the American situation, see Warner, "Work in Progress," 1044–93.

religion
on a pedestal:
exhibiting
sacred art

Ena Giurescu Heller

In their historic presentation of art and artifacts, museums have largely followed in the footsteps of the academy. If Ruskin advised his readers to go to the churches of Venice after Mass, so they could appreciate the architecture and art without being encumbered by unfamiliar ritual and the presence of those who are there for reasons other than aesthetic appreciation, museums have often tried to display religious art as art whose religious function and meaning are at best secondary.[1] An undeniable reluctance to interpret the religious component of art continues to exist today. Generally in our society, people are uncomfortable to discuss and sometimes even to look at objects intimately connected with religious practice. What, then, is the mandate of museums for interpreting religious art today? What are the restrictions, spoken and unspoken? How do we, as museum professionals, present religious artifacts to the general public? How can we educate our visitors and expose them to the religious significance of art without making them uncomfortable, offending their beliefs, or simply putting them off? This essay, by addressing these questions, hopes to sketch a framework for a more comprehensive—and much needed—study of contemporary museums' discourse on religious art.[2]

MUSEUMS AND RELIGIOUS ART

Recent research has pointed out that museums tend to ignore, misinterpret or have difficulty discussing religion.[3] The difficulty stems from the very personal—and charged—character of religious feeling, and, at the institutional level, the fear of being perceived as favoring one religious tradition, or even proselytizing. The balance between, at one end of the spectrum, not addressing the issue, and, at the other end, an interpretive approach which may appear overzealous, is hard to achieve. Reconstructing the ritual use and function of objects when they are removed from their original context is an additional challenge: museums are hard-pressed to find a happy medium between the explanation of iconography and art historical background, and that of the religious ritual in which the object was once central.

During a recent exhibition on Hinduism at the Museum of Natural History in New York, some visitors commented that the display was "too religious" and "did not belong in this museum."[4] Such comments are indicative of a widespread mentality. Many scholars and museum professionals talk about the reticence of museums (especially in the United States, Canada, and Australia) to discuss religious

art, and attribute it to our democratic system and pluralistic religious landscape.[5] Yet since so much of the collections of major museums is art that was used for religious ritual, or embodies religious symbolism, its display and interpretation does indeed tend to isolate the aesthetic object from the religious background without which it would not have existed originally. This is not to purposefully mislead the public, but rather to be more inclusive and insure that the public—or certain portions of it— is not made uncomfortable by an open discourse on faith, religious beliefs and ritual practices. In the Smithsonian Institution's Traveling Exhibitions Services catalog, there are headings for: art, children's exhibitions, history and culture, and science. Under these general headings there are subcategories for gender studies, maritime history, sports and pastimes, but none for religion, religious studies, or religious art. And those exhibitions which include religious art and culture are described in a language devoid of specialized terminology, and even of references to the sacred framework of objects and customs.[6]

In one of the traditional academic approaches to the study of art and religion, discussed by David Morgan in this volume, art is almost always subordinated to religion.[7] The opposite is often true of museums, where religion is subordinated to, and often completely obscured by, art. Do museums, then, purposefully take the religion out of art, in order to make the art more accessible, less problematic, and more appealing?[8] The answer to this question depends on the specifics of museums, and on factors such as the type of museum, its mission, as well as particulars of the collection, and sources of funding. A publicly funded museum dedicated to modern art, for instance, will tackle the presentation of religious art differently than a privately endowed museum of medieval art and architecture.

Generally speaking, we need to be mindful of the fact that works of art in our museums no longer fulfill their religious function: they are there not to glorify God, but rather to illustrate the narrative of human artistic achievement.[9] Museums display these works as cultural artifacts rather than religious art, and install them according to the chronology of styles and cultural geography. The mission of most museums centers on collecting, preserving and interpreting works of art, and even when an important percentage of a museum's collection represents religious art, interpreting the religion behind the art is not necessarily part of the mandate. Since public museums cannot present art as a vehicle to religion in a way that may be interpreted as proselytizing, the emphasis is on the artistic qualities of works rather than the thematic religious message or function. Far from being a new development, this is a consequence of the history of American collecting and nineteenth-century aestheticism. According to James Clifton, "this aestheticization of the sacred is at the heart of the modern museum's presentation of religious art in general, and Christian art of the West in particular."[10] Today many curators at large museums acknowledge the fact that often works of art in their collections beg new interpretations. According to Charles Little of the Metropolitan Museum of Art, we are at the point where "we have to ask that next question in our understanding of the works of art, the question regarding their message." A purposeful analysis of their original message and religious dimension would be welcome, especially as it may bring in new audiences.

MARKETING OF RELIGIOUS ART

A common theme in the literature on the relationship between art and religion in our society is the concept of an obvious split, or bifurcation, between religious practice and artistic images.[11] Both worlds see their coexistence with the other as problematic. In a worship space, the presence of art may be perceived as distracting, or competing with the service itself. Conversely, museum exhibitions that are designated as "religious" routinely attract less people than other exhibitions.

In the fall of 2002 the Cathedral of St. John the Divine in New York City presented an exhibition organized by the Province of Castille-Léon, with the participation of the regional Roman Catholic church in Spain, titled *Ages of Mankind: A Time to Hope*. The exhibition, which did not follow traditional museological criteria and had a distinct religious feel, was structured to present the life of Christ as an eschatological narrative told through a survey of Spanish religious art from the Middle Ages through the eighteenth century.[12] The organizers of the exhibition, which did not travel to other US venues, purposefully chose to not show it in a museum but in a religious building. Implied in their choice was the suggestion that a church sponsor could present devotional objects in a way that museums rarely do. When the exhibition was reviewed in *The New York Times*, the publicist for Castille-Léon was quoted as deploring the very scant press attention that it had received up to that point, and consequently the small number of visitors: "Here you have museum quality art in a beautiful setting and it's free. Maybe because it's too religious. Maybe it would be different if it were in midtown. It certainly would be different if it were in the Metropolitan Museum."[13]

One of the tacit assumptions in the museum world is that exhibitions of religious art are not very sellable. Ronne Hartfield, who served as Executive Director of Museum Education at the Art Institute of Chicago for the last decade, summarized it well: "A lot of people think a good museum experience cannot be too serious. I think a lot of people think that a good religious experience cannot be too much fun." It also seems that the general public is largely uninterested in the religious back-ground or function of the works—and in religion more generally. Educators from The Cloisters, the medieval branch of the Metropolitan Museum of Art in New York City, have reported that the public is always more interested in artistic issues than in religious ones. An exception is made by those religious stories, especially saints' legends, whose moralizing values are of interest to visitors in general and school groups in particular. Research done by colleagues at The Jewish Museum has similarly shown that in the current social climate, Jewish religious art in its narrowest sense is not a public draw; placing it in a social or historical context, however, makes it more attractive to a wider public.

When we at The Gallery at the American Bible Society set out to travel our exhibition *Icons or Portraits? Images of Jesus and Mary from the Collection of Michael Hall*, (fig. 1) some of the museums to which we sent inquiries were not interested because of the overtly religious character of the art.[14] At the same time, at least one of the venues to which it did travel changed our didactics quite significantly, eliminating biblical passages and references, while underscoring the aesthetic analysis of the objects.

The same happened with the traveling exhibition *Angels from the Vatican: The Invisible Made Visible*.[15] The exhibition was shown in three different venues in the United States, and each of them treated the installation in a dramatically different fashion. One of the installations favored an openly devotional interpretation, and even the narrative on the audio guide assumed a certain familiarity with Catholic ritual and devotion. Another overcompensated in the opposite direction and deemphasized the religious aspects to such an extent that the message of the exhibition was obscured. Yet another rethought the presentation, rearranged the layout and found the right balance, making the exhibition both enriching and acceptable in a publicly supported museum.

A colleague shared with me his experience when he presented to the board of trustees a Baroque altarpiece he was considering acquiring. They had been specifically looking for an altarpiece to fill a gap in the collection, and when my colleague found one available that matched their criteria, one of the trustees replied: "But we already have so much religious art!" This anecdote illustrates a more common perception: if only we could have non-religious altarpieces!

Figure 1
Installation View
Icons or Portraits? Images of Jesus and Mary from the Collection
of Michael Hall
The Gallery at the American Bible Society, New York, 2002

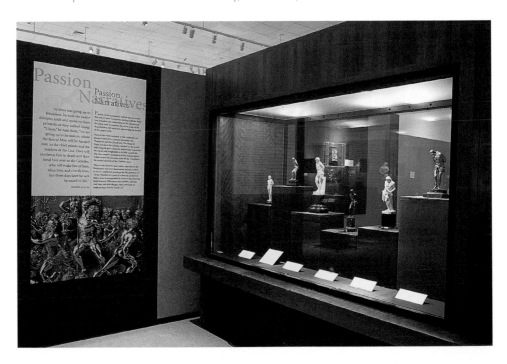

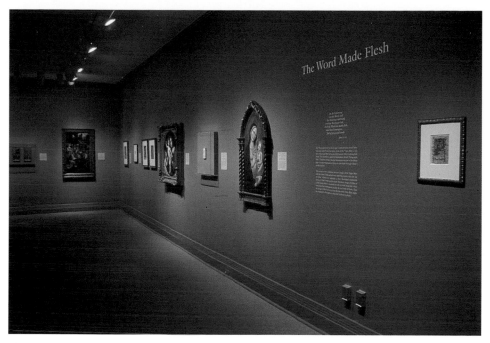

Figure 2
Installation View
The Body of Christ in the Art of Europe and New Spain, 1150–1800
The Museum of Fine Arts, Houston, 1997/98

NEW TRENDS IN EXHIBITING RELIGIOUS ART

Although the fundamental issue of resistance to presenting overtly religious art to a general public continues to exist, recently there have been significant changes. The trend seems to have turned somewhat. Speakers at the symposia *New Directions in the Study of Art and Religion,* organized by The Gallery at the American Bible Society, characterized the last decade as "a golden age of exhibitions devoted to religious art." An unprecedented number of exhibitions with overt religious themes and symbolism have received critical acclaim and attracted record number of visitors.[16] The exhibition *The Image of Christ,* organized by the National Gallery in London in 2000, marked a milestone, since prior to that date few museums of the National Gallery's stature had presented Christian subject matter with an emphasis on the religious.[17] What started as an exhibition project that encountered resistance even from some of the museum's own staff turned out to be the most attended exhibition in the United Kingdom in the year 2000, attracting over 350,000 people in a ten-week run. Its immense popularity attested to the fact that there is a real market for exhibitions that analyze works of art as vessels of belief, and seriously consider their religious significance and symbolism. The year 2000 also saw an analysis of the history of representations of Christ in art on this side of the Atlantic, in the exhibition *Anno Domini: Jesus through the Centuries.*[18] Organized by the Provincial

Museum of Alberta, the exhibition explored visually the history sketched by Jaroslav Pelikan in his seminal study on Jesus.[19] The exhibition was extraordinarily successful and the catalog sold out in record time.

In the United States, one of the most important exhibitions that illustrates this new approach actually preceded *Seeing Salvation*. *The Body of Christ in the Art of Europe and New Spain, 1150–1800*, organized by The Museum of Fine Arts, Houston, was on display between December 21, 1997 and April 12, 1998. The exhibition recognized the "aestheticization of the sacred in the modern museum's presentation of religious art," and intentionally set out to redress the balance between aesthetic and religious. [20] Instead of the usual grouping by style, school, or chronology, the works were displayed under the following thematic headings: *The Word Made Flesh*; *Suffering and Triumph*; *The Eucharistic Body*; and *The Visionary and Devotional Body* (fig. 2). The catalog entries achieve a rare balance between art historical research, connoisseurship, and analysis of textual (mainly Biblical) sources and Christian iconography. Even the planning of the exhibition took into account the liturgical calendar, opening right before Christmas and closing around Easter. The intention on the part of the museum was to re-contextualize Christian images for the American public, presenting them in a way that would shed light on their original function and meaning. This interpretation would add to the more familiar aesthetic notions, and together would offer a more complete understanding of these works of art.

This approach, to be sure, was a leap of faith on the part of a publicly funded museum. But the gamble paid off: the exhibition was a huge success by local standards, attracting more than 125,000 visitors. More significantly than numbers alone, the several hundreds of pages of visitors' comments in the guest book attested to the fact that the exhibition touched a large number of people in a significant way. Many of these visitors were new to the museum, and had been drawn specifically by the subject matter. What was unusual for the museum was that part of the public voiced their reaction to the exhibition in terms foreign to the usual language of visitors' feedback. The exhibition was judged in turn as moving, inspirational, humbling, powerful, inspiring, uplifting. Some even characterized their visit as "truly a worship experience," and the museum environment, as "a place where it is easy to pray."[21] Unusual as these comments are for any public museum, they were appreciated by the organizers of the exhibitions, who took them to mean that their goal was attained. The exhibition showed that the museum could become a place where people engage spiritually with works of art. In the words of the curator, "as an art museum it is our concern to bring as many people as possible to as profound an engagement as possible with works of art, as well as to reach an audience that otherwise might not come to the museum." *The Body of Christ* achieved both, and expanded the concept of engagement to include a segment of the public for whom aesthetic appreciation was, at best, secondary (fig. 3).[22]

Many of the exhibitions that have brought into focus the issue of exhibiting religious, and specifically Christian, art in public museums have focused on the art of the Middle Ages. This is not a new phenomenon, as by nature of its patronage, subject matter and symbolism medieval art has always been linked intrinsically to religion.

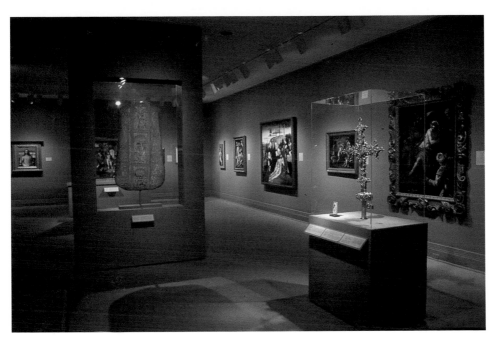

Figure 3
Installation View
The Body of Christ in the Art of Europe and New Spain, 1150–1800
The Museum of Fine Arts, Houston, 1997/98

Consequently, scholarship on medieval art—as carried out both in the academy and museums—has been in the forefront of the discourse on art and religion. Yet in recent years the trend extends beyond the art of the Middle Ages. Other artistic subjects have now joined medieval art in the public dialogue about religious art. In some instances, the art was chosen as representative of local communities, in order to highlight the religious traditions of various ethnic or religious groups. This resulted in exhibitions of unexpected diversity, and sometimes of surprising subject matter. The Cleveland State University Art Gallery, for instance, has had since 1990 a series of exhibitions of sacred art which explored the religious heritage of Cleveland.[23] The Indianapolis Museum of Art hosted in 1998 an exhibition of a five-year documentary photography project at a local Baptist church with a largely African-American congregation.[24] The Newark Museum organized in 1997 an exhibition dedicated to the devotion to the Virgin Mary in the arts of Portugal, targeting the large Portuguese-American community in the area.[25] With the success of these, and other similar exhibitions, public museums have learned the value of opening their doors to exhibitions on religious themes and symbolism. The leadership of the Provincial Museum of Alberta, which hosted the above-mentioned *Anno Domini* exhibition, further recognized the importance of a dialogue about religious art as "…an ideal means to reduce ignorance and prejudice, and, with luck, foster conversations between groups that would never otherwise cross paths."[26]

The unprecedented number of exhibitions dedicated to religious art and culture has not gone unnoticed in the press. Georgette Gouveia, an arts and culture

writer with the Gannett Group, reported that the general attitude of the press regarding religion in general, and religious art in particular, has changed in the last ten years.[27] Traditionally in the media, "there was fear of offending, and fear of not getting it right, as well as the sense that religion just wasn't sexy." Now many newspapers are taking the subject of religion seriously, staffing professional and often acclaimed writers, and generally devoting more attention to the subject. This is a tacit acknowledgement that there is public interest in religion—perhaps more so than ten or twenty years ago.

Other more subtle changes are also occurring. A colleague who has been on the board for reviewing submissions for the Cleveland Museum of Art regional show, for instance, reported that twenty years ago, very few of the works submitted would have had any religious dimension. Today, however, many do—including quite a few with overt religious, and specifically biblical, symbolism. At the Metropolitan Museum of Art in New York, works in the medieval collection have been reinstalled in recent years in a more contextualized setting. The lectern by Giovanni Pisano from Pistoia Cathedral, for instance, which was at one time placed on the wall "like a postage stamp," is now presented in space to give a sense of how it might have functioned originally. In 1991 the Getty Trust sponsored a study of visitors' attitudes, expectations, and experiences in eleven North American museums, which revealed that one of the more common complaints of the museum public is lack of understanding of the works of art.[28] More readily available information was advocated, including interpretive didactics. The Art Institute of Chicago, which was one of the museums featured by the study, took this advice to heart and reinstalled El Greco's Assumption in a way that suggests an altarpiece setting (fig. 4), thus providing the historical context for the piece.

A similar transformation on a larger scale is currently occurring at The Jewish Museum in New York.[29] The origins of the museum go back to the 1904 gift of twenty-six objects of ceremonial and fine arts given by Judge Meyer Salzberger to the Library of the Jewish Theological Seminary, with the hope that they would serve as "a suggestion for the establishment of a Jewish Museum." The museum, originally known as The Museum of Ceremonial Objects, and housed in a room at the Jewish Theological Seminary, has long since changed its name, moved to its own building, and developed a remarkable and comprehensive collection. Ceremonial art dating primarily from the eighteenth through the twentieth centuries continues to represent

the largest percentage of this collection, which also includes fine arts, an archive of television and radio, decorative art with Jewish content, Jewish antiquities, and coins and medals. And yet, looking at the schedule of exhibitions in any given year, the number of Judaica exhibitions is disproportionately small. According to curator Susan Braunstein, this is largely due to the perception that exhibitions of ceremonial objects are not "where the excitement lies" and do not attract large audiences. The Jewish Museum, like many other museums today, is particularly concerned about expanding and diversifying its audience, and the consensus is that the Judaica collection is not going to contribute significantly to that process. At least, not in the way it has been traditionally displayed. New, fresh perspectives and contemporary issues need to be brought into exhibiting ritual art. According to Braunstein, "new methods of presenting and interpreting religious art that speak to contemporary issues need to be found, since eliminating religious art from the programs of the Jewish Museum would remove its soul, the foundation on which all other aspects of Jewish identity have been built." Acknowledging that, Jewish Museum curators have engaged in a process of redefining and reinterpreting the collection and "reinventing" the ways in which it can engage with its public. The process will result in an exhibition on reinventing ritual in the contemporary world. The goal of the curators is twofold: to increase knowledge and appreciation of Jewish ceremonial art both within and outside of the ritual for which it was created; and to affirm a greater resonance that religious art in general, and liturgical art in particular, can have for the contemporary society.

SPECIALIZED MUSEUMS

In recent years a number of museums dedicated specifically to religious art have been founded in the United States. One of the pioneers of this movement is the Museum of Contemporary Religious Art (MoCRA) at St. Louis University.[30] The museum's mission is to create a dialogue between contemporary artists and the great religious traditions, and to provide a forum for learning about and understanding each other's traditions. In its ten years of existence the museum has celebrated artists of various faiths, as well as artists of no particular religious affiliation. Acknowledging the fact that it is impossible to be all-inclusive in every exhibition, Terrence Dempsey, S.J., the founding director of MoCRA, argues that the responsibility of the museum is "…to be open to how the spirit is moving in our time and to find those artists who can articulate this movement in ways that illuminate rather than illustrate." Its exhibitions are very much shaped by the space which houses them, as the museum occupies a former chapel for the Jesuits preparing for priesthood or brotherhood (fig. 5). The main gallery (the former nave of the chapel) is flanked by six side chapels on either side, a sanctuary at one end and a balcony at the other. Exhibiting contemporary art in this space is very different than exhibiting it in a modern, neutral space. The space has certain religious connotations by nature of its architecture—the distinct architecture of a Christian worship space. According to Father Dempsey, "the sacred character, or feeling, of the space provides viewers with an access into the work."

The installations take advantage of and at the same time try to augment this special character of the space. Labels are short; additional information about the works is provided in brochures for those visitors who wish to read more. The director emphasizes the fact that visitors are encouraged to have their own personal experience: information is available but one does not have to read it; staff is present to answer potential questions but tries not to be intrusive. Comfortable chairs throughout the space make the unspoken invitation to stay for a while. Many visitors accept the invitation and stay for hours at a time, which is a relatively long time for a small exhibition space.

The success of MoCRA suggests that its exhibitions have responded to a certain need felt by our society. Elsewhere in the United States, a number of other museums dedicated to exploring religious art in its various guises have been founded in the last decade. The John Paul II Center in Washington, DC; The Gallery at the American Bible Society in New York City; The Heartland Orthodox Christian Museum in Topeka, KA, are only a few examples.[31] These museums contribute to a new, intentional dialogue about the intersection of art and religion and the way it should be presented to a general public.

Surely, other museums have been doing that all along. Hebrew Union College – Jewish Institute of Religion Museum in New York City, for instance, traces its history to the early years of the College (fig. 6).[32] Founded in 1875, Hebrew Union College – Jewish Institute of Religion is the oldest institution of higher Jewish education in the United States and the academic, spiritual, and professional development center of Reform Judaism. From early on the seminary recognized that Jewish material culture was an essential resource for the liberal study of Judaism and the professional training of clergy and scholars, which led to the development of both libraries and art and artifact collections.[33] By the 1920s the college's collections comprised Jewish ceremonial objects, graphic art, tapestries, ceramics, carvings, and illuminated manuscripts; today their collection of Judaica is one of the two most important and extensive in this country. In the last three decades the mission of the New York museum has expanded beyond the faculty and student community to include outreach to the general public of all faiths. The exhibitions of the Hebrew Union College – Jewish Institute of Religion Museum provide, in the words of its director,

> ...a window into Jewish life, history, culture, civilization, and values and provide
> an infinite range of learning possibilities for both students, scholars, and the
> public, that encourage Jewish spiritual and cultural continuity as well as interfaith
> and multi-ethnic understanding. Our collections and permanent collections are
> intended to promote Jewish practice and continuity, advance understanding
> of Jewish history and culture, and demonstrate Judaism's relationship to the host
> cultures in which we dwell, instill Jewish values of remembrance, tolerance and
> social justice.

The museum has also spearheaded an innovative program which engages contemporary artists "seeking to express Jewish spirituality, experience, and identity." Its core

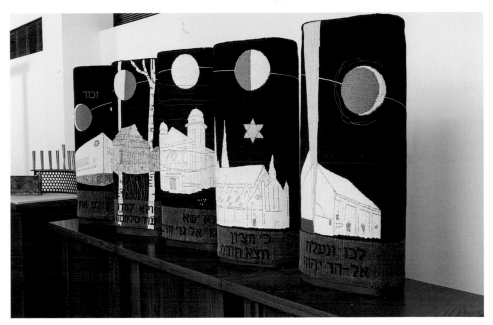

Figure 7
Carol Minarick and Geri Forkner
Lost Synagogues of Europe: Zoppot,Poland; Plauen, Germany; Wolpa, Lithuania;
Rohancs, Hungary; and Ceske Budojovice, Czechoslovakia, 2000
Set of Five Torah mantles; cotton, linen, silk, metallic thread

exhibition, titled *Living in the Moment: Contemporary Artists Celebrate Jewish Time*,
includes works that demonstrate the Jewish values of *hiddur mitzvah* (the beautification
of the fulfillment of the commandments of the Torah). Alongside traditional liturgical
objects, the museum is also asking artists to create new objects (fig. 7) that could
be used in conjunction with modern celebrations and commemorations (related, for
instance, to the commemoration of the Holocaust, the celebration of the Jewish
state, and various ceremonies marking women's lives and new roles in society).
For either category of objects, by asking artists to create modern and personal inter-
pretations, the museum achieves at least two important things. On the one hand,
it provides a catalyst for the creation of quality Jewish religious art by contemporary
artists, and a rare forum for their display.[34] On the other hand, it educates the public
about the significance of the objects, and dispels myths of the mutual exclusion
between religion and contemporary art. Through this program, Hebrew Union
College – Jewish Institute of Religion Museum acknowledges and at the same time
makes a significant contribution to the recent dialogue about art, religion, and
museums. Through the vocabulary of modern art, the ritual objects included in their
installations may even argue that religious art can indeed be exciting!

One of the reasons why Hebrew Union College – Jewish Institute of Religion
Museum, and Jewish museums more generally, have thrived is the fact that they are
very self-conscious about their primary function as educational institutions. Any museum

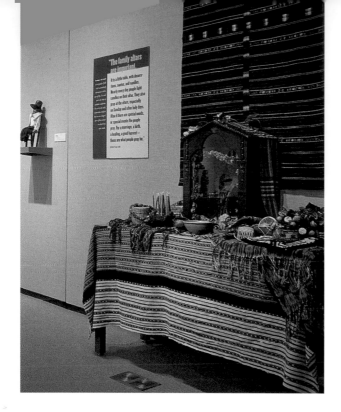

Figure 8
Installation view with
detail of house altar
Devócion del Pueblo:
Religious Folk Art of
Guatemala
The Gallery at the
American Bible Society
New York, 2001

Figure 9
Installation view with visitor
The Holy Art of Imperial Russia
The Gallery at the American Bible Society, New York, 1999

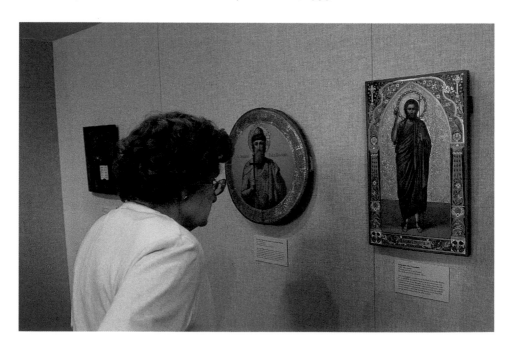

dedicated to exploring the relationship between art and faith, and re-contextualizing religious works of art for a deeper understanding of their multi-faceted meaning, needs to do the same in order to be meaningful to its constituents, and thus successful as an institution.

CONTEXTUALIZING RELIGIOUS ART

The success of museums and exhibitions that highlight the religious context, function and symbolism of art indicates a need in our society for a new look at the role and place of religion in art. The exhibition on Hinduism at the Museum of Natural History—the same exhibition which made certain visitors uncomfortable—was, overall, extraordinarily successful.[35] One of the best, albeit unorthodox, ways to assess its success—aside from the usual museum metrics such as visitor numbers and sold catalogs—is to know its impact on individuals. Much of it is learned through anecdotal evidence and is hard to report and analyze. At the Natural History Museum, for instance, a museum employee went to her supervisor to ask if it would be okay to make an offering in front of one of the statues included in the exhibit. The exhibition had touched her personally, and she felt that the statues spoke of a communication with God in which she wanted to participate. A few years ago at The Gallery at the American Bible Society, during an exhibition of Guatemalan *Santos*, we often had to remove money from a replica of a house altar we constructed in the gallery (fig. 8). Curators at the Metropolitan Museum of Art had the same experience, occasionally finding offerings on various altarpieces (especially those dedicated to the Madonna); such offerings increased throughout the museum in the wake of September 11th.

These incidents bring up the larger question of museums and the lived religion. Do they, or should they, ever intersect? It seems that conflict often arises when they do intersect. During the exhibition *The Year 1200* at The Cloisters, a professor and group of students from General Theological Seminary performed the reconstructed medieval Mass of St. Thomas Beckett in the museum.[36] This isolated event met with a lot of criticism from both camps. It is unclear which was condemned more: that a public institution would be choreographing a religious ceremony, or that it would be held in a non-consecrated space. From a museum curator's point of view, however, this was clearly an attempt to bring alive the medieval liturgical objects on display, by recreating the context in which they functioned originally. Other times, the connection with lived religion is made by the public, not the organizers of the exhibition. At The Gallery at the American Bible Society, during an exhibition of Russian icons, visitors prayed in front of the icons and routinely tried to touch them, according to the Orthodox custom (fig. 9). A few of them became visibly upset when the security guard asked them to please refrain from touching the objects on display, as The Gallery is a museum and not a place of worship. Clearly, not being able to interact with the icons in the way they do routinely in their churches or homes interfered with their experience of this particular exhibition.

At the Art Institute of Chicago, after a visit to an exhibition of sacred textiles by a group of Protestant ministers, one of them told the curator who was accompanying

them that it had been such a wonderful experience, and that they should have a prayer service before they left. Which they did, and in the words of Ronne Hartfield, "…it was an amazing experience, and a very important one because it highlighted the fact that the commonly perceived split between engagement with a work of art, and religious engagement, simply does not exist for certain people. This should be a powerful learning experience for museums."[37]

As museum professionals we can certainly learn from such incidents, and need to be increasingly sensitive to a balanced presentation of religious objects in museums. Yet we also need to be mindful that a museum is not, and cannot become, an approximation of the original context of these artworks, and that delving into religious ritual within the framework of museum exhibitions can be problematic. Not only in the way that it can interfere, as stated above, with the primary mission of most museums, but also because it may run the risk of becoming exclusionary. And the risks are clearly higher with majority religions. While a minority religion performing a little-known ritual in a museum is more easily accepted as anthropologically interesting, if one of the majority religions enacts its ritual in the same space, it is immediately construed as exclusionary. Moreover, too much context may hinder the encounter with the actual object. Finding the right tone—and length—for exhibition didactics is a major issue in museology today.[38] As veteran museum educator Ronne Hartfield pointed out, "you want people to see what is in front of them and not just spend their entire time looking at huge labels and huge amounts of wall text."

The issue of context is indicative of the dialogue about religious art more generally. As this essay has attempted to sketch, exhibiting and interpreting religious art in our museums today continues to be fraught with difficulty. Are we, as a society, comfortable or uneasy with the display of religious art? I believe that the answer is yes to both questions. We can be comfortable, or at least more so than we were ten years ago, but we also continue to be slightly uneasy. Yet as recent years have witnessed an increased dialogue, through both exhibitions and publications, the momentum is clearly building. It is up to those of us in the field to take advantage of it. Museums are ideally positioned to advance this dialogue, as they bridge the worlds of religion, art, and scholarship. Without endorsing any one particular religious belief, museums can be respectful of all traditions, and create a unique environment in which visitors learn about the original context, meaning and functions of religious art. Through thoughtfully presented exhibitions, public programs and education, museums may be able to convey the enriching aspects of art not only aesthetically, but also from the point of view of religious life and history.

1 See Robert Nelson's essay in this volume.

2 This essay was informed and inspired by two of the sessions we held at the Gallery at the American Bible Society in 2002 and 2003 (see Appendix A). I am grateful to all the panelists and participants to those sessions for their insightful presentations; special thanks go to Susan Braunstein; James Clifton; Terrence Dempsey, S.J.; Georgette Gouveia; Rabbi Shirley Idelson; Ronne Hartfield; Charles Little; Gustav Niebuhr; Jean Bloch Rosensaft. I am particularly indebted to David Morgan and Patricia Pongracz for reading early drafts of this essay.

3 Crispin Paine, ed., *Godly Things. Museums, Objects and Religion*, (London: Leicester University Press, 2000), esp. xiii–xvii and essay by Chris Arthur, "Exhibiting the Sacred," 1–27. See also Carol Duncan, *Civilizing Rituals: Inside Public Art Museums* (New York: Routledge, 1995): 7–20.

4 *Meeting God: Elements of Hindu Devotion*, American Museum of Natural History, September 8, 2001–March 31, 2002.

5 Paine, *Godly Things*, 52

6 In a recent SITES catalog, for instance, the exhibition on "Puerto Rico's Carnival Tradition" is presented as documenting "the rich tradition of carnival, the celebration leading up to Lent," and "an expression of Puerto Rican culture and identity," without mention about religion and its role in defining the said culture and identity. This is not unusual considering the Smithsonian's status as a federally-funded institution.

7 See page 19 in this volume on the "evolutionary approach."

8 This is also reflected in the marketing of exhibitions by the press. The exhibition *Divine Mirrors*, dedicated to images of the Virgin Mary, was described in The New York Times as an exhibition "exploring the changing images of the feminine ideal in art" (The New York Times, August 17, 2001, under the heading "A Universe of Art, Centered in Boston").

9 I thank Charles Little for his insightful presentation on the challenges of exhibiting religious art in an encyclopedic museum such as the Metropolitan Museum of Art. Even a museum specifically dedicated to religion, the St. Mungo Museum in Glasgow, felt it was necessary to have the following disclaimer in its galleries: "The objects on display are sacred to believers, and are treated with respect. However, this is not a religious place but a museum." (cf Paine, *Godly Things*, 14). On this topic, see also Ronald L. Grimes, "Sacred Objects in Museum Spaces," *Studies in Religion/Sciences Religieuses*, 21/4 (1992): 419–30; Louise Gover, "Gods in the Gallery," *The Art Quarterly* 8/Winter (1991): 37–40.

10 James Clifton, *The Body of Christ in the Art of Europe and New Spain, 1150–1800* (Munich: Prestel, 1997), 11.

11 See Alberta Arthurs and Glenn Wallach, eds., *Crossroads. Art and Religion in American Life* (New York: The New Press, 2001), esp. xi–xviii; and the chapters by Neil Harris, "Reluctant Alliance: American Art, American Religion," (1–30) and Robert Wuthnow, "Arts Leaders and Religious Leaders: Mutual Perceptions" (31–70). Furthermore, highly publicized controversies in recent years have contributed to portraying the two worlds as fundamentally irreconcilable value systems. This book intentionally does not analyze these controversies, which have received considerable attention elsewhere.

12 See Antonio Alonso Meléndez, *Time of Hope (Tiempo de esperanza)* (Castilla y Léon: Junta de Castilla y Léon, Spain, 2002).

13 New York Times, October 8, 2002, review by Celestine Bohlen titled "Art Treasures Shown, but Few Behold Them." This review had the desired effect, as the visitor numbers increased significantly after it was published.

14 The exhibition originated at The Gallery at the American Bible Society (July 26–November 16, 2002) and traveled to the Mobile Museum of Art, Mobile, AL (February 14–June 8,

2003); the Evansville Museum of Arts and Sciences, Evansville, IN (July 28–October 5, 2003); and the Crocker Museum of Art, Sacramento, CA (November 7, 2003–January 18, 2004). See Ena Giurescu Heller, ed., *Icons or Portraits? Images of Jesus and Mary from the Collection of Michael Hall* (New York: The American Bible Society, 2002).

[15] The exhibition traveled to Los Angeles, St. Louis, Detroit, Baltimore, West Palm Beach, and Toronto, starting in February 1998. See Allen Duston and Arnold Nesselrath, *Angels from the Vatican: The Invisible Made Invisible* (Alexandria, VA: Art Services International, 1998). I thank Terrence Dempsey for bringing this exhibition to my attention.

[16] See *Appendix C* for a list of recent exhibitions illustrating this trend.

[17] Gabriele Finaldi et al., *The Image of Christ* (London: National Gallery Company Limited and distributed by Yale University Press, 2000). The exhibition also led to a BBC series and an accompanying book, *Seeing Salvation: Images of Christ in Art*, by Neil MacGregor with Erika Langmuir (London: BBC Worldwide Limited, 2000).

[18] See David J. Goa, Linda Distad, and Matthew Wangler, *Anno Domini. Jesus through the Centuries* (Edmonton, Canada: The Provincial Museum of Alberta, 2000).

[19] Jaroslav Pelikan, *Jesus through the Centuries: His Place in the History of Culture* (New Haven: Yale University Press, 1985).

[20] See James Clifton, *Body of Christ*. I would like to thank Dr. Clifton for participating in one of our panels; the following description relies on and quotes from his presentation.

[21] I thank James Clifton for generously sharing the visitor comments from this exhibition with me.

[22] The leader of a group who came to the museum to see *The Body of Christ* exhibition was reported to say, as the group was going through a Rauschenberg exhibition, "The *Body of Christ* is this way, and you don't have to look at anything else if you don't want to."

[23] They have included exhibitions of historical liturgical vestments from Cleveland's Roman Catholic and Orthodox churches (*Two Traditions of Sacred Dress and their Common Origins, 1996*) and Slovenian painting (*Window to Heaven: Slovenian Painting on Glass, 1998*), as well as online exhibitions such as *Cleveland Sacred Landmarks 1830–1930: A Pilgrimage*. Information on these exhibitions is available on the Cleveland State University Art Gallery's website, http://www.csuohio.edu/art/religiousart/

[24] The exhibition, organized by The Polis Center and titled *Falling Toward Grace: Images of Religion and Culture from the Heartland*, was on display from June 13 through October 11, 1998. See J. Kent Calder and Susan Neville, *Falling Toward Grace: Images of Religion and Culture from the Heartland* (Bloomington, IN: Indiana University Press, 1998).

[25] See *Crowning Glory. Images of the Virgin in the Arts of Portugal* (Newark, NJ: The Newark Museum of Art, 1997).

[26] David Goa, *Anno Domini*, 5.

[27] I thank Ms. Gouveia for her comments on this topic at our fall symposium.

[28] See *Insights: Museums, Visitors, Attitudes, Expectations: A Focus Group Experiment* (Malibu: Getty Center for Education in the Arts, 1991).

[29] I thank Susan Braunstein, Curator of Judaica at the Jewish Museum, for her insights on the challenges of presenting Jewish ceremonial art to a wide public; this essay is indebted to her presentation.

[30] I thank Terrence Dempsey, S.J., for his participation in two of our symposia and his insightful remarks not only on his experience at MoCRA, but also more generally on the state of the dialogue on art and religion in our society.

[31] For The Gallery at the American Bible Society, see *Appendix B*. Significant examples

internationally are the St. Mungo Museum of Religious Art and Life (St. Mungo, Scotland), and the Museum of World Religions in Taipei, Taiwan.

32 I am indebted to Jean Bloch Rosensaft and her presentation on the Hebrew Union College–Jewish Institute of Religion Museum in New York.

33 The museum on the Cincinnati campus was established in 1913 by the National Federation of Temple Sisterhoods. Today each of the college's campuses (Los Angeles, Cincinnati, New York, and Jerusalem) features a museum or museum affiliate.

34 The museums have also been very intentional in reaching out to artists who had never created Jewish ceremonial art (and including non-Jewish artists), encouraging them to think about redirecting or extending their creativity in the direction of making objects that could be used for ritual purpose.

35 See note 4 above.

36 The exhibition was on view at the Metropolitan Museum of Art February 12–May 10, 1970. See Konrad Hoffman and Florens Deuchler, *The Year 1200* (New York: The Metropolitan Museum of Art, 1970).

37 Ms. Hartfield was, until recently, Woman's Board Endowed Executive Director for Museum Education at The Art Institute of Chicago.

38 One is reminded also that, when it comes to religious art, there are as many interpretations as there are beholders. The Museum of the American Indian once experimented with the concept of multiple labels, written by different people, for each object in an exhibition. A visitor to that exhibition confessed being amazed by the variety of interpretations of and responses to the same object. This type of exercise could be particularly illuminating in respect to religious art.

why art needs religion, why religion needs the arts

Marcus B. Burke

While the other essays in this collection address the issues around religion and the arts from historical, anthropological, museological, pedagogical, and other scholarly points of view, this essay will state the problem from a more purely theological perspective. The essay is (to paraphrase Kant) my personal prolegomena to any future theological aesthetics. It lifts up issues that I, as an ecumenical Christian with a commitment to interfaith sharing, have encountered on a daily basis in my career as a museum curator, critic, and professor of the history of art.[1]

I start with two assumptions. First, I assume for the sake of argument that I am preaching to the converted, one way or the other: that anyone who reads this essay will either be interested in art or in religion (if not both). Second, I am assuming it is fairly clear, at least to anyone who has investigated religious art over the past two centuries, that a remarkable gulf has opened between the life of faith as practiced in the churches, synagogues, mosques, and temples on the one hand, and what has come to be called "the art world," on the other.[2] By "the art world" I mean the culture of "mainstream" Modern art, with its museums, academic centers, critics, dealers, and of course, artists—in Nick Wolterstorff's terms, "the tribe of art."[3] For the sake of argument, I will assume, with Samuel Laeuchli, that "the divorce between religion and art" is a *fait accompli*, the base problem with which anyone interested in contemporary religion and art begins.[4]

In fact, the problem has two sides: art needs religion, and religion needs art. However, I will say little about why art needs religion, leaving that evangelical issue to another arena. Here, I am more concerned with debating those who question the role of art, particularly of contemporary art, in the life of faith. What is more, I hope to open a dialogue with those who feel that what they do in their house of worship, on the one hand, and what happens in an artist's studio, an art museum, or an art history class, on the other, are separate experiences. In my own life and faith, I take the position—although here it will be a hypothesis to be proved—that putting the two cultures, art and religion, back together again is a worthwhile endeavor that will confer both spiritual and artistic benefits. I hope to suggest some theological categories under which a reconciliation of art and religion can begin to be understood.

THE NATURE OF THE PROBLEM

The gulf dividing "the art world" and the churches represents both the Judeo-Christian proscription of idolatry and a separation of subcultures, with the attendant ethical,

aesthetic, political, and epistemological disjunctions. Iconoclasm has a wide history since the Reformation and remains a significant presence in Judaism and Protestantism, not to mention Islam. Iconoclasts usually point to the Second Commandment (Exodus 20.4, Deuteronomy 5.8), which prohibits the making of idols. The proscription of idolatry is beyond question, but what the Torah says about religious art in general is unclear. The ancient Hebrews also received a divine mandate to make beautiful things, including sculpted images, for the Tabernacle and Ark (Exodus 31 and 35). The question has always been: when does an image become an idol? The answer has usually been: when it becomes the object of worship in itself, or when it takes on an importance in itself that ought to be reserved for God alone. (The "-latry" in "idolatry" comes from the Latin word *latria*, meaning adoration of something divine.)

Traditional Orthodox and Catholic theology long ago figured out how to separate idol from image,[5] but the cultural divide between contemporary art and faith is in many ways harder to resolve. Even those Protestants, Catholics, and Orthodox who appreciate holy images recoil at what they perceive as essential aspects of "the art world": its alleged bohemianism, fraught with occasions for sin; its social and political radicalism, including anticlericalism; its artistic unintelligibility (from the point of view of lay people) since the beginnings of Modernism; and the dangerous powers of artistic objects with regard to the human psyche. In this view, Modern art is postulated as an idolatry of the material world, in which certain objects take on social and psychological values that are indistinguishable from those of religious idols. "The art world" becomes nothing less than latter-day Israelites dancing around an artistic Golden Cow, and the art world's morals, as many imagine them, are of a piece.

This is not without foundation. Modern art is in large part about self-expression, and what humans (not just artists) express is not always redeemed. For example, we are sexual creatures, so Modern art often includes the expression of sexuality, including aspects that many find questionable. Unfortunately, some believers move on from this truth to perceive all Modern art as tainted. Similarly, Modern art has undeniably often been allied with social and political radicalism, much of it hostile to organized religion since the eighteenth century. Issues of stewardship intervene, as art auction prices soar into obscene figures. It is not hard to paint a picture of degradation, enslavement to material values, and (at the least) wasted efforts. As in the case of modern iconoclasm, the issues, as John Dillenberger once observed, are not just cultural and aesthetic but also deeply theological.[6]

The importance of modern psychological theory for both art and theology has also contributed to theological suspicion about the arts. Many believers, and certainly many modern artists, have insisted on there being an essential link between religion and psychology. This is true not only at the level of archetype and myth (as in the work of Jung) but also in terms of other psychological approaches, including the work of Freud, behaviorism, transactional analysis, etc. Now, given the importance of psychology in modern theology and especially in ministerial training, it should not be surprising that what, in my understanding, is a type of spiritual tool, has been, in the belief of many artists throughout the Modern period and into the twenty-first

Figure 1
Michelangelo Merisi da Caravaggio
Calling of Saint Matthew, 1599–1602
Oil on canvas

century, something with metaphysical (or ontological) status.[7] Indeed, psychology has been a primary influence on twentieth-century art, especially in movements such as Surrealism, Abstract Expressionism, and their postmodern revivals, so that (to continue the argument) much Modern art, even if it does not seem overtly religious, is in fact spiritual on another level. Even for overtly professing contemporary Jewish and Christian artists, psychology provides powerful motives, functions, and imagery. (We might also cite Existentialism, a philosophical movement with both religious and secular aspects, as another important element linking Modern art to the life of faith.) While many of us may see the psychological and existential aspects in art as a blessing, others see these aspects as demonic forces injecting power into the objects themselves and leading to the objects being, in a sense, worshipped.

While it seems clear to me (and to many other Christian and Jewish believers, not the least of whom are artists), that the misconceptions enumerated above need

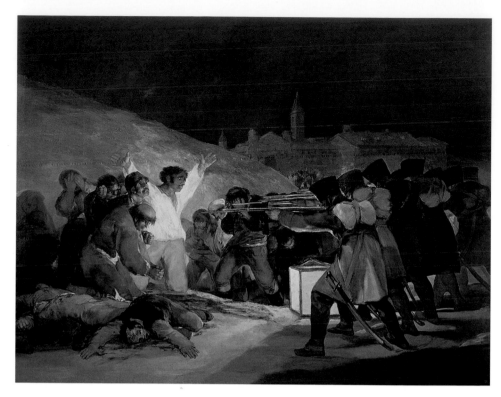

Figure 2
Francisco de Goya y Lucientes
The Executions of the Third of May 1808, *1814*
Oil on canvas

Figure 3
Pablo Picasso, Guernica, *1937*
Oil on canvas

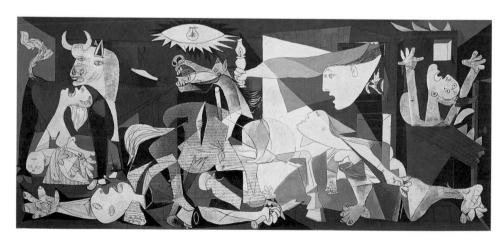

not apply to contemporary artists or their art, we must admit that the power of these stereotypes is strong. Georges Rouault, surely among the most religious of modern artists, received no commissions from the Church until nearly the end of his life! What antidotes can we suggest? Under what rubrics can the faithful appreciate the visual arts theologically? I would suggest that there are in fact many standard theological categories that the arts fit quite well. Among these are: Art as Revelation, Art as Prophecy, Art as a Conduit of Grace, Art as Exegesis, Art as Liturgy or Praise, Art as an Analogue of Divine Creation and Redemption, and Art applied to religious education and evangelism (or put more ecumenically, witnessing to one's own faith).

REVELATION AND NONVERBAL COMMUNICATION

Modern aesthetic theory from Benedetto Croce onwards has identified Art with Communication, just as Philosophy treats Aesthetics as a subcategory of Epistemology.[8] In fact, it is useful to think about the visual arts as ways of knowing, as paths to knowledge, including self-knowledge, and, in necessarily rare cases, pathways of revelation. For Jews and Christians, the principal path of Divine Revelation has always been the Bible, although since the Reformation there has been long dispute over the validity of other paths. In most cases, however, the means of communicating Revelation have been words—the words of the Bible, of the rabbinical commentators, of Church councils, etc.

Words, however, are notoriously dangerous tools for communication. Long before modern philosophy—whether Ludwig Wittgenstein's famous "black box hypothesis,"[9] the observations of the other logical positivists, or the critiques of Husserl, the Phenomenologists, and Existentialists—the ancient Greek philosophers and, indeed, Saint Paul, articulated the limits of verbal expression:

> Likewise the Spirit helps us in our weakness, for we know not how to pray as we ought, but the Spirit intercedes for us with sighs too deep for words.
> (Romans 8.26)

My contention is that works of art typically convey nonverbally what words fail to express. Take for example the *Calling of Saint Matthew* (fig.1) by the Italian early baroque artist, Michelangelo Merisi da Caravaggio (1571–1610). When this work appeared around 1599–1602, it was truly a revelation, proclaiming the power of the Gospel message for the lives of ordinary men and women, and doing so in a radically new way, both artistically and theologically. Whether the revelation was "Revelation," as opposed to exegesis, is not something I will argue here, except to the extent that one accepts the workings of the Council of Trent (1545–1563) as a locus of Revelation. If one accepts this, then Caravaggio's picture is undoubtedly revelatory, as it sums up much of the Council's position on the renewal of faith among the laity. Since the reforms of Trent and the Protestant Reformation were in fact two sides of the same reforming coin, Caravaggio's image also communicates well from a Protestant point of view.

ART AS PROPHECY

It is a short step from Revelation to Prophecy, and here we are on firmer theological ground. That great art can be prophetic is a commonplace: witness, in the secular realm, Francisco Goya's *Executions of the Third of May 1808* (fig. 2) or Pablo Picasso's *Guernica* (fig. 3). Both of these pictures foretell the horrific aspects of modern culture, with its militarism, fascism, suppression of the human spirit, and genocide. In general, I like to say that artists have very powerful "radar sets" (so to speak) within them that enable them to pick up events—blips on the horizon—before the rest of society experiences them. It is hard to look at the light bulb in *Guernica* and not think, with hindsight, of the atomic bomb to come, of which the victims at Hiroshima, as John Hersey recounts, only remembered the blinding light.[10] But Prophecy is more than predicting the future; from the time of ancient Israel onwards, prophets have held us accountable on moral grounds. Similarly, artists since at least the Middle Ages have used images as warnings and examples of applied Christian values. Goya and Picasso also do this; their canvases were both intended to criticize and exhort. Another example, famous among art historians, is a painting by the British Pre-Raphaelite, William Holman Hunt, called *The Awakening Conscience* (fig. 4), in which a young woman, startled by a vision in the garden outside her room, resists the blandishments of a would-be seducer. "Thou art the man!" it says to its male viewers. A lot of Modern art that seems so hostile to churchgoers might be better appreciated if its prophetic messages were properly understood.

148

It was not long ago that I read with interest the headlines announcing of Bob Dylan's conversion to Christianity: interested and thankful, but hardly surprised, since already in the early 1960s I had heard, in my Southern Baptist Church (no less), Dylan's lyrics held up as examples of modern prophesying. If I have found resonance in Dylan's songs of justice and righteousness, why should he not logically have found temporary solace on his spiritual journey in my type of faith? Dylan may be more familiar to the non-artistic readers of this essay than the Pop—artist, Andy Warhol, or if they know Warhol, these same readers may find him indicative of all that is wrong, in their opinion, with Modernism. Yet, we know that Warhol regularly attended Mass and did charitable work at the end of his life, although he never fully realized his own potential for religious art. Nevertheless, this same artist who propagated ironic icons of Brillo boxes, Chairman Mao, Elizabeth Taylor, and Marilyn Monroe, also gave us apocalyptic images of the atomic bomb (fig. 5) and the electric chair, useful provokers of thought in any believer.

ART AS A CONDUIT OF GRACE, AND THE PROBLEMS OF NONVERBAL COMMUNICATION

Many theologians know Paul Tillich's story of how a Botticelli *Virgin and Child,* viewed in a Berlin museum after five years in the trenches of World War I, induced a revelatory "ecstasy."

> That moment has affected my whole life, given me the keys for the interpretation of human existence, brought vital joy and spiritual truth. I compare it to what is usually called revelation in the language of religion.[11]

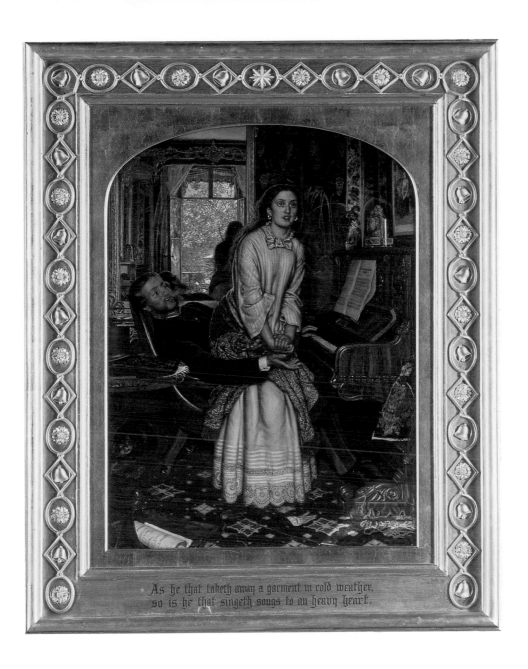

Figure 4
William Holman Hunt
The Awakening Conscience, 1853
Oil on canvas

Figure 5
Andy Warhol
Atomic Bomb, 1965
Synthetic polymer paint and silkscreen
ink on canvas

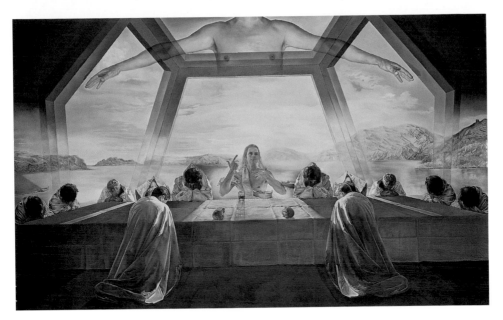

Figure 6
Salvador Dalí
The Sacrament of the Last Supper, *1955*
Oil on canvas

The power of images to induce or augment this sort of faith experience has been celebrated since antiquity and constitutes one of the prime arguments for religious art. But how does any human activity, much less a material object, become a channel for divine blessings? Catholic theology, including the Orthodox, Roman Catholic and closely related Protestant confessions, has developed many answers to this question, including massive thought on the sacraments, sacramentals, divine images, etc., but a truly ecumenical understanding is still far off. Then there is the cultural divide separating the churches from Modernism, so that even one who accepts Orthodox or Roman Catholic teachings might fail to see how they apply to contemporary art.

In particular, many believers fail to see how "bohemian" artists can produce anything that channels grace. Let us take a concrete example. We may probably assume that only a few of the faithful who so admire Salvador Dalí's *Last Supper* (fig. 6) at the National Gallery of Art in Washington would find Dalí's way of living (or most of his art) compatible with their beliefs. Yet the painting has been a focus of faith for hundreds of thousands of viewers over the years. It certainly had a stunning effect on a certain young Southern Baptist when he visited Washington on a 1950s school trip. This same Baptist carried about quite a number of prejudices that interfered almost entirely with any appreciation of the Catholic devotion on the Fourteen Stations of the Cross, until he saw a remarkable theme-and-variation series of this subject by a Jewish artist, Barnett Newman. In the course of creating his

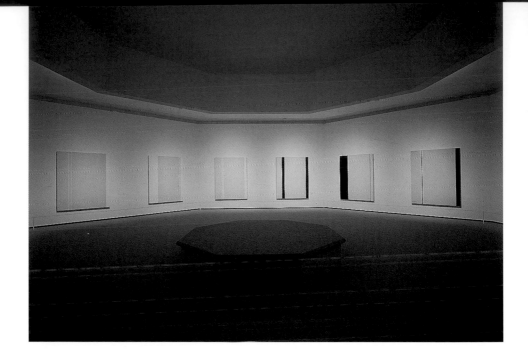

Figure 7
Barnett Newman
Stations of the Cross: Six to Eleventh Stations, *1962–65*
Acrylic/oil/magna on canvas

"Stations," (fig. 7) Newman asked what remains a powerful spiritual question: "Why—
that is, for what purpose—have you forsaken me?" A great deal of Christian theology
hangs precisely on this point. Yet it is safe to assume that Newman is probably
not the interpreter of the New Testament who springs readily to most Christian the-
ologian's minds.

Clearly, the ancient (but heretical) idea of a holy action validated *ex opere
operantis*, "by the work of the doer" is hard to apply to Salvador Dalí, or Caravaggio,
or Mozart, or any number of woefully errant artists who nevertheless produced
works of great spiritual import. Similarly, since most works of visual art are material
objects (and not human actors), there can be no question of the work of art
being an effective channel of grace *ex opere operato*, "by virtue of the work done"
(as Saint Augustine put it with regard to the Sacraments)—although the concept
may be applicable to the performing arts, since "work" is always being done
in performance.

Then how do works of visual art function, theologically? In several ways. First,
as we have seen, they are means of communication between an artist and a viewer
or an audience. Human values are codified by the artist when he or she makes the
work. (In this sense only, the theological content may be considered effective "by
virtue of the work done.") Certainly, this is an essential part of both the theology and
the professional preparation of any Russian or Greek icon painter. What the artist
codifies are not just personal thoughts, beliefs, and emotions, but also the values of

the surrounding culture, including contemporary theological discourse. (Again, Caravaggio is a wonderful example.)

When we say that religious values are built into a work of art, we come dangerously close to implying that the object is somehow holy in itself, which is, by definition, idolatrous. What is worse, with the modern visual arts, many believers question whether an art object can embody religious values at all. These believers hold the opinion, implicit or explicit depending on the theological and cultural values involved, that all modern self-expressive art is so rooted in materialistic hedonism as to be entirely suspect, if not antithetical to faith as it has been traditionally understood.[12]

Yet neither religious nor hedonistic idolatry is necessary in a work of art. For example, among the values encoded may be those enabling the work of art to function as a sign pointing to spiritual reality, as the theology of images in the Greek or Russian Orthodox and Roman Catholic confessions articulates. For Tillich, the work was a direct stimulus to faith and enlightenment. But the artistic code has to be deciphered, so to speak, by the viewer at a subsequent point in time for the transaction to have any theological meaning.

To find an ecumenically acceptable formulation, therefore, we must focus on the viewers of a work of art, including the first viewer, the artist himself. If such a viewer came to a work of art predisposed or prepared to receive spiritual blessings via the work, then Grace will flow, just as it might in the course of an event, a service, a sacrament, an experience, a personal relationship, or the like. To make a Latin pun on Saint Augustine's formulations, we may say that the Berlin Madonna that Paul Tillich found so effective did so *ex opere operatus*, "by virtue of the one on whom the work was performed." This assumes theologically that God is constantly seeking to be in touch with us, and that if we are not communicating, it is because, to cite an old country hymn, we need to "turn the radio on."

I am afraid that these arguments, as persuasive as they may be in the context of old master art, may fail to convince when the field is shifted to modern abstract art. Astract art is powerfully connected to our neural architecture, but it is also necessarily ambiguous, and to the uninitiated (that is, most lay viewers) it can seem unintelligible. (Of course, from the aesthetic point of view, "intelligibility" is not the issue, but we are speaking here from a non-artistic perspective.)

Let me offer an example from graduate theological education. In the course of conducting a seminar on religion and art for a mixed fine arts/theology graduate student audience, I had a fine arts graduate student who literally chained a nonfigurative painting to a Bible opened to John 11.1–44, the story of the resurrection of Lazarus. (She also put a bookmark at Job 19.25, "I know that my redeemer liveth.") The composition was nearly square, in whites and icy greys with minor touches of color, like a summer sunrise in the Arctic. I thought it a fine piece of exegesis and a marvelous expression of her own hope for resurrection—a "sigh too deep for words." Like pictures by Rembrandt and Van Gogh, it approached the story of Lazarus from the resurrected man's point of view, putting, by implication, the viewer in the position of experiencing not only the Christ but also a foretaste of glory. However, one of my colleagues on the faculty, a theologian from a conservative

Figure 8 (pages 154–157)
Donald J. Forsythe, The Long Night, *1989–91*
12-Part box construction: wood, gold leaf, acrylic medium,
lampback, ashes, photo-serigraph on silk tissue, over Bible pages

Protestant background with an aggressively iconoclastic tradition, called me to task for the work. "If it weren't for the Bible," he inquired, "how would we know that this was religious art?" I of course pointed out that the Bible was part of the work, that the artist had provided it to set the intended context, but I also shot a question back to him: "If we didn't know the words, how could we tell that Bach's setting of 'Jesu Joy of Man's Desiring' was a hymn and not a drinking song?" He of course insisted that the great works of sacred music carried the faith of their composers. I replied—and I lift it up here as an important part of my arguments—that if music can serve to express faith without words, why cannot the visual arts at all levels of abstraction do the same? This question is not new; it has been asked by many modern artists from the time of Whistler on. (We particularly remember Wassily Kandinsky, who entitled his works as if they were musical compositions, and Paul Klee.) Sacred music has been understood in terms of Saint Paul's sighs; the visual "sighs" of sacred art can probe equally deeply into the soul.

We might add that often the channels of grace opened by a work of art of any type are not those envisioned by the artist, and not even those expected by the viewer or listener. Successful works of art can function in a manner analogous to water spouts, lighting rods, or (as we have said), antennae, conducting spiritual power to the viewer in surprising ways. Tillich, coming from the horrors of war, for example, found things in Botticelli's *Madonna* that the Florentine never imagined (but would have been very happy to hear about). As Keats might have put it, Tillich

was in the midst of other woes than Botticelli's, and so he found the spiritual values encodified in Botticelli's composition not only a sign and a means of communication with Botticelli's religiosity, but also a key unlocking a torrent of other graces.

ART AS AN ANALOGUE OF CREATION AND REDEMPTION

One aspect of artistic endeavor with deep roots in the Judeo-Christian tradition is that of the artist as creator imitating the prime Creator, God. To put this slightly differently, there is a powerful analogy between Divine Creation and what artists do.[13] From the Book of Genesis, in which God molds Adam out of earth (2.7), through the prophets Isaiah and Jeremiah and the wisdom literature of the Apocrypha, to Saint Paul, the image exists of a potter working with clay—to which is added the necessity of the clay (creation) reflecting the will of its Creator.

When Jeremiah went to the potter's workshop, he articulated the necessity of artistic selection:

> So I went down to the potter's house, and there he was working at his wheel.
> And the vessel he was making of clay was spoiled in the potter's hand, and he
> reworked it into another vessel, as it seemed good for the potter to do. Then
> the word of the Lord came to me: "O House of Israel, can I not do with you as
> this potter has done?"
> (Jeremiah 18.3–6)

Jeremiah applied this event to his prophecy of God's testing Israel, but we can invert the metaphor: does not the potter reenact or imitate God's act of creation with each vessel he throws? The operative words here are imitate and analogy; we do not suggest that what a human artist does is divine, but that it reflects the divine act of creation. That conceptions of beauty enter into this was recognized by Saint Paul, who explicitly cites aesthetic criteria in developing an extended metaphor of both Creation and Salvation:

But who are you, a man, to answer back to God? Will what is molded say to its
molder, 'Why have you made me thus?' Has the potter no right over the clay, to
make out of the same lump one vessel for beauty and another for menial use?
What if God, desiring to show his wrath and to make known his power, has
endured with much patience the vessels of wrath made for destruction, in order
to make known the riches of his glory for the vessels of mercy...
(Romans 9.20–23)

An artist takes base material—mud, in the case of the ceramist—and turns it
into something of use, of beauty, or of both. Again, by analogy, we see the refining
and redeeming power of God's grace reenacted in each work of art. The faithful
artist, keeping clear the necessity to imitate and not supplant God as creator, thus
produces (if successful) works in which both Creation and Redemption are addressed.

ART AS EXEGESIS

Most parents of young children become connoisseurs of book illustrations, and it is
fairly easy to separate the good from the bad, the ones that "work" and the ones that
don't. A really fine illustrator, an N.C. Wyeth or Eric Carle or Peter Sis, is a splendid
exegete, often bringing out nuances in the text that otherwise would be missed, or
expanding hints in ways that, surprisingly, enable rather than restrict the imagination
of the reader. The best biblical illustrations of the past have that same quality of
enabling and expanding our response to Scripture, as may be seen in the works of
Michelangelo, Rembrandt, Dürer, Caravaggio, and many others.

Some years ago, I assisted the late Professor William L. Hendricks (at the time,
on the faculty of the Southwest Baptist Theological Seminary) in the preparation of a
video based on four "portraits" of Christ at the Metropolitan Museum of Art, New
York.[14] Each of the four gospels, he observed, develops a different literary image of
Jesus. Mark, written as it is in a type of "barracks Greek," offers a rough-and-tumble
man of the people. Matthew, with its focus on the Hebrew religious tradition,
presents a subtle young Rabbi. Luke, whose concern it was to present Christianity to

the Roman world, offers a more royal figure; John offers us the suffering servant. (More recently, Robin Griffith-Jones has developed a similar exegesis, using the categories of Rebel, Rabbi, Chronicler, and Mystic.[15]) Hendricks and I applied these conceptions to two works by Rembrandt and one each by Albrecht Dürer and Antonello da Messina. The exercise opened my eyes to the power of the visual arts to illuminate the Bible. (It was also a wonderful explication of the works of art!)

The visual arts select, focus in on, abstract, or expand the meaning derived from texts in a way that augments the viewer's appreciation. Take, for example, one of the most famous images in western art, Michelangelo's *Creation of Adam*. For many believers, this image effectively summarizes the whole creation story of the Book of Genesis, with its establishment of the relation between an active Creator and a passive, receptive Created. Michelangelo's fresco serves an exegetical purpose: it clarifies the theological meaning of the narrative and makes the text more accessible to the faithful. This idea—art as exegesis—seems to me an area of great potential for future studies.

Modern art is no less useful in exegesis, which has one of its goals to keep the interpretation of scripture *au courant* with contemporary life. In an exhibition at The Gallery at the American Bible Society, curated by Ena Heller in 2000, a number of contemporary works were exhibited that opened wonderful new windows on the Scriptures. For example, the artist Donald Forsythe exhibited a series of painted relief constructions entitled, *The Long Night* (1989–91) (fig. 8) in which the images relate to the destruction and rebuilding of the temple. Forsythe's serial images responded to a variety of traditions in Christian art (stations of the cross, works with text included in the image, church architecture) and had the additional virtue of focusing the viewer on Christian/Jewish dialogue. In the same exhibition, Mary McCleary's works brought biblical and apocalyptic subjects into scenes of denominational and regional specificity: the *Prodigal Son* (fig. 9), for example, was seen returning to a barbeque on a west Texas Ranch. The modernity of these pieces is part of the exegetical act, shocking us into dealing with revelation in the context of our own culture. Similarly, there is a series of Biblical images from Sadao Watanabe, who uses Japanese

Figure 9
Mary McCleary
The Prodigal Son, *1986*
Mixed media collage on paper

stencil techniques to re-create Judeo-Christian biblical text.[16] In the Japanese artist's rendering, the apostles fish for fish and men and women. The Adoration of the Magi has the three men noticing the flowers on the Virgin's kimono. Then, in an image strikingly similar to Romanesque art, the magi are warned in a dream not to go back to Herod, but to return to their land by another way. Watanabe has interpreted "another way" not in terms of another path, but another manner of transportation: the Magi return not on foot but in a boat (fig. 11). The artist takes visual traditions and exegetical assumptions about the text, then rips them up and pastes them together in a new context. Isn't such transformation central to the very definition of exegesis?

ART AND LITURGY, ART AS PRAISE
A not uncommon form of theologizing about Art considers it as a type or analogy of liturgical experience.[17] This has deep roots in art and architectural history, which have traditionally connected Christian church architecture and decoration with the liturgy celebrated within. In the Modern era, abstract serial compositions such as Mark Rothko's chapel in Houston (see fig. 5, p.108) or works with overtly liturgical themes such as Rouault's paintings (fig. 11), Barnet Newman's *Stations of the Cross*, and Henri Matisse's Dominican chapel at Vence provide a visual analogue, specific or amorphous as the case may be, to liturgy.

 "Liturgy," however is probably too narrow an ecclesiastical concept to include a sufficiently broad ecumenical gathering. I would suggest an alternate term:

Figure 10
Sadao Watanabe
The Three Wise Man Sailing for Home, 1972
Katazome Stencil Print on Mulberry Paper

Praise the Lord!
Praise, O servants of the Lord,
Praise the name of the Lord!
(Psalm 113.1)

"Praise," in this usage, would encompass everything from the public rituals of Islam, through the celebrations and communal prayers of Judaism and the most elaborate rites of the Orthodox, Roman Catholic, and Anglican churches, to the "praise music" of Evangelical and Charismatic congregations. Thinking of art as visual "Praise" removes many of the cultural and theological impediments to its appreciation.

Is a given icon an idol? No, or at least, not in itself. Some may use it as a sign or a window for communion with the saint in the company of the Blessed, a non-idolatrous use in Orthodox/Catholic understanding. Others, for whom this function has no meaning, may nevertheless find it a beautiful way to praise God and give thanks for God's grace in providing us with the witness of the saint. Is this abstract painting just a mess of self-indulgent blobs? No, it is the artist's testimony, an expression of the joy he or she feels in the life of faith. It is an act of Praise. This avenue seems to me a promising way to bridge many of the theological divides between Catholic/Orthodox and Protestant conceptions in the theology of art.

APPLIED CHRISTIAN ART

I wonder how many Christian commercial artists there are who have never applied their considerable skills to biblical and other Christian illustration? I suspect the number is great. I remember, to cite an extreme example, one particularly gifted young artist, a member of a "plain" church group from Pennsylvania similar to the Mennonites, who was somehow managing to stay "plain" in the midst of an Ivy League university. This was remarkable enough, but even more remarkable was the fact that she was an art major with considerable talent as an illustrator. When I asked her to show me her religious works, however, a blank look came over her face. There were none! Her life as an artist and her (dearly bought) spiritual life had no connection whatsoever. Pull back the camera and take a panoramic view across our culture, and one has to ask: how many Christian artists are there, not just in the visual arts but also in film, television, animation, drama, and music, whose talents are buried in the material secular world? Think at the same time of the many pieces of illustrated literature, films, videos, CD-ROMs, and so forth produced by the publishing houses, Sunday school boards, mission boards, and Christian education departments of the various denominations, and one cannot but wonder if more effort ought not to be expended on bringing Christian artists and Christian purposes

Figure 11
Georges Rouault
Christ de Face, 1938
Sugarlift color aquatint

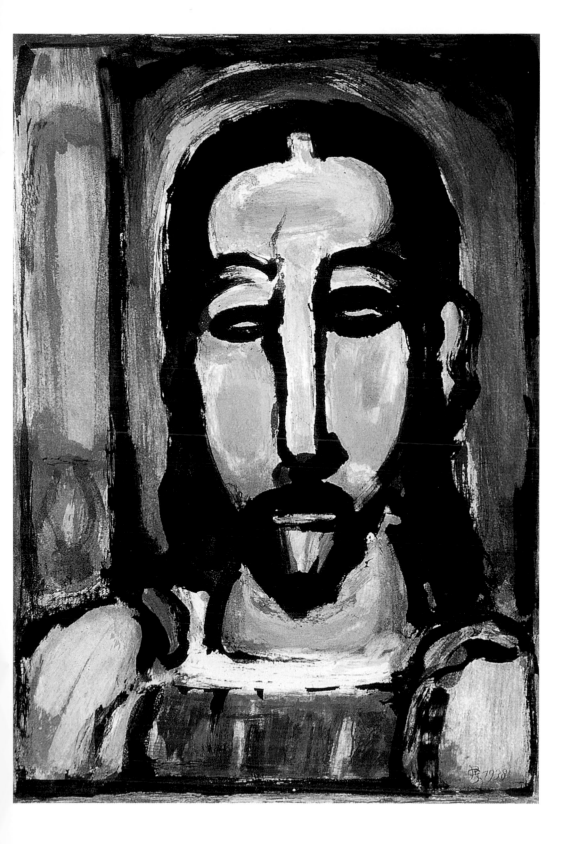

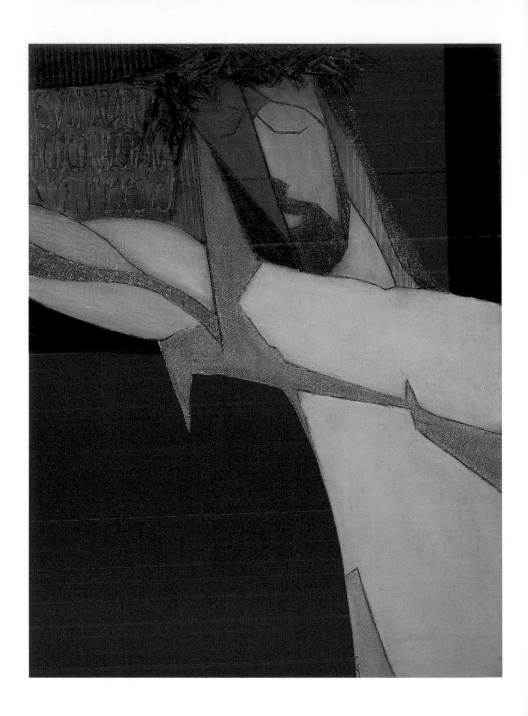

Figure 12
Sandra Bowden
It is Finished I, 1976
Oil on acrylic painting

together. Applied religious art (analogous to commercial art), which I define as art used to illustrate religious education texts and decorate the interiors of church building, is something that may be found in even the most iconoclastic church or indeed, in most synagogues. There is hardly a Sunday school book or synagogue/Sabbath school text that is not illustrated. How many of this great number of images are informed not only by sophisticated theological discourse, but also by sophisticated artistic preparation, is for me an important question.

EVANGELISM AND CONVERSION

What is true of Christian education is even more true of evangelism, a field in which the efficacy of art has a long history of proven effects. I do not mean this only in terms of art being a "Bible for the illiterate," but rather a means of approaching those who would otherwise not be reached by evangelistic efforts. Let us start with "the art world" itself, and with the much larger population of culture consumers who visit museums, galleries, and art events. For millions of people, the only gospel they ever hear preached comes from Botticelli, Michelangelo, and Rembrandt, and from Modern artists such as Van Gogh, Klee, Rouault, Matisse, Dalí, Rothko, Newman, Kienholz, and many others. Project this out onto popular culture and the wider realm of commercial art (including animation, computer art, website design, and other media-related art forms), and one wonders how such a powerful tool for evangelism could be overlooked, or at least, applied so incompletely.

How effective modern art can be as a "Bible for the spiritually illiterate" may be understood from two more works exhibited at The Gallery at the American Bible Society in 2000: Sandra Bowden's painting, *It is Finished I*, 1976 (fig. 14), and Lika Tov's 1992 collograph, *Hagar* (fig. 15). Images such as these jump across the gap between word and faith and connect potential believers with the ancient texts in an immediate way, and in a way that we can imagine projected into art galleries, commercial art contexts, and illustration.

Questions of evangelism raise the issue of the conversion of the individual artist. While it is good if a nonbeliever or a partial believer makes holy art (*ex opere operatus*!), how much better if the artist is one of the faithful. As an experiment, we may set the hypothetical example of an artist working in a contemporary Modernist (or, if one prefers, Postmodern) style who experiences a conversion to, say, evangelical Christianity or traditional Roman Catholicism. What would change in this person's art? We might properly expect, for example, a change in subject matter: what had formerly been considered merely daring might well now be understood as unredeemed, or sinful, or, at the very least, inappropriate. Whole areas of expression, such as gratuitous sex and violence, might now be off limits, although non-gratuitous uses of human sexuality, anger, etc., might well retain their importance within a new understanding of their role in a much larger scheme of things. But must we expect— to take an extreme example—for an Andy Warhol to turn into a Norman Rockwell?

This seems to me to misunderstand true conversion, or perhaps I should say it confuses the cultural aspects of conversion with the spiritual effects. When an artist of integrity converts, those aspects of his or her art that are not rooted in

163

unredeemed behavior are brought along into the new spiritual construct of the convert's life. For the artist to assume that conversion means having to paint saccharine Jesuses knocking at the door or trite stereotypes of the blessed Virgin seems to me a perverse inversion of the materialistic idolatries polluting our modern age—unless of course the artist was already using images of this type or had found a way to both appropriate and reconstitute these images into artistically viable forms.

However, I should admit, from a purely practical point of view, that any conversion must necessarily entail some kind of cultural shift. One sees this all the time: the converted drug user leaves the drug culture, the converted alcoholic leaves the bar and gets "on the wagon," and so forth. To the extent that conversion implies repentance, a "turning away" from sin, it implies at least a partial change of culture. As I have already implied at the beginning of this essay, this would seem to imply a rejection of much of the Modern artistic tradition, putting the artist in a very difficult situation, since his or her training, financial support, philosophical underpinnings, etc., are all connected to "the art world" and the Modern tradition. Certainly, as we have said, modern art often transmits values seemingly at odds with the life of faith. But in fact, this is a matter of selection on the part of the believer, especially given the fact that many of the founders of Modern art (and again we cite Van Gogh, Kandinsky, and Klee, as well as Denis, Kupka, and Mondrian) had decidedly spiritual motives for their artistic radicalism (fig. 14). Recapturing the spiritual aspects of Modern art might be the quintessential exercise for any artist seeking to resolve seeming conflicts of art and faith in a Postmodern world. Or, in the case of artists seeking to return to an old master tradition, it is worthwhile investigating how Early Modern (that is, nineteenth-century) artists imbued older forms with new spiritual energy.

Indeed, I would suggest that, at the outset of the twenty-first century, it is a sort of dereliction of aesthetic duty for a believing artist, whether recently converted or long since brought into the faith, to turn his or her back on the immense power that Modern design has brought to art. Above all, the ability of Modernist techniques to achieve visual and philosophical transformations and access human psychology must not and cannot be ignored by any artist seeking to express the life of faith. Since we seem to have been using Warhol as an example, consider his remarkable ability to transform ordinary, everyday objects and images into something monumental, existentially haunting, and often, quite surprising. Glibly returning to Impressionism, or plein air naturalism, or academic painting, will never be enough in itself—hence the arid sterility of much Cowboy "Art." If we ever want to give the life of faith the sort of visual power its spiritual values deserve, then we will have to merge again the religious and artistic cultures, drawing on the strengths of both.

ART AS WITNESS

Art can give testimony to the faith in several ways. It can express belief directly, in the sense just discussed, but it can also reinforce a sense of connection between the living faithful and those witnesses who have come before. Indeed, from the catacombs of Rome forward (and in the Greco-Roman Jewish context as well), art has enforced a sense of communion with the saints of the past, or indeed, with the heroic witnesses

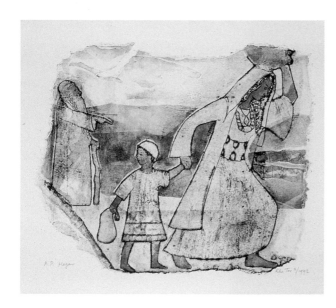

Figure 13
Lika Tov
Hagar, 1992
Collograph

Figure 14
Vincent van Gogh
The Starry Night, 1889
Oil on canvas

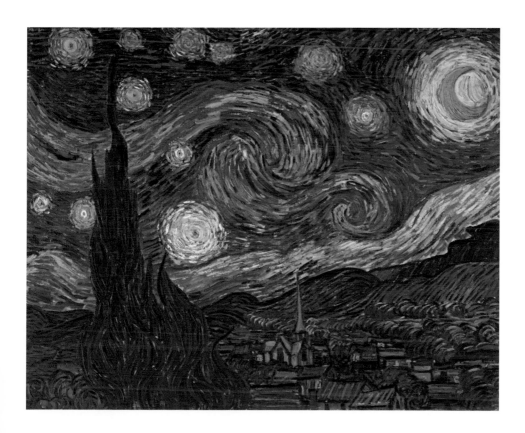

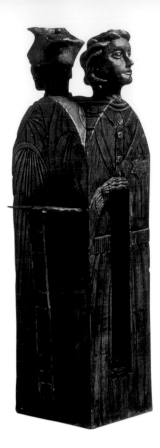

of our own times. Take, for example, the totemic steles (fig. 15) of the contemporary sculp
Aaron Lee Benson, who uses them to celebrate the role selected modern believers have
played, often heroically, in the life of faith. The word martyr originally meant witness, and
Benson commemorates both the witnessing and the price paid. He also turns the viewers
into witnesses—to the spiritual heroism of his subjects, but also to the truths that inspire
them. Indeed, one of the things that art has always done very well is to testify to the faith,
and as we have seen, art makes it possible to testify across cultural divides to those who
not yet part of the communion. (I use these words, testify, witness, in the biblical sense,
the faithful and true witness to the necessities of faith in the real world.)

ISSUES OF STEWARDSHIP, CHURCH PATRONAGE, AND WITNESS
It would be nice if the churches had the status in society to become the active centers of
art patronage they were in the past. But alas! The churches are no longer, in general, so w
endowed, and of course, the poor are still with us, so that we must think hard before we
(as the church) expend scarce resources on art. Yet it is nevertheless true that many churc
are built and decorated and many works of art (especially graphic art and reproductions)
purchased to adorn and instruct in church buildings. Many who give generously to missi
and social ministries also give to this aesthetic purpose, much in the way money is given
church music programs. In this context, let us return to the idea of Praise as a worthwhil
activity of the Church, an activity being worthy of expenditure, as is nearly universally accep
in the case of church music.

Currently, financial support for independent artists is organized around market sales of objects. As we have seen, a ferocious idolatry can attach itself to these objects—that is why the Judeo-Christian tradition has such fears about them. At the same time, Christian artists cite overt prejudice against their subjects in the art world—I remember the Oklahoma artist DeLoss McGraw telling me how, at a Los Angeles gallery in the 1980s, the owner methodically changed every title that might reflect a religious concern! I think we are past that point in many locations, but the odds still remain stacked against the spiritual on the art market.

In spite of all this, I remain convinced that the one sure area in which Christian artists have a role to play is the very same "art world" that seems to be the problem. Indeed, we have little other choice than to continue the assault on the citadels: the galleries, museums and curatorial departments, critics, etc. In this context, we must remember that "the art world" includes departments at universities and art schools, providing "day jobs" that are at least in theory compatible with independent artistic creation, if hardly free from anti-religious prejudice. In this endeavor, the churches, even when they cannot provide patronage, ought at least to provide theological succor. What is needed is a conception of "tent making ministry" applied to the fine arts, including both theological training and some sort of recognition of the potential ministerial role of artists. Indeed, confessions as disparate as the Southern Baptists and the Roman Catholics have been ordaining musicians and other artists for centuries. "Fra" was not Fra Angelico's first name: he was a Dominican friar. (Foundations with an interest in religion might want to look closely at art ministries as an area to develop in their work with seminaries.)

The churches could also benefit immensely simply by using the resources of "the art world", particularly museums. Our museums are cathedrals of Judeo-Christian iconography, litanies of devotional images, powerful arguments for the life of faith. I have seen people (one of them a museum employee) doing quiet private devotions in front of pictures in museums, but how seldom does one see a Sunday school or confirmation class using a museum as a resource, or even a church group visiting museums as a way to develop the life of faith? All this requires is a sign-up sheet and a few phone calls, and of course art historians and museum curators sensitive to issues of faith and willing to provide help.

In sum, I find myself with a great deal of hope for a reconciliation of art and religion. Even after 200 years of separation, this marriage, which produced so much that is noble and inspiring in world culture, seems eminently worth saving. And speaking now to those in my own religious tradition, I would recall that the Great Commission speaks of "all the world," not "everywhere except the art world," and that we are expected to use our talents effectively. What are we waiting for?

[1] This essay is a revision of comments first published as "The Life of Faith and Contemporary Art," in Ena G. Heller, ed., *The Word as Art: Contemporary Renderings*, (New York: The Gallery at The American Bible Society, 2000), 37–55. Among the sources used in the preparation of these remarks are: John Dillenberger, *A Theology of Artistic Sensibilities: The Visual Arts and the Church* (New York: Crossroad, 1986); John Dixon, *Art and the Theological Imagination* (New York: Seabury Press, 1978); Samuel Laeuchli, *Religion and Art in Conflict: Introduction to a Cross-disciplinary Task* (Philadelphia: Fortress Press, 1980); Walter L. Nathan, *Art and the Message of the Church* (Philadelphia: Westminster Press, 1961); George Pattison, *Art, Modernity, and Faith: Towards a Theology of Art* (New York: St. Martin's Press, 1991); Paul Tillich (John and Jane Dillenberger, eds.), *On Art and Architecture* (New York: Crossroad, 1987); Nicholas Wolterstorff, *Art in Action: Toward a Christian Aesthetic* (Grand Rapids: Eerdmans, 1980); and the essays collected in Diane Apostolos-Cappadona, ed., *Art, Creativity, and the Sacred* (New York: Crossroad Press, 1984). For the Roman Catholic and related theological points of view, see Hans Urs von Balthasar, *The Glory of the Lord: A Theological Aesthetics* (Edinburgh: T&T Clark, 1982); M.-A. Couturier, *Sacred Art* (Austin, TX: University of Texas Press, 1983); Alex García-Rivera, *The Community of the Beautiful: A Theological Aesthetics* (Collegeville, MN: Liturgical Press, 1999); and Richard Viladesau, *Theological Aesthetics: God in Imagination, Beauty, and Art* (New York: Oxford University Press, 1999).

[2] The separation of art and faith may be followed implicitly in Robert Rosenblum's alternate explanation of the genesis of modern art, *Modern Painting and the Northern Romantic Tradition: Friedrich to Rothko* (New York: Harper & Row, 1975). How complete the separation had become was ironically demonstrated in the 1986 Los Angeles exhibition curated by Maurice Tuchman, Judi Freeman,

Carel Blotkamp, et al., *The Spiritual in Art: Abstract Painting, 1890–1985* (Los Angeles : Los Angeles County Museum of Art and New York: Abbeville Press, 1986). Cf. Franky Schaeffer, *Addicted to Mediocrity: 20th Century Christians and the Arts* (Westchester, IL: Cornerstone Books, 1981) Not all art historians have accepted the divide—see Sister Wendy Beckett, *The Mystical Now: Art and the Sacred* (New York: Universe Books, 1993); and Jane Dillenberger, *Image and Spirit in Sacred and Secular Art* (New York: Crossroad, 1990), among others cited here.

[3] Wolterstorff, *Art in Action*, 21–25. Compare his remarks in "Art, Religion, and the Elite: Reflections on a Passage from André Malraux," in Apostolos-Cappadona, *Art, Creativity*, 262–273.

[4] Laeuchli, *Religion and Art*, 8.

[5] The Lateran Council of 769 and the Second Council of Nicaea (13 October 787) formulated the iconodule position most fully (on the basis of earlier pronouncements). II Nicaea was followed closely in the decrees of the final session of the Council of Trent, 1563 (published 1564). See H. Schroeder, *Canons and Decrees of the Council of Trent* (St. Louis: B. Herder Book Co., 1960, c1941).

[6] John Dillenberger, *A Theology*, 231–249, especially 243–44; cf. 56–74 on the history of iconoclasm.

[7] The presence of modern psychological categories, especially those of Freud and Jung, may be found throughout the works of art exhibited at Los Angeles in 1986; see Tuchman, Freeman, Blotkamp, et al., *The Spiritual in Art*, passim.

[8] Benedetto Croce, Douglas Ainslie, tr., *Aesthetic as Science of Expression and General Linguistic* (London: Vision Press, 1967).

[9] Ludwig Wittgenstein, G. E. M. Anscombe, tr., *Philosophical Investigations: The English Text of the Third Edition* (New York: Macmillan Publishing, 1958), section 293.

[10] John Hersey, *Hiroshima* (New York: A.A. Knopf, 1946), 42.

[11] Tillich, *On Art and Architecture*, 234–235.

[12] The radical critique of art from the evangelical and reformed point of view has been articulated (in a sort of love-hate relationship) by H.R. Rookmaaker, in *Modern Art and the Death of Culture* (Downer's Grove, IL: Inter-Varsity Press, 1970); and in *Art Needs no Justification* (Downer's Grove, IL: Inter-Varsity Press, 1978).

[13] Cf. Laeuchli, *Religion and Art*, Chapter 7, "Processes of Analogy," 135–166.

[14] See William L. Hendricks, *Christian Art and Symbolism*, videotape. Louisville: Southern Baptist Theological Seminary, Center for Religion and the Arts, n.d. For responses to Hendrick's work, see David M. Rayburn, Daven M. Kari, and Darrell G. Gwaltney (ed.), *Baptist Reflections on Christianity and the Arts: Learning from Beauty. A Tribute to William L. Hendricks* (Lewiston, NY: The Edwin Mellen Press, 1997). Additional theologies of art from a Baptist, and especially Southern Baptist, perspective, may be found in Roger Hazelton, *A Theological Approach to the Visual Arts* (Nashville, TN: Abingdon Press, 1967); John Newport, *Christianity and Contemporary Art Forms* (Waco, TX: Word Books, 1979, c1971); and William L. Hendricks, et al., *Southern Baptists and the Arts* (Louisville: Southern Baptist Theological Seminary, 1990) with essays by John Dillenberger, Jane Dillenberger, Doug Adams, and others.

[15] Robin Griffith-Jones, *The Four Witnesses: The Rebel, the Rabbi, the Chronicler, and the Mystic* (New York: Harper San Francisco [Harper Collins Publishers], 2000).

[16] See *Printing the Word: The Art of Watanabe Sadao* (New York: The Gallery at the American Bible Society, 2000), introduction by Patricia Pongracz.

[17] See Janet R. Walton, *Art and Worship: A Vital Connection* (Wilmington, DE: M. Glazier, 1988).

appendices

The Project *New Directions in the Study of Art and Religion* at The Gallery at the American Bible Society

Ena Giurescu Heller/Lindsay M. Koval

PROJECT DESCRIPTION

In 1999 The Gallery at the American Bible Society received a grant from the Henry Luce Foundation for a series of discussion sessions and symposia on the study of and discourse on art and religion in our society. The goal of the series, titled *New Directions in the Study of Art and Religion,* was an assessment of how the intersection of art and religion is studied and presented in different settings, be they academic (universities and theological seminaries) or public (museums, and through publications and the press). A second but no less important objective was to initiate a network of scholars interested in the connection between art, religion, and culture.

METHODOLOGY

The title of the series indicated the focus of the project: the intersection of art and religion as a field of study, as the object of scholarly inquiry. The goal was to strengthen understanding between scholars and students of art and religion by creating a forum that would encourage cross-disciplinary and ecumenical dialogue among historians, theologians, artists, and art historians. The premise was the need for a more intentional interdisciplinarity in our study and teaching of art and religion, in universities, seminaries, museums, and other cultural institutions. The ideal framework would allow for a collaborative process within which methods, tools, and discoveries are shared, and each specialty informs the others.

FORMAT

The project, developed with the help of an Advisory Committee, included research, exploratory dialogues and three two-day symposia at the Gallery.[1]

1. Art and Religion: One Subject, Many Viewpoints (May 2002)
This session brought together graduate students and scholars in an exchange about the ways in which the intersection of art and religion is studied in the academy. Plenary lectures considered the relationship between art and religion from the perspective of four distinct disciplines: art history, history of music, theology, and history of religion. We asked the four presenters to give their "methods lecture" that defines the métier of their discipline for a course on *Art and Religion*. In the afternoon we invited graduate students in art history, musicology, theology, and the fine arts to participate in group sessions that investigated the variety of method and approach currently used by their respective disciplines by analyzing works from the exhibition "In Search of Mary Magdalene" (on view at The Gallery at the American Bible Society April 5–June 22, 2002).

2. Art and Religion in the Public Realm (October 2002)
This session moved the dialogue from the ivory tower to the public sphere. The
question raised was: how is religious art perceived by American society? And how,
in turn, does it impact our society? For answers we turned to those institutions
that display, discuss and make accessible religious art: museums, galleries, and the
press. How do museums present religious artifacts to a non-religious public
(including the secular press)? How can exhibitions of religious art have greater
resonance for contemporary society? In turn, how does the press (both secular and
religious) popularize such exhibitions? The panel discussions helped piece together
the complex landscape of exhibiting, writing and educating the public about the
connection between art and religion in the Jewish and Christian traditions.

3. Art and Religion: The Relevance of Art History in the Seminary (January 2003)
This session reflected on the study of art (and specifically of art history) as a
resource in Jewish and Christian theological seminaries. The lectures and panel
discussions initiated a dialogue between the theological and the art historical
perspectives on the intersection of art and religion. Some of the questions that we
asked were: how does an understanding of aesthetic allow seminary students and
graduates to have a better historical consciousness and a better sense of religious
dimension? How do we reflect on art religiously? How can the study of art history
be relevant to biblical studies, church history, and historical theology? And finally,
can the study of art history be relevant in traditions that are professedly iconoclast?

4. Art and the Formation of Religious Communities (March 2004)
Building on themes suggested by the exploratory symposia, this conference considered
the role of art and material culture in the definition of identity and the formation
of religious community in the Jewish and Christian traditions, historically and in the
21st century. Papers considered the role of artistic production, display and consumption
in shaping the public and private consciousness of group identity and, conversely,
the way in which spiritual communities engage with and respond to art and
material culture.

[1] The Advisory Committee included Doug Adams (Graduate Theological Union, Berkeley); Diane
 Apostolos-Cappadona (Georgetown University), Susan Boynton (Columbia University); Marcus B.
 Burke (Hispanic Society of America); Margot Fassler (Institute of Sacred Music, Yale University);
 Ronne Hartfield (Harvard Center for World Religions); Rabbi Shirley Idelson (Hebrew Union
 College); David Morgan (Valparaiso University); Robert Bruce Mullin (General Theological Seminary).

Media Response to Exhibiting Religious Art.
A Test-Case: The Gallery
at the American Bible Society

Patricia C. Pongracz

The Gallery at the American Bible Society seems in large part to have entered the world as a "right thing at the right time." The 19 exhibitions to date (Spring 2004) have focused on various facets of Judeo-Christian art and its link to Scripture. The publicity received by The Gallery has in turn helped to build a diverse constituency including visitors interested in the Bible, those interested in art, or those with an interest in both. What follows is a brief description of The Gallery, its mission, organizational structure, and goals, followed by an analysis of the media response in the first five years.[1]

THE GALLERY AT THE AMERICAN BIBLE SOCIETY

The Gallery opened to the public on May 7, 1998 with an exhibition entitled *The Jerusalem Project: The Dome Restoration of the Church of the Holy Sepulcher.* The Gallery has since organized exhibitions dedicated to the interpretation of Judeo-Christian art.[2]

 The Gallery was established as part of the deliberate attempt to open the American Bible Society (ABS) to a broader public. Founded in 1816, ABS is the second oldest not-for-profit in the United States. Its mission has been to "make the Bible available to every person in a language and format each can understand and afford." Located in New York since its foundation, ABS has been a solid, if quiet presence. ABS's image building campaign, begun in the mid-1990s, hinged on architectural as well as programmatic changes.[3]

 The architectural firm Fox & Fowle added a two-story glass pavilion to the front of the prefabricated concrete office building designed in 1966 by Skidmore, Owings & Merrill. The transparent pavilion's sweeping curve was designed to open the building to the street and provide a welcoming façade that would encourage people to enter. The 3500 square foot gallery space was created directly behind the second story of the new glass façade. The Gallery literally opened up onto Broadway.

 Despite its broad mandate—display of Judeo-Christian art—The Gallery was met with skepticism on whether it could build a viable constituency, and if so, who that constituency might be. As part of an interdenominational Christian organization, The Gallery had to be sensitive to the traditions of various Christian denominations. From the outset, The Gallery had to balance the current of aniconic sentiment within its parent organization with its goal of exhibiting religious art to a secular, museum going public and the faithful alike.[4]

Critical to building The Gallery's constituency was media attention. This too, proved an uphill battle. The Gallery's Judeo-Christian specificity was perceived as exclusively Christian, which was not surprising considering we were The Gallery at the American Bible Society. The Gallery's open religious component, combined with its lack of a permanent collection, raised credibility issues, chief among them whether it was indeed a serious museum.

The Gallery's response to such initial skepticism was and continues to be a concerted program of varied exhibitions and special events. Emphasis is placed on a high level of critical and scholarly inquiry combined with adherence to professional museum standards and practices for display stipulated by the American Association of Museums. Special events feature noted scholars with expertise in an aspect relevant to the particular exhibition. Exhibitions range from those organized solely by The Gallery or in collaboration with other institutions, to those borrowed as traveling exhibitions. In an effort to reach a broad audience, didactic materials address traditional art historical questions (objects' function, use, iconography, patronage, material, and style) as well as questions related specifically to religion. Additionally, The Gallery explains iconography as it relates to the Bible. When relevant, specific passages of Scripture are cited in the didactics in an effort to emphasize how an iconographic type is derived from the biblical text. Part of this effort involves untangling the biblical from the extra biblical texts that have inspired art over time (like *The Golden Legend* and *Protoevangelium of James*) and which are often erroneously believed by many to be rooted in biblical text. In short, The Gallery treats the Bible as the primary source that it is.

The result of these sustained efforts has been positive media response over time on a local, national and international level, in both secular and religious outlets.[5] A general breakdown of The Gallery's press coverage reveals that of the 19 exhibitions organized over the last five years: seven have received full reviews by *The New York Times*; three have received syndicated reviews by the *Religion News Service*, which have appeared in various papers including the *Washington Post* and the *Los Angeles Times*; five have news items in *The Wall Street Journal*; and The Gallery itself was listed as one of the top ten places exhibiting religious art to visit by *USA Today* in December 2002. In addition to national coverage, The Gallery has received notice in regional press in the continental United States as the result of its traveling exhibition, *Icons or Portraits: Images of Jesus and Mary from the Collection of Michael Hall*, which has been on view at the Mobile Museum of Arts, Mobile, Alabama (February–June 2003); Evansville Museum of Arts and Science, Evansville,

Indiana (July–October 2003); and the Crocker Museum of Art, Sacramento, California (November 2003–January 2004).

CRITICAL MEDIA RESPONSE

Initial media response to The Gallery (received during its "start-up phase") may be classified according to two general themes: explanation of the nature of The Gallery and its programs and a focus on exhibitions of religious art not generally on display elsewhere, in particular religious art from various cultures.

I. The Nature of The Gallery

Reviews that have focused on the nature of The Gallery, what it is and what it does, explain and validate exhibitions and programs to the public. What I have termed the "it's ok" response goes directly to the heart of the tension between shows about religious art and the apprehension about potential proselytizing, the fear of being actively talked to about religion in an effort to change how you think or feel about personal devotion and notions of faith. Five years ago The Gallery was a totally unknown entity in a fairly non-descript office building in Midtown Manhattan. Unlike the Museum of Contemporary Religious Art at St. Louis University, St. Louis, Missouri, housed in a deconsecrated Catholic chapel, The Gallery's space does not convey a sense of what it is about. As noted above, the name of our parent organization, containing the words American Bible and society, sent a message open to various interpretations. Perhaps as a result the press has spent much time expressing pleased surprise at what we do and how we do it, as well as considerable effort explaining us to the public.

For example, writing in *Crain's, NY Business*, June 1998, Emily Denitto stated:

> The ABS's mission to acquaint people with the Bible resulted in the distribution and sale of over 10 million Bibles and New Testaments last year. But the new museum, free to the public, is not expected to function as an evangelical platform.

To support this statement, Denitto interview Gerard Wertkin, director of the Museum of American Folk Art, which at the time was located just up the street from The Gallery. Mr. Wertkin responded that:

> My sense is they want to make this a serious museum…I'm sure that they'll be happy if someone buys a bible while they're there, but this is not supposed to be a parochial or didactic museum.

The tension between the notion of a serious museum and its presence at the American Bible Society comes up repeatedly. There is genuine surprise that The Gallery is indeed committed to a serious presentation of religious art and, happily, consensus that we are able to accomplish this goal.

Four years later, the press is still discovering that The Gallery is committed to a deliberate, scholarly interpretation of religious art. In the *Julliard Journal* (October 2002) Greta Berman wrote:

I'm sure you have often passed the ABS building on 61st Street and Broadway and were drawn, as I was, to their glass windows adorned with quotes in a dozen languages and signs announcing exhibitions in their art gallery. I noticed it was listed in the The New York Times, The Museums Guide/ New York, and other art guides and meant to go check it out for along time. Wondering whether this was a serious gallery or just a pedagogic center for Bible study, I finally went in last spring and saw an excellent exhibition about representations of Mary Magdalene in art. The elegant gallery, just a stone's throw from Julliard, was a surprise.

These reviews underscore the notion that a visitor to The Gallery need not fear proselytizing. Biblical references are a part of the interpretive framework for the art, but as with any panel or wall text, the visitor is free to ignore them. Should the viewer choose to read them, he/she may find a richer experience of the art on display.

Writing about *The Word as Art: Contemporary Renderings* (July 2000) in the *New York Daily News*, Mila Andre summed up this latter point by stating:

True, most people are drawn to Lincoln Center and the surrounding area because of its theatre, opera, dance, and concerts. Yet other venues nearby are just as worthy of a visit. Take the Gallery at the American Bible Society…Obviously exhibitions there have religious themes, but often there's a twist…All the art harkens to the Word and probably means more to those who know their Bible. But even those who may not be well versed in the Book will find pleasure in the exhibition…

Andre confirms that there are various ways to appreciate these exhibitions, which are not necessarily mutually exclusive. One can approach the art through its scriptural referents or as a purely aesthetic experience. One can also use the exhibitions in The Gallery as a locus for contemplation, something noted repeatedly by other reviewers. Speaking to this point in her review of *Jerusalem and the Holy Land Rediscovered: The Prints of David Roberts (1796–1864)* (December 1999), Andre wrote:

With the holidays upon us, there's more to do than just shop for the latest trendy gift. And for those whose thoughts are on the biblical past an exhibition at the ABS should act like a salve.

Ann Stewart expressed a similar sentiment regarding *Printing the Word: The Art of Watanabe Sadao*, in the *Canberra Times* of Australia (April 2001). Noting that a visit to the exhibition "was a beautiful way to start the season" Stewart wrote that:

It may seem strange when I say I went to a gallery to begin my Easter observance, but there it is. Just a block from Lincoln Center, in New York City the American Bible Society has a small but intriguing gallery devoted to Judeo-Christian art and the inspiration it has found in the Bible.

These reviews confirm that The Gallery's exhibitions are approachable from various perspectives. A visitor may come for a traditional museum experience, to contemplate the full meaning of a selection of religious art, to see how the Bible has inspired various Judeo-Christian art over time, or a combination thereof.

II. Seldom Exhibited Religious Art

A second current running through the press coverage centers on The Gallery's display of less well known Christian religious art, as well as specific cultural identities, such as the 2003 *Finding Faith: Folk Art of Peru from the Collection of Antonio Lulli*, 2001 *Devoción del Pueblo: Religious Folk Art of Guatemala*, or the 1999 icon exhibition *Holy Art of Imperial Russia, 1660–1917*.

Grace Glueck reviewed the Russian icons exhibition under the headline "When Humbler Hands Picked Up the Russian Tradition of Icon Painting" for *The New York Times* (July 1999). The exhibition displayed primarily nineteenth century icons produced in a decidedly western style. In her review, Glueck emphasized the insight the icons provided into the diversity of Russian Orthodox iconography and icon painting style during this period.

Similarly, a listing in *Time Out New York* for *Devoción del Pueblo* (October 2001) focused on the religious context for the *santos*, choosing to highlight that the exhibition "offer[s] insight into the daily lives and religious faith of Guatemalan villagers."

Writing for the Religion News Service, Chris Herlinger wrote a review of *Printing the Word: The Art of Watanabe Sadao*. Entitled "Where East Meets West: Printmaker's message is rooted in Christian Beliefs, His images in Japanese tradition," the review was syndicated in *The Washington Post*. Herlinger noted that the prints on display were "respected in Japan and cherished in the West," and emphasized the integration of Western Christian iconography and Japanese folk art techniques, whereby Watanabe illustrated Bible stories using a visual vocabulary his compatriots could understand.

The above-cited quotations refer to the "twist," so aptly characterized by Mila Andre, of The Gallery's exhibitions. Contrary to initial concerns, the broad mission of The Gallery, to display and interpret the whole of Judeo-Christian art, allows us the latitude to exhibit works that other museums can, or will, not.

Finally, as noted above, the interest in The Gallery's exhibitions can be attributed in part to being "the right place at the right time." The exhibition *In Search of Mary Magdalene: Images and Traditions* (Spring 2002) provides the most salient example. When on display, it was reviewed by Chris Herlinger for Religion News Service (reviews were syndicated in the *Washington Post* and *LA Times*, June 2002) and Grace Glueck for *The New York Times* (April 2002).[6] Although the exhibition closed in June 2002, its topic proved to be timely a year and a half later. *Newsweek Magazine* made reference to it in its December 8, 2003 cover story, "Women of the Bible", an acknowledgement of the resurgence of interest in the Magdalene among the general public in particular as a result of Dan Brown's best selling novel *The DaVinci Code*.

This positive and sustained media coverage has enabled The Gallery to establish a credible reputation among the public —one we hope to continue to build during our next stage of development.

1 This derives from the presentation I gave at the October 2002 session of the *New Directions in the Study of Art and Religion* symposia (cf. *Appendix A*).

2 The mission statement reads: The purpose of The Gallery at the American Bible Society is to foster awareness, appreciation, and understanding of Judeo-Christian art. The Gallery serves audiences interested in the Bible and seeks to educate them through exhibitions, public programs, and publications.

3 For a history of the American Bibles Society from its foundation until 1966 see Creighton Lacy, *The Word Carrying Giant: The Growth of the American Bible Society (1816–1966)*, (South Pasadena, CA: The William Carey Library, 1977).

4 For example *Images in Procession: Testimonies to Spanish Faith* (Spring 2000) organized in collaboration with The Hispanic Society of America and *Devoción del Pueblo: Religious Folk Art of Guatemala* (Fall 2001) inspired internal criticism because of the varied imagery of saints. Exhibiting the art of a specific religious tradition proved equally apt to stir criticism because of the various factions within any given religious tradition. Some of the most animated critical commentary surrounded the didactics for the two exhibitions of Russian icons, focusing on the use of the calendar (Gregorian versus Julian) in noting Saints' Holy Days.

5 International coverage has included reviews in *The Financial Times*, London; *The Canberra Times*, Australia; *The Art Newspaper*, London; *Asaki Shimbun*, Japan; *La Nacion-Buena Aries*, Brazil; *Agence France Press*, Paris. New York area secular press coverage has included features on NY1 (a local cable station) and on Channel 13 (the tri-state area public television affiliate); reviews and listings in *The New York Times*, the *Daily News*, *Newsday*, *New York Post*, *Time Out*, *The Sun*, *Museums New York*, *City Guide*, *The Journal News* (Westchester); *The Newark Star Ledger*, *The Hackensack Record* and the *Bergen Record* in New Jersey, as well as newspapers that cater to local ethnic communities like *El Diario La Prenza* (serving the Hispanic community) and *Novoye Russkoye Slovo* (serving the Russian speaking community). Though the local ethnic coverage began with a specific interest in an exhibition of particular relevance to the community, it has expanded to include mention of other exhibitions of general interest in these papers' arts sections. Religious press coverage has included mention in *Catholic New York*, *Catholic Digest*, *Episcopal Life*, *The Episcopal New Yorker*, *The Lutheran*, and *Bible Revue*, *Sojourners Magazine*, *Americas Magazine*, and *The Forward*.

6 Summarizing the exhibition, Glueck wrote that "[w]hatever their truth, the dramatic stories woven about her have made her art worthy to this day." In a nod to the exhibition's breadth, she concluded that: "Most of its viewers will know a lot more about this appealing figure upon leaving than when going in."

179

APPENDIX C

Recent Exhibitions
Exploring Religious Art

Compiled by Lindsay M. Koval

This list illustrates the "boom" of exhibitions exploring religious art in the last several years. These exhibitions are noteworthy for their deliberate, explicit connection between art and religion. This list is by no means comprehensive; it includes those exhibitions which were most often referenced in the course of the dialogues engendered by the project *New Directions in the Study of Art and Religion* at The Gallery at the American Bible Society.

2002

Iconoclash: Beyond the Image Wars in Science, Religion and Art. Karlsruhe, Germany: ZKM/Center for Art and Media, 4 May–1 September 2002.

Icons or Portraits? Images of Jesus and Mary from the Collection of Michael Hall. New York: The Gallery at the American Bible Society, 26 July–16 November 2002; Mobile, AL: Mobile Museum of Art, 14 February–8 June 2003; Evansville, IN: Evansville Museum of Arts and Sciences, 28 July–5 October 2003; Sacramento, CA: Crocker Art Museum, 7 November 2003–18 January 2004.

In Search of Mary Magdalene: Images and Traditions. New York: The Gallery at the American Bible Society, 5 April–29 June 2002.

Light ×Eight: The Hanukkah Project, 2002. New York: The Jewish Museum, 22 November, 2002–2 February 2003.

The Mother of God: Art Celebrates Mary. Washington, DC: Pope John Paul II Cultural Center, 22 March–17 June 2002.

Sacred Spaces: Building and Remembering Sites of Worship in the Nineteenth Century. Worcester, MA: Iris and B. G. Cantor Gallery, College of the Holy Cross, 30 January–14 April 2002.

Time to Hope/Tiempo de esperanza. Treasures of Castilla y León. New York: Cathedral of St. John the Divine, 7 September–24 November 2002.

2001

The Art of the Cross: Medieval and Renaissance Piety in the Isabella Stewart Gardner Museum. Boston: Isabella Stewart Gardner Museum, 7 February–29 April 2001.

Like a Prayer: A Jewish and Christian Presence in Contemporary Art. Charlotte, NC: Tryon Center for Visual Art, 31 January–1 June 2001.

Telling Tales II: Religious Images in 19th Century Academic Art. New York: Dahesh Museum of Art, 16 October, 2001–26 January 2002.

The Treasury of Basel Cathedral. New York: The Metropolitan Museum of Art, 28 February–27 May 2001.

2000

Anno Domini: Jesus Through the Centuries. Exploring the Heart of Two Millennia. Edmonton, Alberta, Canada: The Provincial Museum of Alberta, 7 October 2000–7 January 2001.

Divine Mirrors: The Virgin Mary in the Visual Arts. Wellesley, MA: Davis Museum and Cultural Center, 9 March–9 July 2000 and Katonah Museum of Art, January 12–March 31, 2002.

Exhibiting the Visual Culture of American Religions. Valparaiso, IN: Brauer Museum of Art, Valparaiso University, 1 September–15 October 2000; New York: The Gallery at the American Bible Society, 10 November 2000–5 January 2001.

Faith: The Impact of Judeo-Christian Religion on Art at the Millennium. Ridgefield, CT: Aldrich Museum of Contemporary Art, 23 January–29 May 2000.

Fragmented Devotion: Medieval Objects from the Schnütgen Museum, Cologne. Boston: Charles S. and Isabella B. McMullen Museum of Art, Boston College, 7 February–22 May 2000.

Images in Procession: Testimonies to Spanish Faith. New York: The Gallery at the American Bible Society in collaboration with The Hispanic Society of America, 3 February–29 April 2000.

Pious Journeys: Christian Devotional Art and Practice in the Later Middle Ages and Renaissance. Chicago, IL: The David and Alfred Smart Museum of Art, The University of Chicago, 14 March–10 September 2000.

Seeing Salvation: The Image of Christ. London: National Gallery, 26 February–7 May 2000.

1998

Beyond Belief: Modern Art and the Religious Imagination. Victoria, Australia: National Gallery of Victoria, 24 April–26 July 1998.

Falling Toward Grace: Images of Religion and Culture from the Heartland. Indianapolis, IN: Indianapolis Museum of Art, 13 June–11 October 1998.

Glory in Glass. Stained Glass in the United States: Origins, Variety and Preservation. New York: The Gallery at the American Bible Society, 12 November 1998–16 February 1999.

1997

Art and Religion: The Many Faces of Faith. Villanova, PA: Villanova University Art Gallery, 1 July–22 August 1997.

The Body of Christ in the Art of Europe and New Spain, 1150–1800. Houston: Museum of Fine Arts, 21 December, 1997–12 April 1998.

Crowning Glory: Images of the Virgin in the Arts of Portugal. Newark, NJ: The Newark Museum, 26 November, 1997–8 February 1998.

Glory of Byzantium. New York: The Metropolitan Museum of Art, 11 March–6 July 1997.

Bibliography

Compiled by Lindsay M. Koval

*This bibliography comprises works cited by authors in this volume, as well as suggestions for further reading. Works not cited elsewhere in this volume are marked by an asterisk. The editor wishes to thank David Morgan, contributor to this volume, for providing bibliographic suggestions throughout our project. An extensive bibliography of American art and religion is found in Morgan and Sally M. Promey, *Exhibiting the Visual Culture of American Religion*, cited below.

Abrams, M. H. *The Mirror and the Lamp: Romantic Theory and the Critical Tradition*. Oxford: Oxford University Press, 1953.

Abu El-Haj, Nadia. *Facts on the Ground: Archae-ological Practice and Territorial Self-fashioning in Israeli Society*. Chicago: University of Chicago Press, 2001.

*Adams, Doug. *Education and Worship through the Church Year*. Prescott: Educational Ministries, Inc., 1995.

———. *Transcendence with the Human Body in Art: George Segal, Stephen De Staebler, Jasper Johns, and Christo*. New York: Crossroad, 1991.

*———. *The Art of Living: Aesthetic Values and the Quality of Life*. Bellingham: Western Washington University, 1980.

———. *Congregational Dancing in Christian Worship*. Austin: The Sharing Company, 1971.

———. and Diane Apostolos-Cappadona. *Dance as Religious Studies*. New York: Crossroad, 1990.

———. and Diane Apostolos-Cappadona, eds. *Art as Religious Studies*. New York: Crossroad, 1987.

———. and Michael E. Moynahan, eds. *Postmodern Worship and the Arts*. San Jose: Resource Publications, 2002.

African American Experience in Worship and the Arts. New Haven: Yale University Institute of Sacred Music, Worship, and the Arts, 1992.

Anderson, Benedict. *Imagined Communities: Reflections on the Origin and Spread of Nationalism*, rev. ed. London: Verso, [1983] 1991.

Anderson, Maxwell L, et al. *Whitney Biennial: 2000 Biennial Exhibition*. New York: Whitney Museum of American Art, 2000.

Andrew, Dudley. "The Well-Worn Muse: Adaptation in Film History and Theory," in *Narrative Strategies: Original Essays in Film and Prose Fiction*, Sydney M. Conger and Janice R. Welsh, eds. Macomb, IL: Western Illinois University Press, 1980, 9–17.

Andrews, Keith. *The Nazarenes: A Brotherhood of German Painters in Rome*. Oxford: Clarendon Press, 1964.

Antal, F. "Remarks on the Method of Art History: I," *The Burlington Magazine* 91 (1949): 49-52 and 73-75.

*Apostolos-Cappadona, Diane. *Dictionary of Women in Religious Art*. New York: Oxford, 1998.

———. *Dictionary of Christian Art*. New York: Continuum, 1994.

————, ed. *Art, Creativity, and the Sacred*. New York: Crossroad Press, 1984.

**Art and Interreligious Dialogue: Six Perspectives*. Lanham, MD: University Press of America; Waterloo, Ont: Religious Studies Program, University of Waterloo, 1995.

Arthurs, Alberta and Glenn Wallach, eds. *Crossroads. Art and Religion in American Life*. New York: The New Press, 2001.

Asad, Talal. *Formations of the Secular: Christianity, Islam, Modernity*. Stanford: Stanford University Press, 2003.

Atterbury, Paul and Clive Wainwright, eds. *Pugin: A Gothic Passion*. New Haven: Yale University Press, 1994.

Auping, Michael. *Seven Interviews with Tadao Ando*. Lingfield, Surrey: Third Millennium Publishing, 2002.

Axel, Brian Keith. *The Nation's Tortured Body: Violence, Representation, and the Formation of a Sikh "Diaspora."* Durham, NC: Duke University Press, 2000.

Babb, Lawrence A. and Susan S. Wadley, eds. *Media and the Transformation of Religion in South Asia*. Philadelphia: University of Pennsylvania Press, 1995.

Bailey, Albert E. *The Use of Art in Religious Education*. New York: Abingdon Press, 1922.

Bailey, Gauvin A. *Art on the Jesuit Missions in Asia and Latin America, 1542–1773*. Toronto: University of Toronto Press, 1999.

Barasch, Moshe. *Modern Theories of Art, 1: From Winckelmann to Baudelaire*. New York: New York University Press, 1990.

Barnes, Susan J. *The Rothko Chapel: An Act of Faith*. Austin, TX: University of Texas Press, 1989.

Bazin, Germain. *Histoire de l'histoire de l'art de Vasari à nos jours*. Paris: A. Michel, 1986.

Beckett, Wendy. *The Mystical Now: Art and The Sacred*. New York: Universe, 1993.

**Begbie, Jeremy S. *Voicing Creation's Praise: Towards a Theology of the Arts*. Edinburgh: T & T Clark, 1991.

Belting, Hans. *Likeness and Presence: A History of the Image Before the Era of Art*, tr. Edmund Jephcott. Chicago: University of Chicago Press, 1994.

Bekkenkamp, Jonneke, ed. *Missing Links: Arts, Religion, and Reality*. Münster: LIT, 2000.

Bell, Clive. *Art*. New York: Capricorn Books, 1958.

Bendroth, Margaret and Henry Luttikhuisen, eds. *The House of God: Religious Observation within American Protestant Homes*. Grand Rapids, MI.: Calvin College, 2003.

Bennett, Anna G. *Five Centuries of Tapestries from the Fine Arts Museum of San Francisco*. San Francisco: The Fine Arts Museum of San Francisco, 1976 (revised edition Fine Arts Museum of San Francisco: Chronicle Books, 1992).

Benoît, Fernand. *Art et Dieux de la Gaule.* Paris: Artaud, 1969.

Berdyaev, Nicolas. *The Meaning of the Creative Act.* New York: Collier, 1962.

Berenson, Bernard. *Aesthetics and History.* Garden City, NY: Doubleday, [1948] 1954.

*Bernheimer, Richard. *Religion and Art.* New York and Toronto: Art Treasures of the World, 1954.

Besançon, Alain. *The Forbidden Image: An Intellectual History of Iconoclasm*, tr. Jane Marie Todd. Chicago: University of Chicago Press, 2000.

Blaser, Werner. *Tadao Ando: Architektur der Stille Architecture of Silence.* Boston: Birkhäuser, 2001.

Blier, Suzanne Preston. *African Vodun: Art, Psychology, and Power.* Chicago: University of Chicago Press, 1995.

Boenisch, Peter M. "coMEDIA electrONica: Performing Intermediality in Contemporary Theatre." *Theatre Research International* 28.1 (2003): 34–45.

*Bolam, David W., and James L. Henderson. *Art and Belief.* New York: Schocken, 1970.

Bonshek, Anna J. *Mirror of Consciousness: Art, Creativity, and Veda.* Dehli: Motilal Banarsidass, 2001.

Brandon, G. F. *Man and God in Art and Ritual: A Study of Iconography, Architecture and Ritual Action as Primary Evidence of Religious Belief and Practice.* New York: Charles Scribner's Sons, 1975.

Bréhier, Louis. *L'art chrétien: son développment iconographique des origins à nos jours.* Paris: Henri Laurens, 1928.

Brew, Kathy, ed., *Concerning the Spiritual: The Eighties.* San Francisco: San Francisco Art Institute, 1985.

Brown, Frank Burch. *Good Taste, Bad Taste, Christian Taste: Aesthetics in Religious Life.* New York: Oxford University Press, 2000.

———. *Religious Aesthetics: A Theological Study of Making and Meaning.* Princeton: Princeton University Press, 1989.

Buehner, Andrew J., ed. *The Church and the Visual Arts.* Saint Louis, MO: Lutheran Academy for Scholarship, 1968.

Buggeln, Gretchen. *Temples of Grace. The Material Transformation of Connecticut's Churches, 1790–1840.* Hanover: University Press of New England, 2003.

Bullen, J. B. "Byzantinism and Modernism 1900–14." *The Burlington Magazine* 141 (Nov. 1999): 665–75.

Burke, Marcus B. "The Life of Faith and Contemporary Art." In Ena G. Heller, ed., *The Word as Art: Contemporary Renderings.* New York: The Gallery at The American Bible Society, 2000: 37–55

Byrne, Julie. *O God of Players: The Story of the Immaculata Mighty Macs.* New York: Columbia University Press, 2003.

Calder, J. Kent and Susan Neville. *Falling Toward Grace: Images of Religion and Culturea from the Hearland.* Bloomington, IN: Indiana University Press, 1998.

Canons and Decrees of the Council of Trent, Henry John Schroeder. St. Louis, MO: B. Herder, 1941.

Carriere, Moriz. *Die Kunst im Zusammenhang der Culturentwickelung und die Ideale der Menschheit*, 5 vols. Leipzig: F. A. Brockhaus, 1863–74.

Casanova, José. *Public Religions in the Modern World.* Chicago: University of Chicago Press, 1994.

Clark, Lynn Schofield. *From Angels to Aliens: Teenagers, the Media, and the Supernatural.* New York: Oxford University Press, 2003.

Clark, Vicky A., Barbara J. Bloemink, et al. *Comic Release! Negotiating Identity for a New Generation.* New York: Distributed Art Publishers, 2003.

Clifton, James. *The Body of Christ in the Art of Europe and New Spain, 1150–1800.* Munich: Prestel, 1998.

Coleman, Earle. *Creativity and Spirituality: Bonds between Art and Religion*. Albany: State University of New York Press, 1998

Cook, E. T. and Alexander Wedderburn, eds. *The Works of John Ruskin*. London: George Allen, 1904.

*Cope, Gilbert Frederick, ed. *Christianity and the Visual Arts; Studies in the Art and Architecture of the Church*. London: Faith Press, 1975.

Cort, John E. "Art, Religion, and Material Culture: Some Reflections on Method." *Journal of the American Academy of Religion* 64, no. 3 (Fall 1996): 613–32.

Costantini, Ceslo. *L'Art chrétien dans les missions: manuel d'art pour les missionaries*. Paris: Desclée de Brouwer, 1949.

Countryman, William. "How Many Basketsful: Mark 8:14–21 and the Values of Miracles in Mark." *Catholic Biblical Quarterly* 47 (Oct. 1985): 643–55.

Couturier, M.-A. *Sacred Art*. Austin, TX: University of Texas Press, 1983.

Cram, Ralph Adams. *The Catholic Church and Art*. New York: Macmillan, 1930.

Croce, Benedetto. *Aesthetic as Science of Expression and General Linguistic*, tr. Douglas Ainslie. London: Vision Press, 1967.

Crowning Glory. Images of the Virgin in the Arts of Portugal. Newark, NJ: The Newark Museum of Art, 1997.

Crumlin, Rosemary, ed. *Beyond Belief: Modern Art and the Religious Imagination*. Melbourne: National Gallery of Victoria, 1998.

Dal Co, Francesco. *Tadao Ando: Complete Works*. London: Phaidon, 1995.

Davis, Richard. *Lives of Indian Images*. Princeton: Princeton University Press, 1997.

Dean, Carolyn. *Inka Bodies and the Body of Christ*. Durham, NC: Duke University Press, 1999.

de Borchgrave, Helen. *A Journey into Christian Art*. Minneapolis: Fortress, 2000.

*De Concini, Barbara. "State of the Arts: The Crisis in Meaning in Religion and the Arts." *Christian Century* 108, no. 10 (20–27 March, 1991): 323–26.

De Gruchy, John W. *Christianity, Art, and Transformation: Theological Aesthetics in the Struggle for Justice*. Cambridge, Engl.: Cambridge University Press, 2001.

della Seta, Alessandro. *Religion and Art: A Study in the Evolution of Sculpture, Painting, and Architecture*, tr. Marion C. Harrison. London: T. F. Unwin, 1914.

Detzel, Heinrich. *Christliche Ikonographie. Ein Handbuch zum Verständni_ der christlichen Kunst*, 2 vols. Freiburg im Breisgau, 1894.

*Dillenberger, Jane. "The Arts as Sources in Theological Education." *Arts* 4 (Fall 1994): 11–17.

*———. *Image and Spirit in Sacred and Secular Art*. Ed. Diane Apostolos-Cappadona. New York: Crossroad, 1990.

———. "Reflections on the Field of Religion and the Visual Arts." In Doug Adams and Diane Apostolos-Cappadona, eds. *Art as Religious Studies*. New York: Crossroad, 1987: 12–25.

———. *Style and Content in Christian Art*. New York: Crossroad, 1986 [1965].

Dillenberger, John. *Images and Relics: Theological Perceptions and Visual Images in Sixteenth-Century Europe*. London and New York: Oxford University Press, 1999.

*———. "Theological Education and the Visual Arts." *Arts* 5 (Fall 1992): 3–6.

———. *The Visual Arts and Christianity in America. From the Colonial Period to the Present*. New, expanded edition. New York: Crossroad, 1989.

———. *A Theology of Artistic Sensibilities: The Visual Arts and the Church*. New York: Crossroad, 1986.

*———. "Contemporary Theologians and the Visual Arts." *Journal of the American Academy of Religion* 53:4 (Dec. 1985): 599–615.

*———. "The Diversity of Disciplines as a Theological Question: The Visual Arts as Paradigm." *Journal of the American Academy of Religion* 48:2 (June 1980).

———, ed. *John Calvin: Selections from His Writings*. Garden City, N.Y.: Anchor Books, 1971.

———, ed. *Martin Luther: Selections from His Writings*. Garden City, N.Y.: Doubleday, 1961.

*Dillistone, F. W. and James Waddall, eds. *Art and Religion as Communication*. Atlanta: John Knox, 1974.

Dilly, Heinrich. *Deutsche Kunsthistoriker, 1933–1945*. Munich: Deutscher Kunstverlag, 1988.

———. *Kunstgeschichte als Institution: Studien zur Geschichte einer Disziplin*. Frankfurt am Main: Suhrkamp, 1979.

Dixon, John W., Jr. *Images of Truth: Religion and the Art of Seeing*. Atlanta: Scholars Press, 1996.

———. *The Christ of Michelangelo*. Atlanta: Scholars Press, 1994.

———. "What Makes Religious Art Religious." *Cross Currents* (Spring 1993): 5–25.

———. "Reckonings on Religion and Art." *Anglican Theological Review*, vol. 74, no. 2 (Spring 1992): 267–75.

———. "Art as the Making of the World: Outline of Method in the Criticism of Religion and Art." *Journal of the American Academy of Religion*, vol. 51, no. 1 (March 1983): 15–36.

———. *Art and the Theological Imagination*. New York: Seabury Press, 1978.

———. *Nature and Grace in Art*. Chapel Hill: University of North Carolina Press, 1964.

Doss, Erika. "Death, Art, and Memory in the Public Sphere: The Visual and Material Culture of Grief in Contemporary America." *Mortality* 7, no. 1 (2002): 63–82.

———. *Elvis Culture: Fans, Faith, and Image*. Lawrence: University Press of Kansas, 1999.

Driskel, Michael Paul. *Representing Belief: Religion, Art, and Society in Nineteenth-Century France*. University Park: Pennsylvania State University Press, 1992.

Drew, Philip. *Places of Worship*. London: Phaidon, 1999.

Drucker, Johanna. *The Alphabetic Labyrinth: The Letters in History and Imagination*. New York: Thames and Hudson, 1995.

Duffy, Eamon. *The Stripping of the Altars: Traditional Religion in England 1400–1580*. New Haven: Yale University Press, 1992.

Duncan, Carol. *Civilizing Rituals: Inside Public Art Museums*. New York: Routledge, 1995.

Duston, Allen and Arnold Nesselrath. *Angels from the Vatican: The Invisible Made Invisible*. Alexandria, VA: Art Services International, 1998.

Dyrness, William A. *Visual Faith: Art, Theology, and Worship in Dialogue*. Grand Rapids, MI: Baker Book House, 2001.

Eck, Diana L. *Encountering God: A Spiritual Journey from Bozeman to Banaras*, 2nd ed. Boston: Beacon Press, 2003.

———. *Darśan: Seeing the Divine Image in India*. Chambersburg, PA.: Anima Books, 1981.

Egan, Rose Frances. "The Genesis of the Theory of 'Art for Art's Sake' in Germany and in England." Part One, *Smith College Studies in Modern Languages* 2, no. 4 (July 1921): 5–61; Part Two, vol. 5, no. 3 (April 1924): 1–33.

Egenter, Richard. *The Desecration of Christ*, tr. Edward Quinn, ed. Nicolete Gray. Chicago: Franciscan Herald Press, 1967.

Eliade, Mircea. *Symbolism, the Sacred, and the Arts*, ed. Diane Apostolos-Cappadona. New York: Crossroad, 1986.

———. *Patterns in Comparative Religion*, trans. Rosemary Sheed. New York: Sheed and Ward, 1958.

Elkins, James. *Pictures and Tears: A History of People Who Have Cried in Front of Paintings*. New York: Routledge, 2001.

———. *The Object Stares Back: On the Nature of Seeing*. New York: Simon and Schuster, 1996.

Ernstrom, Adele M. "'Why should we be always looking back?' 'Christian Art' in nineteenth-century Historiography in Britain." *Art History* 22 (1999): 421–435.

Fabre, Abel. *Pages d'art Chrétien*. Paris: Bonne Presse, 1927.

Fernández-Olmos, Margarite and Lizabeth Paravisini-Gebert. *Creole Religions of the Caribbean*. New York: New York University Press, 2003.

Finaldi, Gabriele, ed. *The Image of Christ*. London: National Gallery, 2000.

Focillon, Henri. *The Life of Forms in Art*, tr. Charles B. Hogan and George Kubler. New York: Zone Books, 1989. [Original, *La Vie des Formes*, 1934].

Foucart, Bruno. *Le Renouveau de la peinture religieuse en France (1800–1860)*. Paris: Arthéna, 1987.

Frank, Frederick. *Art as a Way: A Return to the Spiritual Roots*. New York: Crossroad, 1981.

Freedberg, David. *The Power of Images: Studies in the History and Theory of Response*. Chicago: University of Chicago Press, 1989.

Furuyama, Masao. *Tadao Ando*. Boston: Birkhäuser, 1996.

Gablik, Suzi. *The Reenchantment of Art*. London: Thames and Hudson, 1991.

Galante, Pierre. *Malraux*. New York: Cowles Book Co., 1971.

*García-Rivera, Alex. *A Wounded Innocence: Sketches for a Theology of Art*. Collegeville, MN: Liturgical Press, 2003.

García-Rivera, Alex. *The Community of the Beautiful: A Theological Aesthetics*. Collegeville, MN: Liturgical Press, 1999.

Gardiner, Percy. *The Principles of Christian Art*. London: John Murray, 1928.

Germann, Georg. *Gothic Revival in Europe and Britain: Sources, Influences and Ideas*. Cambridge, MA: MIT Press, 1973.

Giedion, Sigfried. *Space, Time and Architecture: The Growth of a New Tradition*. Cambridge, MA: Harvard University Press, 1941.

Goa, David J., Linda Distad, and Matthew Wangler. *Anno Domini. Jesus through the Centuries*. Edmonton, Canada: The Provincial Museum of Atlanta, 2000.

Goffen, Rona. *Piety and Patronage in Renaissance Venice: Bellini, Titian, and the Franciscans*. New Haven: Yale University Press, 1986.

Goldsworthy, Andy. *Time: Andy Goldsworthy*. New York: Harry N. Abrams, 2000.

Gombrich, E. H. *The Story of Art I*. New York: Phaidon, 1950.

Gover, Louise. "Gods in the Gallery." *The Art Quarterly* 8/Winter (1991): 37–40.

Grabar, Oleg. *The Formation of Islamic Art*, rev. ed. New Haven: Yale University Press, 1987.

Greenberg, Clement. *The Collected Essays and Criticism*. Chicago: University of Chicago Press, 1993.

———. *Arrogant Purpose, 1945–1949, The Collected Essays and Criticism*, ed., John O'Brian. Chicago: University of Chicago Press, 1986.

Greenfeld, Liah. *Nationalism: Five Roads to Modernity*. Cambridge, MA: Harvard University Press, 1992.

Grewe, Cordula. *Painting Religion: Art and the Sacred Imaginary in German Romanticism*. Burlington, VT: Ashgate, forthcoming.

Griffith-Jones, Robin. *The Four Witnesses: The Rebel, the Rabbi, the Chronicler, and the Mystic*. New York: Harper San Francisco [Harper Collins Publishers], [2000].

Grimes, Ronald L. "Sacred Objects in Museum Spaces." *Studies in Religion/Sciences Religieuses* 21, no. 4 (1992): 419–30.

Grimouard de Saint-Laurent, Henri. *Guide de l'art chrétien: études d'esthétique et d'iconographie*, 5 vols. Paris: Librarie archéologique de Didron, 1872–74.

Gruzinski, Serge. *Images at War: Mexico from Columbus to Blade Runner (1492–2019)*, tr. Heather MacLean. Durham, NC: Duke University Press, 2001.

Guha-Thakurta, Tapati. "Archaeology and the Monument: An Embattled Site of History and Memory in Contemporary India." In Robert S. Nelson and Margaret Olin, eds. *Monument and Memory, Made and Unmade*. Chicago: University of Chicago Press, 2003, 233–257.

Guilbaut, Serge. *How New York Stole the Idea of Modern Art: Abstract Expressionism, Freedom, and the Cold War*. Chicago: University of Chicago Press, 1983.

Hackett, Rosalind I. J. *Art and Religion in Africa*. London: Cassell, 1996.

Haeger, Barbara Joan. "The Religious Significance of Rembrandt's Return of the Prodigal Son: An Examination of the Picture in the Context of the Visual and Iconographic Tradition." Ph.D. dissertation, University of Michigan, 1983.

Hamburger, Jeffrey F. *Nuns as Artists: The Visual Culture of a Medieval Convent*. Berkeley: University of California Press, 1997.

———. *The Visual and the Visionary: The Image in Late Medieval Monastic Devotions*. New York: Zone Books, 1998.

Harned, David Bailey. *Theology and the Arts*. Philadelphia: Westminster, 1966.

Harris, Maria. "Art and Religious Education: A Conversation." *Religious Education* 83 (Summer 1988): 453–73.

Hartlaub, G. F. *Kunst und Religion: Ein Versuch über die Möglichkeit neuer Religiöser Kunst*. Leipzig: Kurt Wolff Verlag, 1919.

Harootunian, Harry. "Memory, Mourning, and National Morality: Yasukuni Shrine and the Reunion of State and Religion in Postwar Japan." In Peter van der Veer and Hartmut Lehmann, eds., *Nation and Religion: Perspectives on Europe and Asia*. Princeton: Princeton University Press, 1999, 144–60.

*Harris, Neil. *The Artist in American Society: The Formative Years 1790–1860*. Chicago: University of Chicago Press, 1966.

Hart, Frederick, Homan Potterton, and Tom Wolfe. *Frederick Hart Sculptor*. New York: Hudson Hills Press, 1994.

Hayum, Andrée. *The Isenheim Altarpiece: God's Medicine and the Painter's Vision*. Princeton: Princeton University Press, 1989.

Hazelton, Roger. *A Theological Approach to the Visual Arts*. Nashville: Abingdon, 1967.

Hedling, Erik and Ulla-Britta Lagerroth, eds. *Cultural Functions of Intermedial Exploration*. Amsterdam: Rodopi, 2002.

Hegel, G. W. F. *Aesthetics: Lectures on Fine Art*, 2 vols., tr. J. M. Knox. Oxford: Clarendon, 1998.

———. *On Art, Religion, Philosophy: Introductory Lectures to the Realm of Absolute Spirit*, ed. and tr. J. Glenn Gray. New York: Harper Torchbooks, 1970.

Heller, Ena Giurescu, ed. *Icons or Portraits? Images of Jesus and Mary from the Collection of Michael Hall*. New York: The Gallery at the American Bible Society, 2002.

Hendricks, William L., et al. *Southern Baptists and the Arts*. Louisville: Southern Baptist Theological Seminary, 1990.

Heneghan, Tom. *The Colours of Light: Tadao Ando Architecture*. London: Phaidon, 1996.

Hersey, John. *Hiroshima*. New York: A.A. Knopf, 1946.

Heyer, George S. *Signs of Our Times: Theological Essays on Art in the Twentieth Century*. Grand Rapids, MI: Eerdmans, 1980.

188

Higgins, Dick. *Horizons: the Poetics and Theory of the Intermedia*. Carbondale, IL: Southern Illinois Univ. Press, 1984.

Hill, Gary. *Gary Hill: Selected Works and catalogue raisonné*. Wolfsburg: Kunstmuseum Wolfsburg, 2002.

Hilton, Tim. *John Ruskin*. New Haven: Yale University Press, 2002.

Hinnells, John R. "Religion and the Arts." In Ursula King, ed., *Turning Points in Religious Studies: Essays in Honour of Geoffrey Parrinder*. Edinburgh: T. & T. Clark, 1990, 257—74.

Hobbs, Edward. "The Gospel of Mark and the Exodus." Ph.D. dissertation, University of Chicago, 1958.

Hoffman, Konrad and Florens Deuchler. *The Year 1200*. New York: The Metropolitan Museum of Art, 1970.

Hollstein, F. W. H. *German Engravings and Woodcuts, ca. 1400–1700*. New Series, 5 vols. Roosendaal: Royal Van Poll Printers, 1993.

Howitt, Margaret. *Friedrich Overbeck. Sein Leben und Schaffen*, 2 vols. Bern. Herbert Lang, 1971.

Huizinga, Johan. *The Autumn of the Middle Ages*, tr. Rodney J. Payton and Ulrich Mammitzsch. Chicago: University of Chicago Press, 1996 [1919].

Huyler, Stephen P. *Meeting God: Elements of Hindu Devotion*. New Haven: Yale University Press, 1999.

Hygen, Johan B. *Morality and the Muses: Christian Faith and Art Forms*, tr. Harris E. Kaasa. Minneapolis: Augsburg Publishing House, 1965.

Inbody, Tyron, ed. *Changing Channels: The Church and the Television Revolution*. Dayton, OH: Whaleprints, 1990

Insights: Museums, Visitors, Attitudes, Expectations: A Focus Group Experiment. Malibu: Getty Center for Education in the Arts, 1991.

Isard, Walter. *Commonalities in Art, Science, and Religion: An Evolutionary Perspective*. Aldershot, Engl.: Brookfield: Avebury, 1996.

Ivey, Paul Eli. *Prayers in Stone: Christian Science Architecture in the United States, 1894–1930*. Urbana, IL: University of Illinois Press, 1999.

Jensen, Joli. *Is Art Good for Us? Beliefs about High Culture in American Life*. Oxford: Rowman & Littlefield, 2002.

Jinarajadasa, C. *Karma-less-ness: Theosophical Essays on Art*. Madras: Theosophical Publishing House, 1932.

Jung, Carl C., et al. *Man and His Symbols*. Garden City, NY: Doubleday, 1964.

Kandinsky, Wassily. *Concerning the Spiritual in Art*, tr. M.T.H. Sadler. New York: Dover, 1977; original: *Ueber das Geistige in der Kunst*, 1912.

Kant, Immanuel. *Observations on the Feeling of the Beautiful and Sublime*, tr. John T. Goldthwait. Berkeley: University of California Press, 1960.

Katz, Melissa R. and Robert R. Orsi, *Divine Mirrors: The Virgin Mary in The Visual Arts*. New York: Oxford University Press, 2001.

Kilde, Jeanne Halgren. *When Church Became Theatre: The Transformation of Evangelical Architecture and Worship in Nineteenth-Century America*. New York: Oxford University Press, 2002.

Kieschnick, John. *The Impact of Buddhism on Chinese Material Culture*. Princeton: Princeton University Press, 2003.

Kleinschmidt, Beda, O.F.M. *Lehrbuch der christlichen Kunstgeschichte*. Paderborn: Ferdinand Schöningh, 1910.

Konrad, Joachim. *Religion und Kunst: Versuch einer Analyse ihrer prinzipiellen Analogien*. Tübingen: J. C. B. Mohr, 1929.

Kraus, Franz Xaver. *Geschichte der christlichen Kunst*, 2 vols. Freiburg im Breisgau, 1908.

Kristeva, Julia. *Revolution in Poetic Language*, trans. Leon Roudiez. New York: Columbia University Press, 1984.

Kultermann, Udo. *The History of Art History*. New York: Abaris Books, 1993.

Künstle, Karl. *Ikonographie der christlichen Kunst*, 2 vols. Freiburg im Breisgau: Herder, 1926–28.

Kuspit, Donald. "Reconsidering The Spiritual in Art." *Art Criticism* 17, no. 2 (2002): 55–69.

Ladis, Andrew and Shelley E. Zuraw. *Visions of Holiness: Art and Devotion in Renaissance Italy* (Athens, GA: Georgia Museum of Fine Art, University of Georgia, 2001.

*Laeuchli, Samuel. *Religion and Art in Conflict: Introduction to a Cross-disciplinary Task*. Philadelphia: Fortress Press, 1980.

Lange, Konrad. *Das Wesen der Kunst: Grundzüge einer realistischen Kunstlehre*, 2 vols. Berlin: G. Grote, 1901.

Lavin, Irving, ed. *Meaning in the Visual Arts: Views from the Outside. A Centennial Commemoration of Irwin Panofsky (1892–1968)*. Princeton: Institute for Advanced Study, 1995.

Lekan, Thomas M. *Imagining the Nation in Nature: Landscape Preservation and German Identity, 1885–1945*. Cambridge, MA: Harvard University Press, 2003.

Lethaby, William. *Architecture, Mysticism, and Myth*. London: Percival & Co., 1892.

———. *Medieval Art, from the Peace of the Church to the Eve of the Renaissance, 312–1350*. New York: Nelson, 1904.

Lévéque, Charles. *Le spiritualisme dans l'art*. Paris: Germer Bailliere, 1864.

Lévy-Bruhl, Lucien. *How Natives Think*, tr. Lilian A. Clare. Princeton: Princeton University Press, 1985.

Lewis-Williams, J. David. *A Cosmos in Stone: Interpreting Religion and Society through Rock Art*. Walnut Creek, CA: Alta Mira Press, 2002.

Linde, Ernst. *Religion und Kunst*. Tübingen: J. C. B. Mohr, 1905.

Lindsay, Arturo, ed. *Santería Aesthetics in Contemporary Latin American Art*. Washington: Smithsonian Institution Press, 1996.

Lindsay, Lord. *Sketches of the History of Christian Art*, 2 vols., 2nd ed. London: John Murray, 1885 [1846].

Lings, Martin. *The Quranic Art of Calligraphy and Illumination*. London: World of Islam Festival Trust, 1976.

Lipsey, Roger. *An Art of Our Own: The Spiritual in Twentieth Century Art*. Boston: Shambhala, 1989.

Loir, Christophe. *La sécularisation des oeuvres d'art dans le Brabant (1773–1842): la création du musée de Bruxelles*. Bruxelles: Éditions de l'Université de Bruxelles, 1998.

Lowie, Robert H. *Primitive Religion*. New York: Liveright, 1948 [1924].

Macmurray, John. *Religion, Art, and Science: A Study of the Reflective Activities in Man*. Liverpool: Liverpool University Press, 1961.

MacGregor, Neil. *Seeing Salvation: Images of Christ in Art*. New Haven: Yale University Press, 2000.

Malraux, André. *Les voix du silence*. Paris: NRJ, 1951.

Man, John. *Alpha Beta: How 26 Letters Shaped the Western World*. New York: John Wiley & Sons, 2000.

Mann, Vivian B., *Jewish Texts on the Visual Arts*. Cambridge, MA: Cambridge University Press, 2000.

Marsden, Peter V. "Religious Americans and the Arts in the 1990s." In Alberta Arthurs and Glenn Wallach, eds. *Crossroads: Art and Religion in American Life*. New York: New Press, 2001, 71–102.

Interview with Kerry James Marshall on the PBS show *art:21*.

Martin, David F. *Art and the Religious Experience: The "Language" of the Sacred*. Lewisburg: Bucknell University Press, 1972.

Martin, James Alfred, Jr. *Beauty and Holiness: The Dialogue between Aesthetics and Religion*. Princeton: Princeton University Press, 1990.

Martland, Thomas. *Religion as Art: An Interpretation*. Albany: State University of New York Press, 1981.

Mathews, Patricia Townley. *Aurier's Symbolist Art Criticism and Theory*. Ann Arbor: UMI Research Press, 1986.

Matisse, Henri, M.-A. Couturier, L.-B. Rayssiguier. *The Vence Chapel: The Archive of Creation*. Milan: Skira, 2003.

Maurer, Naomi E. *The Pursuit of Spiritual Wisdom: The Thought and Art of Vincent van Gogh and Paul Gauguin*. Madison, NJ: Fairleigh Dickinson University Press; London: Associated University Presses, 1998.

*May, John, ed. *The Bent World: Essays on Religion and Culture*. New York: Scholars Press, 1981.

McClellan, Andrew. *Inventing the Louvre: Art, Politics, and the Origins of the Modern Museum in Eighteenth-Century Paris*. Berkeley: University of California Press, 1999.

McDannell, Colleen. *Material Christianity: Religion and Popular Culture in America*. New Haven: Yale University Press, 1995.

Meier-Graefe, Julius. *Modern Art Being a Contribution to a New System of Aesthetics*. New York: G.P.Putnam's Sons, 1908.

Meléndez, Antonio Alonso. *Time of Hope (Tiempo de esperanza)*. Castilla y León, Spain: Junta de Castilla y León, 2002.

Menneckes, Friedhelm, S.J. "Between Doubt and Rapture—Art and Church Today: The Spiritual in the Art of the Twentieth Century." *Religion and the Arts* 4, no. 2 (2000): 165–83.

Meyer, Jeffrey F. *Myths in Stone: Religious Dimensions of Washington, D.C.* Berkeley: University of California Press, 2001.

Michels, Karen. *Transplantierte Kunstwissenschaft: Deutschsprachige Kunstgeschichte im amerikanischen Exil*. Berlin: Akademie Verlag, 1999.

Middleton, Darren J. N., ed., *Scandalizing Jesus?: Reappreciating Kazantzakis's The Last Temptation of Christ*. Harrisburg, PA: Trinity Press International, forthcoming, 2005.

Miles, Margaret R. *Carnal Knowledge: Female Nakedness and Religious Meaning in the Christian West*. Boston: Beacon, 1989.

*———. *Image as Insight: Visual Understanding in Western Christianity and Secular Culture*. Boston: Beacon Press, 1985.

Mitchell, W. J. T., ed. *Art and the Public Sphere*. Chicago: University of Chicago Press, 1992.

Moon, Beverly, ed. *An Encyclopedia of Archetypal Symbolism. The Archive for Research in Archetypal Symbolism*. Boston: Shambhala, 1991.

Moore, Albert C. *Arts in the Religions of the Pacific: Symbols of Life*. London: Pinter, 1995.

———. *Iconography of Religions: An Introduction*. Philadelphia: Fortress Press, 1977.

Morgan, David. "Aesthetics." *Encylopedia of Protestantism*, 4 vols., ed. Hans Hillerbrand. New York: Routledge, 2003.

*———. "Religious Imagery and Visual Practice in American Mass Culture." In *Practicing Religion in the Age of the Media: Explorations in Media, Religion and Culture*, ed. Stewart Hoover and Lynn Schofield Clark. New York: Columbia University Press, 2002, 37–62.

*———. "Religion in the Context of Art," in *Like a Prayer: A Jewish and Christian Presence in Contemporary Art*, ed., Ted Prescott, Tryon Center for Visual Arts, Charlotte, NC, 2001, 18–31.

———. *Religious Visual Culture in Theory and Practice*. Berkeley: University of California Press, 2001.

———. "Visual Religion," *Religion* 30 (2000): 41–53.

―――. *Protestants and Pictures: Religion, Visual Culture, and the Age of American Mass Production.* New York: Oxford University Press, 1999.

―――. "Secret Knowledge and Self-Effacement: The Spiritual in Art in the Modern Age." In Richard Francis, ed., *Negotiating Rapture.* Chicago: Museum of Contemporary Art, 1996, 34–47.

―――. *Visual Piety: A History and Theory of Popular Religious Images.* Berkeley: University of California Press, 1998.

―――― and Sally M. Promey, eds. *The Visual Culture of American Religions.* Berkeley: University of California Press, 2001.

―――― and Sally M. Promey, eds. *Exhibiting the Visual Culture of American Religions.* Valparaiso, IN: Brauer Museum of Art, Valparaiso University, 2000.

Moritz, Karl Philipp. "Versuch einer Vereinigung aller schönen Künste und Wissenschaften unter dem Begriff des in sich selbst Vollendeten." (1785). Reprinted in Moritz, *Schriften zur Aesthetik und Poetik*, ed. Hans Joachim Schrimpf. Tübingen: Max Niemeyer, 1962.

Mosse, George L. *The Nationalization of the Masses: Political Symbolism and Mass Movements in Germany from the Napoleonic Wars through the Third Reich.* Ithaca: Cornell University Press, 1975.

Murray, Peter and Linda. *Dictionary of Christian Art.* New York: Oxford University Press, 2001.

*Murray, Sister Mary Charles. "Art and The Tradition: Theology, Art, and Meaning." *Arts: The Arts in Religious and Theological Studies.* II: 2 (1999): 28–35.

Nathan, Walter L. *Art and the Message of the Church.* Philadelphia: Westminster Press, 1961.

Nelson, Robert S. *Hagia Sophia, 1850–1950: Holy Wisdom Modern Monument.* Chicago: University of Chicago Press, forthcoming 2004.

―――. "Signs of the Times: Modernist Churches in the Greek Orthodox Diocese of Chicago," *Criterion* 40 (2001): 16–23.

―――. "The Map of Art History." *Art Bulletin* 79, no. 1 (March 1997): 28–40.

―――., ed. *Visuality Before and After the Renaissance: Seeing as Others Saw.* Cambridge, Engl.: Cambridge University Press, 2000.

Newport, John. *Christianity and Contemporary Art Forms.* Waco, TX: Word Books, 1979.

Nodelman, Sheldon. *The Rothko Chapel Paintings: Origins, Structure, Meaning.* Austin, TX: University of Texas Press, 1997.

Nouwen, Henri J. M. *The Return of the Prodigal Son: A Story of Homecoming.* New York: Doubleday, 1992.

Nussaume, Yann. *Tadao Andô et la question du milieu: réflexions sur l'architecture et le paysage.* Paris: Moniteur, 1999.

Olin, Margaret. *The Nation without Art: Examining Modern Discourses on Jewish Art.* Lincoln, NE: University of Nebraska Press, 2001.

―――. "From Bezal'el to Max Lieberman, Jewish Art in Nineteenth-Century Art Historical Texts." C. M. Sousselof, ed., *Jewish Identity in Modern Art History.* Berkeley: University of California Press, 1999, 19–40.

―――. "The Cult of Monuments as a State Religion in late 19th Century Austria." *Wiener Jahrbuch für Kunstgeschichte* 38 (1985): 177–98.

Ong, Walter. *Orality and Literacy.* London: Routledge, 1982.

Orsi, Robert. *The Madonna of 115th Street: Faith and Community in Italian Harlem, 1890–1950,* 2nd ed. New Haven: Yale University Press, 2002.

―――., ed. *Gods of the City.* Bloomington: Indiana University Press, 1999.

Otto, Rudolf. *The Idea of the Holy: An Inquiry into the Non-Rational Factor in the Idea of the Divine and its Relation to the Rational,* tr. John W. Harvey. London: Oxford University Press, 1950.

Ouaknin, Marc-Alain. *Mysteries of the Alphabet.* New York: Abbeville Press, 1999.

Paine, Crispin ed. *Godly Things: Musems, Objects, and Religion*. London: Leicester University Press, 2000.

*Palmer, Michael F. *Paul Tillich's Philosophy of Art*. Berlin: de Gruyter, 1983.

Panofsky, Erwin. "Three Decades of Art History in the United States: Impressions of a Transplanted European." Reprinted in *Meaning the Visual Arts*. Garden City, NY: Doubleday, 1955, 321–346.

Papadakis, Andreas C., ed. *Abstract Art and the Rediscovery of the Spiritual*. London: Art & Design, Academy Group Ltd., 1987.

Parezo, Nancy J. *Navajo Sandpainting: From Religious Act to Commercial Art*. Albuquerque, NM: University of New Mexico Press, 1991.

Pattison, George. *Art, Modernity, and Faith: Towards a Theology of Art*. New York: St. Martin's Press, 1991.

Pearce, Susan M., ed. *Interpreting Objects and Collections*. London: Routledge, 1994.

Pelikan, Jaroslav. *Jesus through the Centuries: His Place in the History of Culture*. New Haven: Yale University Press, 1985.

Pfeiffer, John E. *The Creative Explosion: An Inquiry into the Origins of Art and Religion*. New York: Harper and Row, 1982.

Pihl, Marshall. *The Korean Singer of Tales*. Cambridge: Harvard University Press, 1994.

Pijper, F. *Handboek tot de geschiedenis der Christelijke Kunst*. 'S-Gravenhage: Martinus Nijhoff, 1917.

Plate, S. Brent, ed. *Religion, Art, and Visual Culture: A Cross-Cultural Reader*. New York: Palgrave, 2002.

Plazaola, Juan. *Historia y sentido del arte cristiano*. Madrid: Biblioteca de autores cristianos, 1996.

Portig, Gustav. *Religion und Kunst in ihrem gegenseitigen Verhältniss*, 2 vols. Iserlohn: J. Bädeker, 1879–80.

*Powell, Richard J. "Art, History, and Vision." *The Art Bulletin* 77:3 (1995): 379–82.

Prescott, Theodore, ed. *Like A Prayer: A Jewish and Christian Presence in Contemporary Art*. Charlotte, NC: Tryon Center for Visual Art, 2001.

Printing the Word: The Art of Watanabe Sadao (New York: The Gallery at the American Society, 2000).

Promey, Sally M. "The 'Return' of Religion in the Scholarship of American Art," *The Art Bulletin* 85, no. 3 (September 2003): 581–603.

———. *Painting Religion in Public: John Singer Sargent's Triumph of Religion at the Boston Public Library*. Princeton: Princeton University Press, 1999.

*———. "Celestial Visions: Shaker Images and Art Historical Method." *American Art* 7, no. 2 (Spring 1993): 78–99.

———. *Spiritual Spectacles: Image and Vision in Mid-Nineteenth-Century Shakerism*. Bloomington: Indiana University Press, 1993.

Prothero, Stephen. *American Jesus: How the Son of God Became a National Icon*. New York: Farrar, Straus, and Giroux, 2003.

Prown, Jules David. *Art as Evidence: Writings on Art and Material Culture*. New Haven: Yale University Press, 2001.

Rayburn, David M., Daven M. Kari, and Darrell G. Gwaltney, eds. *Baptist Reflections on Christianity and the Arts: Learning from Beauty. A Tribute to William L. Hendricks*. Lewiston: E. Mellen Press, 1997.

Read, Sir Herbert Edward. *Art and Society*. New York: Macmillan, 1937.

———. *Icon and Idea: The Function of Art in the Evolution of Human Consciousness*. Cambridge, MA.: Harvard University Press, 1955.

Réau, Louis. *Iconographie de l'art chrétien*, 3 vols. Paris: *Presses universitaires de France*, 1955–59.

Regier, Kathleen J., ed. *The Spiritual Image in Modern Art*. Wheaton, IL: Theosophical Publishing House, 1987.

193

*"Religion and the Visual Arts: A Case Study."
Religion and Intellectual Life. 1:1 (1983): 3–103.

Rinder, Lawrence R., et al. *2002 Biennial Exhibition*. New York: Whitney Museum of American Art, 2002.

Robbins, Daniel. "From Symbolism to Cubism: The Abbaye of Créteuil." *Art Journal* 23, no. 2 (Winter 1963): 112–16.

Roberts, Allen F. and Mary Nooter Roberts. *A Saint in the City: Sufi Arts of Urban Senegal*. Los Angeles: UCLA Fowler Museum of Cultural History, 2003.

Rookmaaker, H. R. *Art Needs No Justification*. Downer's Grove, IL: Inter-Varsity Press, 1978.

———. *Modern Art and the Death of a Culture*. London: Intervarsity Press, 1970.

Rose, Michael S. *Ugly as Sin: Why They Changed Our Churches From Sacred Places to Meeting Spaces and How We Can Change Them Back Again*. Manchester, NH: Sophia Institute Press, 2001.

Rosenblum, Robert. *Modern Painting and the Northern Romantic Tradition: Friedrich to Rothko*. New York: Harper & Row, 1975.

Rotberg, Robert I. and Theodore K. Rabb, eds. *Art and History. Images and Their Meaning*. Cambridge: Cambridge University Press, 1988.

Ruskin, John. *The True and the Beautiful in Nature, Art, Morals, and Religion*, ed., Mrs. L. C. Tuthill. New York: John Wiley & Sons, 1870.

Schaeffer, Franky. *Addicted to Mediocrity: 20th Century Christians and the Arts*. Westchester, IL: Cornerstone Books, 1981.

Schiller, Gertrud. *Iconography of Christian Art*, 2 vols., tr. Janet Seligman. Greenwich, CT: New York Graphic Society, 1971.

Schiller, Friedrich. *On the Aesthetic Education of Man in a Series of Letters*, ed. and tr. Elizabeth M. Wilkinson and L. A. Willoughby. Oxford: Clarendon Press, 1967.

Schlegel, A. W. *Vorlesungen über schöne Literatur und Kunst*, ed. Bernhard Seuffert. Stuttgart: G. J. Göschen, 1884.

Schlegel, Friedrich. "Dritter Nachtrag alter Gemählde." *Europa*, vol. 2 (1803).

Schleiermacher, Friedrich. *On Religion: Speeches to Its Cultural Despisers*, tr. Richard Crouter. Cambridge, Engl.: Cambridge University Press, 1988.

Schopen, Gregory. "Archeology and Protestant Presuppositions in the Study of Indian Buddhism." *History of Religions* 31, no. 1 (1991): 1–25.

Schopenhauer, Arthur. *The World as Will and Representation*, tr. E. F. J. Payne, 2 vols. New York: Dover, 1969 [1818].

*Schroeder, Henry Joseph, *Canons and Decrees of the Council of Trent*. St. Louis, MO: B. Herder Book Co., 1960, 1941.

Scribner, R. W. *For the Sake of Simple Folk: Popular Propaganda for the German Reformation*. Oxford: Clarendon Press, 1984.

Sedlmayr, Hans. *Verlust der Mitte: die bildende Kunst des 19. und 20. Jahrhunderts als Symptom und Symbol der Zeit*. Salzburg: O. Müller, 1948.

Semali, Ladislaus and Ann Watts-Pailliotet, eds *Intermediality: The Teachers' Handbook of Critical Media Literacy*. Boulder, CO: Westview, 1999.

Sexson, Lynda. *Ordinarily Sacred*. Charlottesville, VA: University of Virginia Press, 1992.

Sherry, Patrick. *Spirit and Beauty: An Introduction to Theological Aesthetics*. Oxford: Clarendon Press, 1992.

Shlain, Leonard. *The Alphabet Versus the Goddess: The Conflict Between the Word and the Image*. New York: Viking, 1998.

Sinding-Larsen, Staale. *"Créer des images: remarques pour une théorie de l'image."* In Françoise Dunand, Jean-Michel Spieser, and Jean Wirth, eds. *L'image et la production du sacré*. Paris: Méridiens Klincksieck, 1991, 6–71.

Smith, Jeffrey Chipps. *Sensuous Worship: Jesuits and the Art of the Early Catholic Reformation in Germany*. Princeton: Princeton University Press, 2002.

Spaeth, David. *Mies van der Rohe*. New York: Rizzoli, 1985.

Spiegelman, Art. *Maus II: A Survivor's Tale: And Here My Troubles Began*. New York: Pantheon, 1991.

————. *Maus I: A Survivor's Tale Volume 1: My Father Bleeds History*. New York: Pantheon, 1986.

Stein, Roger B. *John Ruskin and Aesthetic Thought in America, 1840–1900*. Cambridge: Harvard University Press, 1967.

Steinberg, Leo. *The Sexuality of Christ in Renaissance Art and in Modern Oblivion*, 2nd. ed. Chicago: University of Chicago Press, 1996.

Steiner, Rudolf. *The Arts and Their Mission*. New York: Anthroposophic Press, 1964.

Stephens, Mitchell. *The Rise of the Image, The Fall of the Word*. New York: Oxford University Press, 1998.

Stewart, Charles. "Syncretism and Its Synonyms: Reflections on Cultural Mixture." *Diacritics* 29.3 (1999): 40–62.

Strohm, Stefan, ed. *Die Bibelsammlung der Wuerttembergischen Landesbibliothek Stuttgart*. Stuttgart: Fromann-Holzboog, 1984.

Strzygowski, Josef. *Spuren indogermanischen Glaubens in der Bildenden Kunst*. Heidelberg: C. Winter, 1936.

Suhr, Norbert. *Philipp Veit (1793–1877). Leben und Werk eines Nazareners*. Weinheim: VCH Verlagsgesellschaft, 1991.

Sweeney, Kevin M. "Meetinghouses, Town Houses, and Churches: Changing Perceptions of Sacred and Secular Space in Southern New England, 1720–1850." *Winterthur Portfolio* 28 (Spring 1993): 59–93.

Takenaka, Masao. *Christ Art in Asia*. Kyoto: Kyo Bun Kwan with Christian Conference of Asia, 5.

Tambiah, Stanley Jeyaraja. *The Buddhist Saints of the Forest and the Cult of Amulets: A Study in Charisma, Hagiography, Sectarianism, and Millennial Buddhism*. Cambridge, Engl.: Cambridge University Press, 1984.

Taylor, Mark C. *Disfiguring: Art, Architecture, Religion*. Chicago: University of Chicago Press, 1992.

Tillich, Paul. *On Art and Architecture*, tr. Robert P. Scharlemann, John Dillenberger and Jane Dillenberger, eds. New York: Crossroad, 1987.

Tolstoy, Leo. *What is Art?*, tr. Charles Johnston. Philadelphia: H. Altemus, 1898 [1896].

Tuchman, Maurice, et al. *The Spiritual in Art: Abstract Painting 1890–1985*. Los Angeles: Los Angeles County Museum of Art, 1986.

van der Leeuw, Gerardus. *Sacred and Profane Beauty: The Holy in Art*, tr. David E. Green. New York: Holt, Rinehart and Winston, 1963.

van Os, Henk, et al. *The Art of Devotion in the Late Middle Ages in Europe, 1300–1500*. Princeton: Princeton University Press, 1994.

*Viladeseau, Richard. *Theology and the Arts: Encountering God Through Music, Art, and Rhetoric*. New York: Paulist Press, 2000.

————. *Theological Aesthetics: God in Imagination, Beauty, and Art*. New York: Oxford University Press, 1999.

von Balthasar, Hans Urs. *The Glory of the Lord: A Theological Aesthetics*. Edinburgh: T & T Clark, 1982.

Walton, Janet R. *Art and Worship: A Vital Connection*. Wilmington, DE: M. Glazier, 1988.

Warner, R. Stephen. "Work in Progress toward a New Paradigm for the Sociological Study of Religion in the United States." *American Journal of Sociology*, 98 no. 5 (1993): 1044–93.

Watt, Tessa. *Cheap Print and Popular Piety 1550–1640*. Cambridge, Engl.: Cambridge University Press, 1991.

Werner, Wolf. *The Musicalization of Fiction: A Study in the Theory and History of Intermediality*. Amsterdam: Rodopi, 1999.

Wheeler, Michael. *Ruskin's God*. New York: Cambridge University Press, 1999.

White, James F. *Christian Worship in North America, A Retrospective: 1955–1995*. Collegeville, MN: Liturgical Press, 1997.

Wiedmann, August. *Romantic Roots in Modern Art: Romanticism and Expressionism: A Study in Comparative Aesthetics*. Surrey, Engl.: Gresham Books, 1979.

Wilcox, John. "The Beginnings of *l'art pour l'art*." *Journal of Aesthetics and Art Criticism* 11 (June 1953): 360–77.

Williams, Peter W. "Sacred Space in North America." *Journal of the American Academy of Religion* 70, no. 3 (September 2002): 593–609.

Winckelmann, Joann Joachim. *Reflections on the Imitation of Greek Works in Painting and Sculpture*, tr. Elfriede Heyer and Roger C. Norton. La Salle, IL: Open Court, 1987.

Wittgenstein, Ludwig. *Philosophical Investigations: The English Text of the Third Edition*, tr. G.E.M. Anscombe. New York: Macmillan Publishing, 1958.

Witvliet, John. "Toward a Liturgical Aesthetic: An Interdisciplinary Review of Aesthetic Theory." *Liturgy Digest* 3:1 (Winter 1996): 4–86.

*Wolterstorff, Nicholas. "Evangelicalism and the Arts." *Christian Scholar's Review* 17, no. 4 (1988): 449–73.

———. *Art in Action: Toward a Christian Aesthetic*. Grand Rapids, MI: Eerdmans, 1980.

Wood, Christopher. *The Pre-Raphaelites*. New York: Viking, 1981.

Wood, Christopher S. "Art History's Normative Renaissance." In *The Italian Renaissance in the Twentieth Century*, Allen J. Grieco, et al., eds. Florence: Olschki, 2002, 65–92.

Worringer, Wilhelm. *Abstraktion und Einfühlung*. Munich: Reinhold Piper, 1908.

Wuthnow, Robert. *All in Sync: How Art and Music Are Revitalizing American Religion*. Berkeley: University of California Press, 2003.

*———. *Practicing Spirituality: The Way of the Artist*. Berkeley: University of California Press, 2000.

Zarur, Elizabeth Netto Calil and Charles Muir Lovell, eds. *Art and Faith in Mexico: The Nineteenth-Century Retablo Tradition*. Albuquerque: University of New Mexico Press, 2001.

Contributors

DOUG ADAMS is Professor of Christianity and the Arts, Pacific School of Religion and Doctoral Faculty Member in the History of Art and Religion, Graduate Theological Union, Berkeley, CA. His books include *The Prostitute in the Family Tree: Discovering Humor and Irony in the Bible; Congregational Dancing in Christian Worship; Transcendence with the Human Body in Art: George Segal, Stephen De Staebler, Jasper Johns, and Christo*. He co-edited *Postmodern Worship and the Arts* (with Michael Moynahan), *Art as Religious Studies* and *Dance as Religious Studies* (with Diane Apostolos-Cappadona).

MARCUS B. BURKE is Curator of Paintings, Drawings, and Metalwork, The Hispanic Society of America, New York City, and a consultant for the Provenance Index, Getty Art History Information Project. His publications include: *El Barroco; Pintura y Escultura en Nueva Espana; Mexican Art Masterpieces; Spain and New Spain: Mexican Colonial Arts in their European Context* (with Linda Bantel); and the exhibition catalogs *Jesuit Art and Iconography, 1550–1800; The Mexican Colonial Collection of the Davenport Museum of Art; Velázquez in New York Collections.*

ENA GIURESCU HELLER is Director, The Gallery at the American Bible Society, New York City. She is contributing editor of the exhibition catalogs *Icons or Portraits? Images of Jesus and Mary from the Collection of Michael Hall* and *The Word as Art: Contemporary Renderings*. She is a contributor to the forthcoming *Women's Space. Parish, Place and Gender in the Middle Ages* and *The Art of Sandra Bowden*.

VIVIAN B. MANN is Morris and Eva Feld Chair in Judaica, the Jewish Museum, and Adjunct Professor and Advisor to the Master's Program at The Graduate School of the Jewish Theological Seminary, New York City. Her publications include *Jewish Texts on the Visual Arts* and the exhibitions catalogs *Danzig 1939: Treasures of a Destroyed Community; From Court Jews to the Rothschilds: Art, Patronage, and Power, 1600–1800; Convivencia: Jews, Muslims and Christians in Medieval Spain*, and *Gardens and Ghettoes: the Art of Jewish Life in Italy*, which won the Henry Allen Moe Prize for the Catalogue of Distinction in the Arts in 1989.

DAVID MORGAN is Phyllis and Richard Duesenberg Chair in Christianity and the Arts at Christ College, Valparaiso University, Valparaiso, IN. His books include *Visual Piety: A History and Theory of Popular Religious Images; Protestants and Pictures: Religion, Visual Culture, and the Age of American Mass Production* (winner of the 1999 Award for best book in the category of religion and philosophy from the Professional and Scholarly Publishing Division of the Association of American Publishers), and *The Visual Culture of American Religions*, which he co-edited with Sally M. Promey.

ROBERT S. NELSON is Distinguished Service Professor of Art History and History of Culture at the University of Chicago. He is author of *The Iconography of Preface and Miniature in the Byzantine Gospel Book; Theodore Hagiopetrites. A Late Byzantine Scribe and Illuminator,* and the forthcoming *Hagia Sophia, 1850–1950: Holy Wisdom Modern Monument.* He is contributing editor of *Visuality Before and Beyond the Renaissance: Seeing as Others Saw; Art of the Mediterrranean World, AD 100–1400; The Nature of Frank Lloyd Wright;* and *Critical Terms for Art History* (co-edited with Richard Schiff).

S. BRENT PLATE is Assistant Professor of Religion and the Visual Arts at Texas Christian University, Fort Worth, TX. He is editor of *Religion, Art, and Visual Culture: A Cross-Cultural Reader; The Apocalyptic Imagination: Aesthetics and Ethics at the End of the World,* and *Imag(in)ing Otherness: Filmic Visions of Living Together* (with David Jasper), and author of the forthcoming *Allegorical Aesthetics: Walter Benjamin, Religion, and the Arts.*

PATRICIA C. PONGRACZ is Curator, The Gallery at the American Bible Society, New York City. She is contributing editor of the exhibition catalogs *Printing the Word: The Art of Watanabe Sadao, Reflections on Glass: 20th Century Stained Glass in American Art and Architecture,* and *Threads of Faith: Recent Works from the Women of Color Quilters Network.* She is a contributor to *The Tiffany Chapel* and *Glory in Glass. Stained Glass in the United States: Origins, Variety, and Preservation,* and the editor of the Corpus Vitrearum Volume *Stained Glass Before 1700 in the Collections of the New York Metropolitan Area (excluding The Cloisters and the Metropolitan Museum of Art),* forthcoming.

PHOTOGRAPHIC ACKNOWLEDGEMENTS

Cover: Jerry Evenrud Collection, photo courtesy of the collector. © Britt Wikstrom.

30: Museo Pio Clementino, Vatican Museums. Photo credit: Scala/Art Resource, NY.

34: Solomon R. Guggenheim Museum, New York. Gift, Solomon R. Guggenheim, 1937. 37.239. © 2004 Artists Rights Society (ARS), New York/ADAGP, Paris.

35: Photo courtesy of David Morgan.

36: Photo courtesy of Württembergische Landesbibliothek, Stuttgart.

54: Collection of the Modern Art Museum of Fort Worth, Museum Purchase, 1995.30P.V. Photo credit: Kira Perov.

56: Courtesy by Gary Hill and Donald Young Gallery, Chicago.

59: Photo: Edna M. Rodríguez-Mangual.

70, 81: Photo Credit: Scala /Art Resource

71: Devonshire Collection, Chatsworh. Reproduced by permission of the Duke of Devonshire and the Chatsworth Settlement Trustees.

73: Fine Art Museums of San Francisco, Museum Purchase, California Palace of the Legion of Honor, General Fund, 1930.25.

75: Jerry Evenrud Collection, photo courtesy of the collector. © Britt Wikstrom.

77: National Gallery of Art, Washington, 1948.12.1 (1027)/ PA. Gift of the Avalon Foundation, Image © 2003 Board of Trustees.

78: The Connecticut Historical Society, Hartford, Connecticut, 1957.63.8.

80, 81: Collection Miami Art Museum, gift of the George and Helen Segal Foundation, Inc.; 2001.10. Photo by Peter Harholdt.

90, fig. 1: The Jewish Museum, New York, Gift of Leonard and Phyllis Greenberg, 1986-121f. Photo © The Jewish Museum, New York; Photo by John Parnell. Fig 2: Photo by Vivian Mann.

91: After H. A. Meek, The Synagogue. London: Phaidon, 1995, p. 80.

92, fig. 4 and 5: After Gabrielle Sed-Rajna, *Jewish Art.* New York: Harry N. Abrams, 1997, fig. 316 and fig. 311. Photos: Zev Radovan, Jerusalem.

93, fig. 6: After Rebecca Martin Nagy et al, *Sepphoris in Galilee: Crosscurrents of Culture.* Roanoke: North Carolina Museum of Art, 1996, fig. 68. Photo: Gabi Laron. Fig. 7: After Ze'ev Weiss and Ehud Netzer, *Promise and Redemption: a Synagogue Mosaic from Sepphoris.* Jerusalem: The Israel Museum, 1996, p. 29.

94, fig. 8: After Gabrielle Sed-Rajna, *Jewish Art.* New York: Harry N. Abrams, 1997, fig. 74. Photo: Alain Mahuzier. Fig 9: After Marilyn Stokstad, *Art History.* New York: Harry N. Abrams, 1997, fig. 7-8.

95, fig. 10: After Gabrielle Sed-Rajna, *Jewish Art.* New York: Harry N. Abrams, 1997, fig. 70. Photo: Philippe Perchero/Artephot. Fig. 11: Cod.theol.gr. 31, pag. 13 = fol. 7r. Bildarchiv der ÖNB, Wien.

96: After Volkmar Gantshorn, *The Christian Oriental Carpet*. Cologne: Benedikt Taschen, 1991, Pl. III. Museum of Turkish and Islamic Art, Istanbul.

104: Photo credit: Scala /Art Resource.

105: Photo credit: Scala /Art Resource, NY.

106: Photo credit: Cameraphoto Arte, Venice/ Art Resource, NY.

107: Photo by Robert L. Nelson.

108: © 2004 Kate Rothko Prizel & Christopher Rothko / Artists Rights Society (ARS), New York. Photo credit: Nicolas Sapicha/Art Resource.

110: Photo credit: Maurice Jarnoux / Paris-Match.

112, fig. 7: Photo © Vince Streano, 1985. Fig. 8: Photo © Susan Storch /The Imagery.

114: Photo © Werner Blaser.

126: Photo: The Gallery at the American Bible Society /Gina Fuentes Walker.

127, 129: Photo courtesy of The Museum of Fine Arts, Houston.

130: Gift of Nancy Atwood Sprague in memory of Albert Arnold Sprague.1906.99; with frame, June 1989. Reproduction, The Art Institute of Chicago.

133, fig. 5:Photo courtesy of MOCRA. Fig. 6: Photo courtesy of Hebrew Union College— Jewish Institute of Religion Museum, New York.

135: Photo courtesy of Hebrew Union College— Jewish Institute of Religion Museum, New York. © Richard Lobell Photography.

136, fig. 8: Photo: The Gallery at the American Bible Society /Gina Fuentes Walker. Fig. 9: Photo: The Gallery at the American Bible Society.

145: Photo credit: Scala /Art Resource NY.

146, fig. 2: Photo credit: Scala /Art Resource NY. Fig. 3: © 2004 Estate of Pablo Picasso/ Artists Rights Society (ARS), New York. Photo credit: John Bigelow Taylor/Art Resource/NY

149: Photo credit: Tate Gallery, London /Art Resource, NY.

150: © 2004 Andy Warhol Foundation for the Visual Arts Arts / Artists Rights Society (ARS), New York. Photo credit: The Andy Warhol Foundation, Inc./Art Resource, NY.

151: Chester Dale Collection, 1963.10.115.(1779)/ PA. Image © 2003 Board of Trustees, National Gallery of Art, Washington.

152: Robert and Jane Meyerhoff Collection, 1986.65.6-11/PA. Image © 2003 Board of Trustees, National Gallery of Art, Washington.

154–57: Photo courtesy of Donald J. Forsythe.

158: Photo courtesy of Mary McCleary. Collection of Harry H. Orenstein and Ellen Tuchman.

159: © Ms. Watanabe, Japan. Photo credit: The Gallery at the American Bible Society /Eduardo Calderón. Collection of Anne H. H. Pyle.

161: © 2004 Artists Rights Society (ARS), New York/ADAGP, Paris. Photo: Wiseman Images. Collection Sandra Bowden.

162: Photo courtesy and © Sandra Bowden.

165, fig. 13: Photo: The Gallery at the American Bible Society. © Lika Tov. Fig. 14: Aquired through the Lillie P. Bliss Bequest (472.1941). The Museum of Modern Art, New York, NY. Digital Image © The Museum of Modern Art/ Licensed by SCALA /Art Resource, NY.

166: Photo: The Gallery at the American Bible Society. © Aaron Lee Benson.